The Curatorial

Also available from Bloomsbury

Art and Institution, Rajiv Kaushik

The Curatorial

A Philosophy of Curating

Edited by Jean-Paul Martinon

Bloomsbury Academic
An imprint of Bloomsbury Publishing Plc

B L O O M S B U R Y
LONDON • NEW DELHI • NEW YORK • SYDNEY

Bloomsbury Academic

An imprint of Bloomsbury Publishing Plc

50 Bedford Square	1385 Broadway
London	New York
WC1B 3DP	NY 10018
UK	USA

www.bloomsbury.com

BLOOMSBURY and the Diana logo are trademarks of Bloomsbury Publishing Plc

First published 2013

British Library Cataloguing-in-Publication Data
A catalogue record for this book is available from the British Library.

ISBN: HB:	978-1-47252-560-4
PB:	978-1-47422-921-0
ePub:	978-1-47253-361-6
ePDF:	978-1-47252-316-7

Library of Congress Cataloging-in-Publication Data
A catalog record for this book is available from the Library of Congress.

Typeset by Newgen Knowledge Works (P) Ltd., Chennai, India
Printed and bound in Great Britain

Contents

Illustrations

Preface

Curatorial/Knowledge PhD Programme, Goldsmiths College

We wish to talk about curating: about its potentials and its scopes.

We wish to talk about curating: about the knowledges it builds on and the knowledges it produces.

We wish to talk about curating: about its sociabilities, collectivities and convivialities.

We wish to talk about curating: about its commitments to seeing, reading and speaking and exchanging as a form of public activity.

We wish to talk about curating: because it has been seeking novel ways of instantiating the crises of our world in other modalities, of finding other ways to engage with our current woes.

We wish to talk about curating, because we thought we saw a possibility nestling within its protocols, a possibility for other ways of working, relating and knowing.

This wish of ours to talk about curating led us to institute a space of gathering, a practice-led PhD programme in 2006 called Curatorial/Knowledge to which many young curators and artists have come to share in the discussion and embark on their own investigations. Our friends and colleagues from many different arenas have also come along and held seminars and discussed their complex practices and intricate thought processes.

At the very beginning, six years ago, someone said half-jokingly, 'our project is to stop people curating!' and some weeks later someone else said, a bit more vehemently: 'so are we agreed that this programme is not about becoming better curators?' With hindsight, these were actually statements of considerable substance, which recognized that the proliferation of curatorial activities, courses, residencies and prizes has led to massive activity, driven by energy and an enthusiasm for displays and events, much of which is less than fully considered. It also recognizes that all this activity is not founded on a solid intellectual basis that might empower its practitioners to have the critical courage to resist

demands to simply supply more and more excitement to a market ravenous for spectacle and entertainment.

It has always been our desire to enter the discussion as 'provocateurs' rather than as 'experts' – we have understood that historical and other expertise is easily converted into the legitimation of market-driven spectacles and therefore cannot provide the self-reflexive speculation we continue to think the field requires if it is to become more than a series of professional protocols.

Alongside these market-driven spectacles a whole gamut of curatorial activities take place, calling into question what it is that is really taking place underneath all this glitter. These activities have taken many shapes: for example, we have seen the entry of the pedagogical into the field under the aegis of 'the educational turn', the (re)animation of abandoned sites and the (re-)infiltration of existing institutions, and we have also witnessed a strong insistence on talking, conversing, discussing and reading, activities that are in themselves often understood as the very stuff of what it is to make things visible, legible and relevant.

And so our discussions have taken place between these two quite opposite poles of what it means to work in the field, two poles whose differences have become increasingly accentuated – bowing to the expanding market on the one hand and an ever-increasing activist spirit within sectors of the worlds of art and artistic education.

Initially we recognized a necessity to distinguish between 'curating' and 'the curatorial'. If 'curating' is a gamut of professional practices that had to do with setting up exhibitions and other modes of display, then 'the curatorial' operates at a very different level: it explores all that takes place on the stage set-up, both intentionally and unintentionally, by the curator and views it as an event of knowledge. So to drive home a distinction between 'curating' and 'the curatorial' means to emphasize a shift from the staging of the event to the actual event itself: its enactment, dramatization and performance. 'Curating' takes place in a promise; it produces a moment of promise, of redemption to come. By contrast, 'the curatorial' is what disturbs this process; it breaks up this stage, yet produces a narrative which comes into being in the very moment in which an utterance takes place, in that moment in which the event communicates and says, as Mieke Bal once observed, 'look, that is how this is'.

So 'the curatorial' is a disturbance, an utterance, a narrative. And within this disturbance, works of art can no longer be a process of interpellation, a conscious or unconscious hailing by some internalized mode of knowledge. Instead, they

engage in another process, that of precipitating our reflection, of encouraging another way of thinking or sensing the world. From being reactive to the world to precipitating another reflection on the world (and inevitably sparking ways to change the world), works of art reflect the myriad ways of being implicated in the world, not just as passive recipients, but as active members of a world that is never one with itself, always out of joint, out of place, but always intrinsically ours – of our own making.

Not wishing to operate within a space of binary oppositions (art vs art history or practice vs theory, for example), we have brought in 'the philosophical', not as a master discipline or narrative to explain all, but as a slightly distantiated mode of reflection. This has enabled the introduction of a critical edge that maintains a somewhat sovereign position, detached from the seeming imperatives of everyday demands. The move to 'the philosophical' we have affected to enact is not a hierarchical conceit or the privileging of one kind of discipline or practice over another. It is simply the recognition that by bringing some strands of contemporary philosophical and theoretical thought to the discussion of 'the curatorial', we open the possibility of reflecting in a way that goes beyond the simple description of projects and experiences. Given the immense expansion of the field and of how central it has become to the visual arts and other modes of cultural practice, it seems to us that it is now imperative to develop a discourse that reaches outwards, beyond the professional milieu, and that allows itself to be challenged by some of the most complex and ethics-driven thought of our times.

We would like to thank all the participants and guests who attended our seminars and the institutions that have hosted us, all of whom continue to contribute to our ongoing discussions. We would particularly like to thank our department at Goldsmiths, Visual Cultures, whose ethos of constant experimentation and testing whatever comes our way has been so hospitable to establishing new programmes that perform the urgencies of the culture we live in. From the moment we established the Curatorial/Knowledge programme, we fell into an ongoing conversation that meandered in many directions and has moved us all, quite unawares, along with it. We probably have not changed the field very significantly, but we have certainly established a conversation about 'the curatorial' that has challenged all of us.

What follows includes some of the voices that were heard during the first five years of the programme. This volume does not pretend to be a complete

and authoritative delineation of a body of knowledge but we hope that it will encourage the kind of deconstructive speculation that has been the most productive and enjoyable part of our studies.

<div align="right">

Jean-Paul Martinon and Irit Rogoff
Visual Cultures, Goldsmiths College
University of London

</div>

Notes on Contributors

Cihat Arinç is independent writer and academic researcher based in London. His research interests focus on memory and global film cultures exploring themes such as haunted subjectivities, auto/biographical narratives, silenced histories and the ruins left by war. He has published a number of essays in edited books and film magazines, and also contributed to art projects and exhibitions in art institutions such as The Serpentine Gallery, Institute of International Visual Arts and The Showroom Gallery, London. He has just completed his PhD entitled *Postcolonial Cyprus on the Haunted Screen: Spectral Realism and the Politics of Remembering in New Turkish Cinema*.

Ariella Azoulay teaches in the Department of Modern Culture and Media and Comparative Literature at Brown University in the USA. Her recent books include: *From Palestine to Israel: A Photographic Record of Destruction and State Formation, 1947–1950*, (Pluto, 2011), *Civil Imagination: The Political Ontology of Photography* (Verso, 2012) and *The Civil Contract of Photography* (Zone, 2008). She is also the co-author with Adi Ophir of *The One State Condition: Occupation and Democracy between the Sea and the River* (Stanford, 2012). She is also a curator and documentary filmmaker. Her recent projects include *Potential History* (2012, Stuk / Artefact, Louven) and *Civil Alliances, Palestine, 47–48* (2012). http://cargocollective.com/ariellaazoulay

Alfredo Cramerotti is a writer, curator and editor working across TV, radio, publishing, writing and exhibition making. He co-curated Manifesta 8, the European Biennial of Contemporary Art, 2010, the Maldives Pavilion and the Wales Pavilion at the 55th Venice Art Biennial, 2013. He directs MOSTYN, Wales' leading contemporary art institution, and the itinerant projects AGM Culture and Chamber of Public Secrets. He is Research Scholar at the European Centre for Photography Research, University of Wales, Newport, and Editor of the *Critical Photography* series by Intellect Books. His own publications include the book *Aesthetic Journalism: How to Inform without Informing* (2009).

Bridget Crone is a curator and writer based in London. From 2006–11, she was the director of Media Art Bath – a publicly funded organization dedicated to

commissioning new work in performance and moving image practice. Projects include: *Eye Music for Dancing* (Flat Time House, London, 2012), *The Sensible Stage* (Holburne Museum and various venues, Bath, 2007; Whitechapel Gallery, London, 2008; ICA, London, 2012), *The Body The Ruin* (Ian Potter Museum, Melbourne, 2005). Publications include: *The Sensible Stage: Staging and the Moving Image*, an edited collection addressing the relationships between moving image, performance and theatre (Picture This, 2012). Bridget teaches at Goldsmiths, University of London.

Anshuman Dasgupta is an art historian and curator teaching at the Visva-Bharati University, Santiniketan since 1997. He studied Art History in Santiniketan and M.S University, Baroda and Film Appreciation from F.T.I.I. Pune. Anshuman has published numerous essays for LKC, Marg, Art-India and de Appel. His essays are also part of larger compilations like *Contemporary Sculptures* (Marg, 2000), *Towards a New Art History* (Printworld, 2003), *Art & Visual Cultures in India 1857–2007* (Marg, 2009). Major curatorial projects include *Santhal Family* at MuHKA, Antwerp and *Ramkinkar Baij Centenary Exhibition* at Visva-Bharati in 2006–7. He was organizer and chairperson of Khoj Kolkata in 2006.

Jean-Louis Déotte is Professor of Philosophy at the Université Paris 8. Between 1986 and 1992, he directed a research programme on museums and the patrimony of ruins at the College International de Philosophie in Paris. He has participated in numerous conferences and seminars on the idea of the museum and its role in society. He has published over ten books on art, visual culture, aesthetics and politics, including *Le musée, l'origine de l'esthétique* (1993), *Oubliez! L'Europe, les ruines, le musée* (1995), *Qu'est-ce qu'un appareil? Benjamin, Lyotard, Rancière* (2007) and *Walter Benjamin et la forme plastique* (2012). In English, his latest essay is 'The Museum, a Universal Apparatus', in *Ici et Ailleurs*, 2012 (ici-et-ailleurs.org/spip.php?article27).

Valentina Desideri was best defined by a friend who called her a 20-year-old on tour. Although this was meant as a reproach, she found this definition more suiting than performance artist or anything on that tone. Lately she has also been called a psychic, which now makes of her a psychic 20-year-old on tour. She trained in contemporary dance in London then did a MA in Fine Arts in Amsterdam, she does Fake and Political Therapy, she makes performances, she writes biographies by reading people's palms. She writes other things too but mostly she's around.

Jenny Doussan is a philosopher based in London. She is currently a Visiting Tutor in the Department of Visual Cultures at Goldsmiths, University of London. She

is the author of *Time, Language, and Visuality in Agamben's Philosophy* (Palgrave, 2013); 'Time and Presence in Agamben's Critique of Deconstruction', in *Cosmos and History: The Journal of Natural and Social Philosophy*, 2013 (forthcoming); and 'The Scent of the Jonquil', in *Rattle: A Journal at the Convergence of Art & Writing* 3, London, 2012.

Helmut Draxler is an art historian, art critic, curator and Professor of Art Theory at the Merz Academy in Stuttgart. He was the director of the Kunstverein Munich from 1992 to 1995. In 2004–6 he co-organized the project *Avant-garde Film Biopolitics* at the Jan van Eyck Academy, Maastricht. More recently, Draxler curated the exhibition *Shandyism: Authorship as Genre* at the Secession, Vienna, 2007. He writes extensively on contemporary art and theory for a variety of international magazines and artists' catalogues. Recent publications include: *Film, Avantgarde, Biopolitik* (Schlebrügge, 2009); *Gefährliche Substanzen* (Polypen, 2007); *Coercing Constellations. Space, Reference, and Representation in Fareed Armaly* (Polypen, 2007); and *Shandyism. Authorship as Genre* (Secession, 2007).

Charles Esche is a curator and writer based in Scotland. He is director of Van Abbemuseum, Eindhoven since 2004 and co-director of *Afterall Journal and Books* based at Central St. Martins College, London since 1998. He has (co-)curated a number of major international exhibitions including: Sao Paulo Bienal (2014); U3 Triennale, Ljubljana (2011); Riwaq Biennale, Ramallah (2007 and 2009); Istanbul Biennale (2005); Gwangju Biennale (2002). He teaches regularly on the Exhibition Studies course at the University of the Arts, London and the De Appel Curatorial Course, Amsterdam. From 2000–4 he was director of Rooseum, Malmö.

Valeria Graziano practises as a researcher, educator and organizer within (and against) contemporary artistic circuits and academia. Some of the items she holds dear include adventures, carrots, schizo-practices, relays and photo-romances. She teaches and is undertaking her PhD at Queen Mary University, London. Her research theorizes the role of radical conviviality emerging within histories of self-organizing, institutional analysis and militant research. She has a penchant for deviceful pedagogical experiments, which she has been breeding with the Micropolitics Research Group (micropolitics.wordpress.com), The Centre for Ethics and Politics (cfep.org.uk) and many other ravishing collaborators over the years.

Stefano Harney is Professor of Strategic Management Education at the Lee Kong Chian School of Business, Singapore Management University and a co-founder of the School for Study. He is the author of *State Work: Public Administration and Mass Intellectuality* (Duke University Press, 2002) and with Fred Moten of *The Undercommons: Fugitive Planning and Black Study*, published by Autonomedia in 2013. His recent writings include 'Fate Work: A Conversation' with Valentina Desideri, in the journal *Ephemera: Theory and Politics in Organization* (www. ephemerajournal.org).

Natasa Ilić is a curator and critic. She is a member of What, How and for Whom/ WHW, a curatorial collective formed in 1999 and based in Zagreb and Berlin. Its members also include Ivet Ćurlin, Ana Dević, Sabina Sabolović and designer Dejan Kršić. WHW organizes a range of exhibitions and publishing projects and runs Gallery Nova, a non-profit, city-owned gallery in Zagreb. Recent WHW exhibitions include *One Needs to Live Self-confidently . . . Watching*, Croatian Pavilion at the 54th Venice Biennial (2011), *Second World*, Steirischer Herbst, Graz (2011), *How much fascism?*, BAK, Utrecht (2012), *Dear Art*, Museum of Moden Art, Ljubljana (2012). WHW is currently curating the next edition of *Meeting Points*, a multidisciplinary event taking place in various cities in Europe and the Middle East (2013–14).

Susan Kelly is a writer and artist whose research looks at the relationships between art and micropolitics, rhetoric and practices of organization. She works in performance, installation, video, and writes and publishes. She works both independently and collectively with various art-activist groups in London. Over the last ten years, she has shown her work in Belfast, New York, Toronto, Helsinki, Prague, Dublin, St Petersburg, Krasnoyarsk, Tallin, Innsbruck and Zagreb, and has published articles in *re-public art, Parallax, Journal of Visual Cultures* and elsewhere. In 2012, she was Künstlerhaus Büchsenhausen Fellow in Art and Theory. She currently teaches Fine Art at Goldsmiths College, University of London.

Adnan Madani is an artist and writer. Born in Karachi, he graduated from the Indus Valley School of Art and Architecture in 2001. His work has been shown in numerous galleries in Karachi, Dubai, Mumbai and Lahore. He has written widely on Pakistani art, with a focus on the relationship between the artist and the nation. He is a regular contributor to *NuktaArt, the Contemporary Art Magazine of Pakistan* (www.nuktaartmag.com). His research interests include contemporary South Asian visual culture, theories of modernity and

contemporaneity. He is currently pursuing a PhD at Goldsmiths, University of London and divides his time between London and Karachi.

Jean-Paul Martinon was the co-founder and curator of Rear Window (www.rear-window.org.uk) an independent arts trust that staged a series of exhibitions and conferences in temporary sites across London. He is currently the Programme Leader of the MPhil-PhD Programme in Visual Cultures at Goldsmiths College, University of London. He has written monographs on a Victorian workhouse (*Swelling Grounds*, Rear Window, 1995), the idea of the future in the work of Derrida, Malabou and Nancy (*On Futurity*, Palgrave, 2007), the temporal dimension of masculinity (*The End of Man*, Punctum, 2013) and the concept of peace after the Rwandan genocide (*After 'Rwanda'*, Rodopi, 2013). www.jeanpaulmartinon.net

Doreen Mende is a curator and theorist who lives in Berlin and London. Her practice-based PhD at Goldsmiths addresses the geopolitics of exhibiting. It starts with photography as a practice of solidarity and liberation during the period of socialist internationalism. Its aim is to rethink the potential of exhibition today. As a curator, one of her recent projects include *doubleboundeconomies. net*. She is currently working on an exhibition of KP Brehmer's work for Raven Row in London. She is the co-founder of the magazine *Displayer* at HfG/ZKM Karlsruhe. Since 2010, Mende runs a theory class at the Dutch Art Institute, in The Netherlands.

Suzana Milevska is a theoretician and curator. In 2013 she was appointed the Endowed Professor for Central and South Eastern European Art Histories at the Academy of Fine Arts Vienna. She holds a PhD in visual culture from the University of London. She lectured at various institutions: Alvar Aalto University Helsinki, Academy of Fine Arts Vienna, Oxford University, The Chicago School of Art Institute, Columbia University, IUAV Venice, Akademie der Kunst Berlin, Moderna Museet Stockholm, Tate Modern London, KIASMA Helsinki, MUMOK Vienna, CAMK Japan, etc. In 2010, she published her book *Gender Difference in the Balkans*. In 2012 she won Igor Zabel Award for Culture and Theory and ALICE Award for political curating.

Je Yun Moon is a curator and writer. She lives and works in Seoul and in London. She is currently finishing her PhD at Goldsmiths College, working with the notion of choreography as a particular technology of making and unmaking the modern subject. She studied curatorial studies at the Royal College of Arts and art history at Cornell University. She has worked in various areas of art, architecture

and performance projects, including exhibitions, public programmes, seminars and publications at institutions such as the Sonje Art Center, the Anyang Public Art Project, the Venice Architecture Biennale and the Nam June Paik Art Center, Seoul.

Ines Moreira is an architect, researcher and curator based in Portugal. In 2013, she completed her PhD, an epistemological and processual research on the issues of curating architecture, space and exhibition display, presented under the title *Performing Building Sites: A Curatorial Research on Space*, developed on the Curatorial / Knowledge PhD Programme, Goldsmiths College. Her curatorial projects approach specific spaces (as post-industrial hangars, burnt historical buildings, minor architectures or abandoned museums) exploring knowledge-oriented research/production in the intersection of art, architecture, techno-science and the humanities. www.petitcabanon.org

Stefan Nowotny is a philosopher based in Vienna. He is currently a Lecturer in the Department of Visual Cultures, Goldsmiths College, University of London, where he teaches on the Curatorial / Knowledge PhD Programme. He is a member of the Vienna-based European Institute for Progressive Cultural Policies (www.eipcp.net). He has published widely on philosophical and political topics, co-edited several anthologies, translated a number of texts from both French and English into German, and co-authored the volumes *Instituierende Praxen: Bruchlinien der Institutionskritik* (with Gerald Raunig, 2008) and *Übersetzung: Das Versprechen eines Begriffs* (with Boris Buden, 2008). He is also a co-editor of the book series *Es kommt darauf an: Texte zur Theorie der politischen Praxis*.

Sarah Pierce is an artist based in Dublin. Since 2003, she has used the term The Metropolitan Complex to describe a practice involving different working methods including performance, self-publishing, workshops and installation. Alongside recent exhibitions and performances, between 2011–13, she was artist-in-residence and guest faculty at the Center for Curatorial Studies, Bard College, and in 2010 she was a DIVA fellow with the University of Copenhagen where she guest taught on the MA Curating. In 2013–15, she will join the School of Missing Studies as a tutor on the Sandberg Institute's MA in Art and Learning.

Raqs Media Collective enjoys playing a plurality of roles, often appearing as artists, occasionally as curators, sometimes as philosophical agent provocateurs. They make contemporary art, films, exhibitions, books, staged events; often collaborating with architects, computer programmers, writers and theatre directors. Their projects have been exhibited at numerous international venues

including Documenta and the Venice Biennale. The Raqs Media Collective was founded in 1992 by Jeebesh Bagchi, Monica Narula and Shuddhabrata Sengupta. Raqs remains closely involved with the Sarai programme at the Centre for the Study of Developing Societies (www.sarai.net), an initiative they co-founded in 2000. www.raqsmediacollective.net

Irit Rogoff is a writer, curator, and organizer working at the intersection of contemporary art, critical theory and emergent political manifestations. She is Professor of Visual Cultures at Goldsmiths, University of London where she heads the PhD in Curatorial / Knowledge programme, MA in Global Arts and the new Geo-Cultures Research Center. Rogoff has written extensively on geography, globalization and contemporary participatory practices in the expanded field of art. A collection of recent essays, *Unbounded – Limits' Possibilities* (e-flux/Sternberg, 2012) and her new book, *Looking Away – Participating Singularities, Ontological Communities*, comes out in 2013.

Joshua Simon is a curator, writer and filmmaker. He is the Director and Chief Curator of the Museum of Bat Yam, Israel. He is a research fellow at the Vera List Center for Art and Politics at the New School, New York, and co-founding editor of several magazines: *Maayan Magazine for Poetry and Literature*, a magazine dedicated to film, *Maarvon* (which in Hebrew means Western) and *The New & Bad Art Magazine*, all based in Tel Aviv-Jaffa. In 2007, he curated the first Israeli biennial, *The Herzliya Biennial* presenting more than 70 artists. He is the editor of *Solution 196–213 United States of Palestine-Israel* (Sternberg, 2011) and the author of *Neomaterialism* (Sternberg, 2013).

Roopesh Sitharan is an artist, curator, academic and sometimes an explorer of cultural paradigms. He obtained an MFA in Digital Arts and New Media from the University of Santa Cruz and is currently finishing his PhD. His area of specialization is Malaysian studies, New Media cultures and curatorial practices. He often examines the boundaries of meaning and value in the production and interpretation of art and technology. He has participated in numerous national and international art projects and showcases such as those organized by the Inter-Society of Electronic Arts (ISEA), Siggraph and the Gwangju Biennale (2008). www.roopesh.com

Nora Sternfeld is an educator and curator. She is Professor in Curating and Mediating Art at the Aalto University, Helsinki and Co-Director of ECM (Educating/Curating/Managing) Master Programme in exhibition theory and practice at the University of Applied Arts, Vienna. She is part of Trafo. K, Office

for Art Education and Critical Knowledge Production (with Renate Höllwart and Elke Smodics-Kuscher), Vienna. She is also the co-founder and member of the network Schnittpunkt: Exhibition Theory and Practice and serves on the editorial board of *Bildpunkt*, the magazine of the Viennese artist association IG Bildende Kunst. She publishes on contemporary art, exhibition theory, education, politics of history and anti-racism.

Aneta Szyłak is a curator, writer, activist, founding director of Wyspa Institute of Art in Gdansk Shipyard and Artistic Director of Alternativa. Her exhibitions are characterized by a strong response towards the cultural, political, social, architectural and institutional specificity. She has been working internationally on exhibitions and public events since 1997. She has lectured at many art institutions and universities, including Copenhagen University, New School University, Dutch Art Institute, Queens College and New York University and worked as a guest professor at the Akademie der Bildende Kunste in Mainz, Germany. She has just completed her PhD thesis at Copenhagen Doctoral School Copenhagen University and Goldsmiths College, London.

Leire Vergara is an independent curator from Bilbao. She is a founding member together with Beatriz Cavia, Isabel de Naverán and Miren Jaio of Bulegoa z/b, an independent office for art and knowledge. Between 2002 and 2005, she co-directed, together with Peio Aguirre, the independent art production structure called D.A.E (*Donostiako Arte Ekinbideak*) in Donostia-San Sebastián, Spain. Between 2006 and 2009 she worked as chief curator at Sala Rekalde, Bilbao. She has contributed as a writer to numerous art and cultural magazines and catalogues. She is a PhD student in the Curatorial/Knowledge Programme in the Department of Visual Cultures at Goldsmiths College and in the Department of Audiovisual Communication, University of the Basque Country.

Introduction

Jean-Paul Martinon

On the eve of 26 July 1866, in his flat at 89 Rue de Rome in Paris, the symbolist poet, English teacher, theatre and fashion critic Stéphane Mallarmé starts to jot down on paper plans for a series of 2-hour multi-sensory events that, he hopes, will constitute the final Orphic explanation of life on earth.[1]

In his mind, the events will combine magic, a small parade, some ballet, a recital, the execution of an alchemical ritual, the calculation of a mathematical formula, the reading of sacred texts, some mime, the contemplation of a crystal chandelier and a carefully planned fireworks display. The events will take place on a giant site designed to resemble a stage, but which will also look like a chancel with an altar installed in the middle of a nineteenth-century salon with cozy fireplaces and some gas lamps. An 'Operator' (half-priest half-comedian) will orchestrate the shows from behind the scenes with the help of 24 'Assistants'.

Contrary to what one might think when the name of Mallarmé is mentioned (refined, carefully written abstract poetry), these events are very much conceived as an unscripted popular melodrama 'without heroes' to be performed by the general public itself ('the Crowd'), a mass communal liturgy bringing all the arts together. Overall, Mallarmé's aim is to expose 'thought thinking itself' and to synchronize poetry and art with the movement of the universe, and in the process allow the Absolute to expose and perform itself everywhere, once and for all. Not a small undertaking, but then again, Mallarmé envisions the project as a lifelong commitment, hoping to accomplish it before dying.

Twenty-two years later, on 21 November 1888, the project remains unfinished. Slightly disgruntled at the complexity of the undertaking, Mallarmé finally agrees to give his project a title: he will call his final Orphic event *This Is* [*C'est*]. Ten years later, Mallarmé dies leaving behind a half-scribbled note urging his family to burn all the documents relating to his masterpiece, unfinished despite

being 30 years in the making. The quasi-eschatological masterpiece never sees the light of day.

With some distance, Mallarmé's phantasmagorical plans can now, obviously, be seen as a typical example of an artist attempting, yet again, to come up with a 'Total Work of Art' in the same vein as Wagner's *Gesamstkunstwerk* or Scriabine's *Mysterium*. However, it can also be understood in a different way: as the ultimate curatorial event. Indeed, how is one *not* to see, in this aborted project, an attempt to think 'the curatorial' a century or so before the very word began to acquire meaning? The whole gamut of issues facing curators today is all laid out in the few cryptic notes Mallarmé's family saved from the fire he mandated, which can perhaps be summarized in the following way (in no particular order):

- *This Is* displays the work of others (mimes, dancers, pyrotechnists, priests, etc.): it is *essentially expository*: it both shows and explains.
- *This Is* brings the past and the present together (old alchemy and the live contemplation of a chandelier, for example): it is *a multi-temporal event*.
- By bringing several arts and spaces together, *This Is* puts forward *a constellation of meaning* that no single art form could have generated.
- *This Is* has a message: *it actually says something*: *This Is* the final Orphic explanation of life on earth.
- *This Is* has no hero. The curator is a simple operator working behind the scenes. No artist predominates over the others. *It is seemingly egalitarian*.
- *This Is* reveals the way artifice (the arts) exposes nature (the universe). It is a planned victory of *techne* over *phusis*: *a victory over entropy*.
- *This Is* brings human agency and the Absolute together. It is therefore not religious, but *secular and yet transcendental*.
- *This Is* does not pitch an object (artwork) against a subject (viewer), but is viewer-centered: the crowd makes it *experiential and participatory*.
- *This Is* resembles a manifestation and not an exhibition. It exposes, but does not exhibit; *it manifests a coming together of talents and artefacts*.
- *This Is* has no centre of significance: it takes place at once on a stage, salon and chancel, thus creating several centres of significance: *it is multi-sited*.
- *This Is* has no predetermined rules, grammar or syntax. *It needs to invent its own language* then and there as the events take place.
- *This Is* does not put forward a prescribed plot or pattern: instead, it offers the audience a 'deal', the opportunity to determine the event. *It is contingent, open to the unpredictable*.

- *This Is* is simultaneously performative (it performs the Absolute), constative (it is an explanation) and it has truth-value (it will succeed or not). As such, *This Is exposes language* as it exposes itself.
- *This Is* has no single point of view or perspective: the participants make the perspective. *It is formative, educational, and potentially political.*

This Is might perhaps resemble a failed attempt at a 'Total Work of Art', it might also be delusory and grandiose beyond reckoning, but it is also a contemporary curatorial project *before* its time: the author is dead, disciplines are blurred, it is performative, open-ended, synaesthetic, potentially politically transformative and above all, as Mallarmé's notes with their endless numerical figures testify, regulated by financial concerns for its realization.

Invoking this odd, imagined project at the start of a collection of texts on contemporary curatorial practices is not intended to identify *This Is* as the clichéd point of origin or ultimate referent for the curatorial, but to highlight some of the issues that are at stake when addressing this multifaceted and controversial practice. I say 'some' because, as is well known, the curatorial can never be constricted. As one can already intimate by looking both at the long list drawn on the basis of Mallarmé's imaginary project and at the contents of this book, the curatorial seeps and bleeds into many different fields and practices. Some complain that this is a problem. I would argue that, on the contrary, the protean guises of 'the curatorial' are precisely what give it its power and potential. It is also what makes it quintessentially of our time and, inevitably, a difficult thing to define.

So what is the book you are currently holding in your hands telling us about that protean practice, which old Mallarmé wrapped in his shawl, could never have imagined, let alone formulated on his own all these years ago?

The enclosed anthology of specifically commissioned texts provides an overview of a number of approaches to understand 'the curatorial'. Again, I say a 'number of approaches' because its protean guises do not allow for the possibility of providing a comprehensive or exhaustive overview of the curatorial as such. The lengthy, but non-exhaustive bibliography provided at the end of this book clearly shows the many publications that have already attempted – with varying degrees of success – to do just that.

This book also does not contextualize the curatorial within a specific history (a totalizing and therefore hegemonic narrative of key events that tells us what art is and how it has been 'best' exhibited, for example) or framework (in relation to a ill-defined Zeitgeist abstraction such as 'the contemporary'). Two recent

books, Terry Smith's *Thinking Contemporary Curating* and Paul O'Neill's *The Culture of Curating and the Curating of Culture(s)*, provide new and reinvigorating contextualizations (historical and otherwise) of what the word 'curatorial' means and their work cannot therefore be repeated here.

The following essays only attempt to think what the word 'curatorial' actually means without necessarily entrenching it within a particular discourse (art history, art criticism, etc.), discipline (anthropology, philosophy, etc.), field of knowledge (art practice, visual culture, etc.) or ideology (a social ideal, a set of beliefs, a political agenda, etc.). The aim of the following attempts is simply to reveal that the curatorial is an embattled term that cannot be singularized or totalized and that it is perfectly OK to live and work with such a warring term. Allow me to roughly summarize how this comes across (a summary that curiously echoes some of the remarks made about Mallarmé's fantasy project).

The curatorial is a jailbreak from pre-existing frames, a gift enabling one to see the world differently, a strategy for inventing new points of departure, a practice of creating allegiances against social ills, a way of caring for humanity, a process of renewing one's own subjectivity, a tactical move for reinventing life, a sensual practice of creating signification, a political tool outside of politics, a procedure to maintain a community together, a conspiracy against policies, the act of keeping a question alive, the energy of retaining a sense of fun, the device that helps to revisit history, the measures to create affects, the work of revealing ghosts, a plan to remain out-of-joint with time, an evolving method of keeping bodies and objects together, a sharing of understanding, an invitation for reflexivity, a choreographic mode of operation, a way of fighting against corporate culture, etc.

Although these answers vary greatly, six different themes can perhaps be discerned. These six themes structure the book in order to provide the reader not so much with an already fixed model of interpretation, but with a suggestive structure to articulate the various platforms from which one can depart when thinking the curatorial. These themes are as follows.

* * *

The Part I is called *Send-Offs* and is inspired by the way Jacques Derrida understands the metaphysical shift that has taken place in academia between the old disciplines of the humanities and the ones put forward today. These no longer posit a limitation to their fields of inquiry, but offer instead a new set of platforms from which to start thinking again. This can be understood both at the

level of ontology and that of the ontic 'sciences', including the fields of art history and curatorial activities. With this shift in mind, this first section puts forward the spirit of the whole book: to provoke shifts in thought in order to redistribute the parameters of what is understood by the curatorial. The aim of this first section is therefore to ensure that right at the start of this publication what is understood by the curatorial is put into question. In a way, this first section says: the curatorial is not necessarily what you think, so let's shift focus and think again: on your marks, get set, go! These send-offs take different shapes:

- In a poetic and evocative verbal acrobatics, Raqs Media Collective begin the proceedings with a thought-provoking allegorical text that offers a new cluster of tasks, expectations and possibilities to make sense of the curatorial today. Their aim is to expand the orbit and charge of the game in order to offer new ways of using the vocabulary of the curatorial. Self-declared 'jailbreakers', they call upon us to reach out to each other.
- I follow suit with a series of compact short theses that try to evaluate what goes on when the curatorial is understood together with thought. The aim of these short theses is to demonstrate that the curatorial is not necessarily tied to a history or a time (modern or contemporary art, for example), but a way of organizing thought in the encounter with the other and/or with objects (on display, for example).
- Alfredo Cramerotti asks us to abandon our androids, tablets and computers in order to rethink how the future comes. His reply is that it comes from the immemorial past that old stories (in newspapers) always seem to hold ready for us to discover. Once opened, the work then consists in curating for ourselves our own future. With Cramerotti, the curatorial becomes the way in which the future is articulated.
- In a personal and engaging text, Irit Rogoff gives us a stern reminder that our cherished infrastructures (museological, exhibitionary, academic, architectural, etc.) are effectively forms of containment and that we need to free ourselves from them by shifting knowledges, sensitivities and imaginaries. Rogoff's essay is a call to arms: not to destroy infrastructures, but to engage ourselves with our own contemporaneity in order to invent new points of departure.
- Finally, Natasa Ilić takes up the challenge to ask the brazen question: why do we still need art today? Ilić addresses this issue by contextualizing the way this question has been addressed over the years in the former Yugoslavian Republics and by reassessing the role of her curatorial collective

(WHW) in the past decade. In a bid to continue avoiding normalization, institutionalization and spectacularization, Ilić's frank answer is simply to wait, renew allegiances and ask the question again, all in order to set off afresh in a new direction.

<div align="center">* * *</div>

Part II, *Praxeologies*, explores the intricate relationship between the body and exhibitions. As is well known, it is no longer possible to talk of self-contained subjectivities experiencing exhibitions in a disinterested manner. Our relationship to exhibitions is a complex and ambivalent event, in which what is exhibited is not necessarily the centre of attention. However, even if we know this, the question always comes back: how do our (artists', curators', viewers') bodies interact with what does not belong to our bodies? The four attempts to answer this question in this section all start from the premise that the representational model with which this relationship has traditionally been thought is no longer valid, that a new approach is necessary if we want to avoid the narcissism, autism and self-absorption that this old model implies. With this premise in tow, the following four authors take us on a journey using a treacherous path that knows neither respite nor end result. In doing so, they open up the possibility of new forms of practices (*praxis*) and language (*logos*).

- Stefan Nowotny takes us back to the mythological origin of the word 'curatorial' with Gaius Julius Hyginus's fable of Cura. His aim is not to emphasize once again that the origin of this concept relates to the activity of caring (for objects, for example), but to a moment of suspension or questioning in the middle of a whirlpool of uncertainties and dangerous currents. With this focus, Nowotny uncovers a new potential for curators, one which suddenly directs us right at the heart of what it means to be human.
- Drawing a distinction between the professional decision to become a curator and the ongoing act of becoming-curator, Suzana Milevska invigorates the way current curatorial strategies operate today. Her aim is to explore not only what it means to sustain the activity of curating, but also how it can be used productively to question hegemonic power structures and defend lesser-known art forms and cultural productions.
- Leire Vergara challenges us by considering the idea of exhausting as much as possible all institutional apparatus – including the white cube – not in order to propose a new model, but in order to reinvent new conditions of practices

and subjectivity. Vergara's essay draws a parallel between choreography and curating and in the process proposes to practise an 'exhausted curating'. This is not an invitation to take a break amidst the ruins of institutions, but to create new forms of engagement with reality.

- Finally, Jenny Doussan puts forward the idea that there can be a corporeal experience that is not dependent on spectacle and therefore on the instrumentality of language and its appendant institutional or exhibitionary apparatuses. In order to address this issue, Doussan puts forward three approaches: the self-renewing vitality of the body; the gratuitousness of collective embodied experiences and the embodied cognitive experience provided by the senses. Through these, Doussan strikes a serious blow to the autism that Agamben confined us to.

<p style="text-align:center">✳ ✳ ✳</p>

Part III is called *Moves*. This could give the impression that, once again, the focus will be on the fact that everything is transient, there are no subjects, no objects, no fixed knowledge, no finite bodies, no clear marks or demarcations and that we all live endless performances over constantly shifting grounds. Nothing is further away from this cliché than this section. *Moves* implies not simply fluctuation or unsteadiness, but a deliberate change of position or a calculated shift of settings. The overall aim of the following 'moves' is political in the sense that they attempt to distort, subvert, abuse, misuse what is generally taken for granted and is therefore hegemonic. The five authors in this section use all the available tools (real or imaginary) to do this. The end result is a reconfiguration and redistribution of words, events, tactics, names and language that any serious reading of the curatorial would and from now on *will* find difficult to ignore, to brush off, to which it can no longer turn a blind eye or a deaf ear.

- Ariella Azoulay begins the proceedings by providing us – in three languages – with the tools that have helped her curate the exhibition *Constituent Violence 1947–50*. At first, these tools appear as if they are only applicable to the context of Israel and Palestine: shifting the treacherous delineations and sedimentations that have structured a geopolitical situation in order to open up a different future. However, a careful reading of these tools reveals a greater potential for curators: a way of thinking the ethics of a curatorial politics in general.
- Sarah Pierce highlights the shifts that occur between curating and the curatorial. In doing so, her aim is to focus on this intangible moment

called 'the beginning': the point at which the curatorial sets off. Unlike curating, which structures itself by setting up or obeying real or imaginary limits (funding deadlines, openings, closings, etc.), the curatorial is, on the contrary, a simple operator that allows us to blur all these (dead)lines and limits thus challenging and (some times) attenuating their constraining powers.

- Doreen Mende proposes three short vignettes that allow us to see how a small displacement of meaning can potentially open up a new field of investigation in curatorial studies. She asks three pointed questions: is there not a blind spot between curating and the curatorial? Is there not, alongside what is exhibited, what is also inhibited? And finally, are exposures and interpretations not symptoms of a missing origin to the work of art? The use of words such as blind spot, inhibiting and symptom might at first seem unreasonable, but on reflection they soon reveal their true potential.

- Roopesh Sitharan confronts us by giving us a text written in both Malay and English. His aim is not perverse: an act of pedantic sophistry, for example. His aim is to deliberately expose how knowledge takes place: in shifts of language. These can be idiomatic (Malay-English in his case), but these can also be curatorial (subject-object, for example). These shifts show that knowledge cannot take place without blind spots or 'vacuums' as Sitharan says. The curatorial needs them for otherwise nothing (on the page or the exhibiting space) would ever take place.

- Finally, Joshua Simon, adopting the style of a public declaration at a political rally, brings this section back to Israel-Palestine. In doing so, he reveals for us the most paradigmatic and problematic shift imaginable: 'betrayal'. With this word, his aim is not to propose a new tool. He does not want all of us to become betrayers or traitors. His aim is to highlight the driving force that exhibition displays can often produce. In doing so, he exposes how the curatorial operates politically: an operation that cares little for protocols of allegiance.

* * *

Part IV is entitled *Heresies*. At first, the word 'heresies' could be understood as a set of opinions profoundly at odds with what is generally accepted. If this were the case, then the following essays would simply be understood as performing a critique of received ideas about the curatorial and its place in the

world. However, *Heresies* is understood here to have a different meaning. As the essays in this section demonstrate, the issue is not one of critique (pretending to stand outside of the institution) or criticality (shifting the parameters within the institution), but about inventing new terms that defy the odds. The shift is here crucial because the aim is not to put forward new opinions (*doxa*), but of regenerating knowledge (*episteme*). In doing so, these contributors ask us to have a good look at our vocabulary for it might contain many clichés and hang-ups and it is high time that these are replaced.

- Defying all received knowledge in political theory, Valentina Desideri and Stefano Harney propose to abandon all notions of collectivity and community because they are both based on plots, that is schemes of destination that rest on the supremacy of the 'one', ruthlessly achieving its destiny by any means possible. Against this, they propose to become complicit in acts of conspiracy that, extraordinarily, know no plot. This has huge consequences for the curatorial because it provides a clear ethics that defy 'good governance' and 'good policy'. Anarchical, we should all work together on this conspiracy without a plot. We have nothing to lose.

- Shunning the idea that a question is just a starting point or a framework for a discourse, Susan Kelly addresses the possibility of transforming questions into political incentives able to challenge the way knowledge and practice are appropriated by hegemonic systems of power. Armed with a renewed understanding of what a question is, Kelly helps us to see that, contrary to what is commonly believed, an artwork, an exhibition, or an institution are not just questions waiting to be answered, but sites of empowerment where knowledge and practice can regain all their political potential.

- Nora Sternfeld challenges the received idea that curating is simply the work of displaying art or artefacts for educational and aesthetic experiences in order to put forward the idea that curating is the task of ensuring that something actually happens between viewers. Inevitably, the problem is always, how does one make sure that this 'something' is actually worth happening? Sternfeld addresses this problem by emphasizing the importance of always retaining the uncertainty or the possibility of the question (a decided 'perhaps') as the central tenet of any curatorial event.

- Valeria Graziano situates curatorial practices within a history of social encounters: on the one hand, the aristocratic and/or bourgeois social meet-ups and on the other hand, the festive sociabilities of popular gatherings. While the former is constituted by a haughty attention to language, the

latter is brought together through the affects of bodies. With this history, Graziano aims to bastardize curatorial practices in order to make them what they ought to be: neither elitist nor populist events.

<center>* * *</center>

The title of Part V (*Refigurations*) is borrowed from Donna Haraway and its use in the context of this book is an attempt not to fall victim to the temptation of always re-con-figuring the world, that is, of always pretending that we all agree (*con* – together) on the particular shapes and forms of our world. Abandoning the need to articulate these false accords, this fifth section therefore focuses on personal refigurations of what is usually taken for granted. This takes a variety of unexpected shapes: rethinking the idea of the modern, reimagining exhibitions as devices, rewriting the history of a local community or region, and refiguring what 'being-contemporary' actually means. With these refigurations, the curatorial expands its remit and becomes not only a tool to challenge disciplines (history, geography, anthropology, ethnography, etc.) and their appending fields of knowledge, but also a tool with increasing political potential.

- What else calls the most for refiguration, but modern art? Contrary to received opinion, Helmut Draxler argues that modern art is not a specific period in history that would pitch itself neatly against contemporary art. Modern art has never left our horizons of understanding because it is a multiplicity of affects and discourses that, so far, has resisted all attempts at generalization and reduction. Draxler's argument becomes particularly poignant with regards to collection and curating because they are the real motors that continue to make the 'modern' in art such an uncanny presence today.
- Jean-Louis Déotte challenges us by considering the exhibition at the same level as the radio: both are surfaces of (re)production. Basing his argument on the work of Walter Benjamin, Déotte argues that an exhibition and a radio are surfaces of (re)production because unlike art, they are aesthetic devices. This does not mean that the exhibition and the radio are identical to mechanical reproduction. This simply means that they are tools of signification and therefore of power that, contrary to artistic production, can never fall out of fashion.
- Anshuman Dasgupta takes us to Sikkim. For him, the curatorial reveals itself as a 'sensuous' event that takes place when the dynamics of a site are exposed in a workshop. The aim of this workshop is to get the local

community to come together and work out the dynamics of the sites they inhabit. In this way, the curator is therefore neither an anthropologist nor an ethnographer, but simply one who brings people together for a sensuous gathering of community building. With his unusual curatorial project, Dasgupta slowly refigures the history of this little-known part of the world.

- In a thorough analysis, Cihat Arınç teaches us that the curatorial is an event that also takes place in cinema and specifically, in what concerns him here, in recent Turkish cinema. His aim is to reveal how particular directors curate ghostly objects (architectural, soundscape, narrative) in their film in order to reveal a different political side to official Turkish history. With precision and patience, Arınç singlehandedly refigures a troubled history and the way it is visually exposed.

- Finally, Adnan Madani offers four intertwined vignettes of what it's like to be at once contemporary, Pakistani and involved in the art world. For him, the crux of the matter is to understand what kind of contemporaneity one is speaking about when it comes to the unsteady balance between the secular and the religious that characterizes Pakistan today. This does not imply proposing a different modernity (a different precursor to today's world, for example), but aims to expose the many contradictions that make an individual 'contemporary' today, all in the hope of not ending up in a timeless no man's land.

* * *

Part VI is titled *Stages*. With this word, the intention is not to compare the curatorial with theatre. In theatre, a stage is usually a raised floor or platform on which actors perform. When it comes to the curatorial, the stage expands beyond all recognition, taking in buildings, sites, geographical areas and even, in some cases, countries. With the word *Stages*, the intention is also not to compare the curatorial with a specific length of time, a point, period or step in a process of development (the seven stages of man, for example). When it comes to the curatorial, the idea of 'period' always gets a bit fuzzy: times crisscrossing each other to the point where it is no longer possible to talk of a determined period when this or that happened, when a show started or ended. *Stages* mark instead, as Hannah Arendt's quote in exergue of the texts in this section tells us, the co-appearance of subjects, objects, architectures, communities and worlds and with it, the formation of a polis. The curatorial is this polis, always transient,

incomplete and thus necessarily controversial. In this way, the world is not a stage; stages make the world.

- In order to differentiate between the curatorial (this event that sees the encounter of people and/or objects) and the para-curatorial (these secondary events that accompany the exhibition; participatory projects, for example), Bridget Crone proposes to understand the former as a sensible stage, that is, as a site's organization and legibility. The curatorial or the sensible stage is therefore an event and a diagram that forms itself as people, spaces and objects come together. This interpretation not only sets the tone for this section; it also allows us to have a clear understanding of the dynamisms at work when we speak of the curatorial.
- Aneta Szyłak expands the notion of stage by exploring the notion of context. As a self-confessed methodologist who curates contexts, Szyłak's aim is to show that a context is not a frame, but an event that is not only deliberately created as the process of curating is under way, but also occurs spontaneously and without agency. With this way of looking, Szyłak does not propose a set of formulas on how to investigate a site or a stage, a building or a gallery, a situation or an environment, but to put forward a praxis that needs to be reinvented each time anew.
- Ines Moreira asks us to divert our attention from the stage, its conceptualization, its actors and its settings in order to pay attention to what goes on behind the scenes: the backstage. To take a reverse perspective or to focus on the opposite side of a show's construction is to focus on the mess, confusion and disorder that usually takes place before (and some times also behind) the stage and to expose the participatory processes of reflexivity that characterize exhibitions. From such a perspective, suddenly, concepts, ideas, and even languages all appear in a different light and the curatorial is no longer what it seems.
- Finally, Je Yun Moon proposes to understand the curatorial as a choreographic mode of operation. Her aim is not to compare curating with dancing or curators with choreographers, but to highlight the way a renewed practice can create a different relationship to subjectivity and therefore to the profession that results from it. Curating is not the product of a subject in an assembly line; it is the result of a play of epistemic games that constantly put into question the limits of the subject and its practice. With Moon, the curatorial becomes this act of writing

for the other, a gift of words, images and gestures that can only in turn be put in question.

*　*　*

This anthology ends with a rather cynical coda. Charles Esche's take on 'the curatorial' is very much that of a museum director burdened with financial, political, educational and social responsibilities. Ending with such a tone is not a complacent way of bringing everything down to earth; one final 'get real' postscript destined at best to question or at worst to invalidate what was discussed in the preceding chapters. Esche's text is here to simply remind us of the task at hand, that of producing what he calls 'a critical surplus', that is, an excess or remainder that allows not only for reflection, but also for the imagination to take off; an excess or remainder that, for once, cannot be appropriated by either ideology or market forces, precisely because it belongs to no one.

If the old symbolist poet read these essays today, he would probably remain his disgruntled self because they would not give him the keys or methodologies to accomplish his 'Total Work of Art', but he would perhaps reluctantly agree that life on earth knows in fact no final Orphic explanation, only fragmentary answers that, surprisingly, not only give the chance to think again, but also the courage to fight back against the complacency of easy formulations, the lure of spectacles, the sedimentation of ideas, the draw of the sound bite, and, above all, against endless empty promises. Much thus needs to be thought out and done and I am proud to say that *The Curatorial: A Philosophy of Curating* is a good place to start.

Jean-Paul Martinon

Notes

1　The few scribbled notes that Mallarmé's family rescued for posterity are, inevitably, eminently open to interpretation. The account provided in this introduction is therefore only indicative of the general gist of the project. For the most comprehensive introductions to and analyses of Mallarmé's unrealized masterpiece, see: Jacques Scherer, *Le 'Livre' de Mallarmé* (Paris: Gallimard, 1957) and Eric Benoit, *Mallarmé et le mystère du 'Livre'* (Paris: Honoré Champion, 1998).

Part I

Send-Offs

On the one hand, the modern sciences ('human or social sciences', 'life sciences', and 'natural sciences') are continuing or beginning again to adjust themselves to the problems (. . .) of destination (aim, limits, teleology of systems). And their irreducibly philosophical dimension is often there, at the moment when philosophy returns, whether or not we want it, whether or not we hold on to the representation of a post- or extra-philosophical scientificity. On the other hand – and above all – the recourse to a thought of the sendoff, or of dispensation, signals today one of the most singular and, it seems to me, most powerful – in any case one of the last – attempts to 'think' the history and structure of onto-theology, even the history of being in general. However we interpret them, and whatever credit we grant this thought or this discourse, we should pause before this marker: the 'destinal' significations (sending or sendoff, dispensation, destiny of being, Schickung, Schicksal, Gabe, 'es gibt Sein', 'es gibt Zeit', etc.) do not seem to belong to the within of onto-theological philosophemes any longer, without being 'metaphors' or empirical or derived concepts either. There is a sense here that is thus not reducible to what the sciences can and should determine of it, whether it is a matter of the empirical sciences, the natural or life sciences, so-called animal or human societies, techniques of communication, linguistic, semiotic, and so forth. Another thought of the 'sendoff' thus seems necessary to the unfolding of the 'great question' of philosophy and of science, of truth, of meaning, of reference, of objectivity, of history.

<div align="right">Jacques Derrida*</div>

*Jacques Derrida, 'Sendoffs', in *Eyes of the University*, trans. Thomas Pepper (Stanford: Stanford University Press, 2004), 220–4.

On the Curatorial, From the Trapeze

Raqs Media Collective

AZ

Advantage ~ Zeitgeist
Advantage: a position or condition of benefit.
Zeitgeist: the spirit of the times.

The curatorial has an advantage. An edge over other sensibilities. Its ability to privilege a precarious balance of forces and to deploy a flying chorus of terms, images and ideas in the interests of combatting any effort at aesthetic or epistemic stability gives it the advantage.

This text offers a provisional, disorderly yet rigorous design of a lexical conceit: a bookending of successive alphabetic extremities, A-Z, B-Y, C-X, D-W, E-V, right up to M-N, as fly-bars from which it suspends 13 word-pairs.

These pairs of acrobatic and ephemeral cluster of tasks, expectations and combinatory possibilities offer our 'sense' of the curatorial for today. This sense of the '*geist*' is a set of two-letter codes (AZ, BY, CX and so on) that notate moves in an evolving game (or act) that embodies the spirit of our times. Readers are welcome to add words to each two-letter pair to expand the orbit and charge of the game.

Let it swing! On your marks. To each their advantage.

BY

Boundary ~ Yorick
Boundary: limit, frontier, perimeter.

Yorick: the unfortunate clown who was reduced to a skull in Hamlet's hand and a strophe in his graveyard ruminations.

To be conscious of a limit, or frontier, is to be reminded at the same time of a horizon. The horizon becomes a prison when the vantage point of the observer remains static. But the moment the observer moves, the prison gates open. The horizon extends, expanding outwards in all directions with every step. Curatorial stasis produces an imprisoning boundary of frames and references. But the extension of curatorial curiosity into 'dead zones' may yet awaken new forms of artistic life.

'Alas poor Yorick,' says Hamlet, holding a dead jester's skull in a graveyard. The skull marks a limit – the frontier between life and death. Once, Yorick the clown was a man 'of infinite jest and excellent fancy', and then, he shrinks to a bony, grinning knob in Hamlet's hand. To consider the skull with Hamlet is to reflect on the inevitability of the transaction between jest, fancy and what remains after. But the memory of laughter in the presence of death is a sign that every border contains the secret of how it may be breached. The horizon is visible from the graveyard and sits next to the prison.

CX

Collision ~ Xeriscape

Collision: an instance of the two or more entities striking against each other. A confrontation.

Xeriscape: a dry garden, using little or no irrigation.

We come face to face with the 'curatorial' whenever we witness within ourselves or around us the collision of artistic forms. There can be head-on collisions, unforeseen accidents, jolts born of contact, eerie after-images as well as the accumulation of readings against the grain of intention. Contact and confrontation, in art, as in life, are an occasion for the multiplication of misunderstandings, for epidemics of meaning. There is no getting away from collisions and contagion, no insuring them away into a zone of illusory safety. And then there is the flak of ricochet. Constant ricochet. Now that the farewell to progress has been sung, collisions appear untamed and with their full force, opening out choices and possibilities. The curatorial can be said to be a post-progress practice.

How to irrigate a minefield?

First, make do with pebbles, driftwood and shrapnel. Second, appreciate the tenacity of weeds and other rude forms of life. Wait for rain. Third, learn to sustain life without life-support systems.

DW

Drone ~ Wake

Drone: the constant sounding or buzzing of a single tone, a slave, an unmanned aircraft, a remote agent.

Wake: an ephemeral pattern left behind as a trace in water or any liquid by a passing body or vessel; the verb for being aroused, especially from sleep or unconsciousness; a gathering that sits in remembrance and/or mourning around a deceased person through a night.

Afloat over uncertain territory, a drone, an agent of remote curatorial imperatives, buzzes while it selects, surveys and releases its payload with approximate precision. A territory is pacified, for now. But the need for more drones grows.

On the ground, there is a wake gathering around collateral damage. In time, the lament – an ephemeral trace under the flight path of the passing drone – will be analysed. This labour of analysis will also be called curatorial labour.

EV

Emblematic ~ Void

Emblematic: significant, iconic, heraldic.

Void: emptiness, nothingness.

Once upon a time, it was possible to talk about an emblematic work of 'our' time or of 'all' times. These solitary monarchs could unravel and reveal the genius and the trauma of life and time.

The king is dead. Where there was a crown is now a void. Jesters, chroniclers and bards are unwittingly possessed by the ghosts of dead monarchs. Some lie buried, waiting for gravediggers. The curatorial sensibility could be seen as making a graveyard walkable through inventive gardening.

FU

Forensic ~ Umbra

Forensic: analytical and investigative procedures that unpack the scene of a crime.
 Originally, a public demonstration or performance of evidentiary truth.
Umbra: a shadow.

Whenever a curatorial undertaking seeks to scrutinize the crimes of the world, it automatically creates its own shadow by coming between the light of truth and the surface it seeks to illuminate. The greater the urge to produce a forensic demonstration, the thicker is the parabola of uncertainty. Occasionally, one could try the opposite procedure. Curating for the shadows, the light source can be inferred, forensically, in absentia.

GT

Genie ~ Tachometer

Genie: a spirit that does the bidding of whosoever uncorks the bottle in which
 it lies imprisoned, a being endowed with magical power, a template
 for the unfolding of the magic of genius.
Tachometer: a device for counting revolutions, for measuring the speed and power
 of a motor.

The power of genii has impressed everyone from time immemorial. The vicious one unleashed a few hundred years ago appears beyond anyone's control and grasp as it builds a wall around itself and its capital.

 Curatorial energies are battling with the myriad forms of the materialization of this genie's power. Counter-chants are being sung to trick it into submission. Meanwhile, attempts are being made to shape-shift into tiny insects so as to escape the gaze of this genie and yet stay in the reckoning by droning in its eardrum.

 Here it is imperative to work with broken engines, interrupted revolutions, so that they may transport themselves a little further.

HS

Hocus-pocus ~ Surge
Hocus-pocus: a playful exclamation of a pretended magical spell.

Surge: a powerful upward or forward movement; may be sudden, as in a thrust,
 or sustained, as in a wave.

Every spell has its secret. When someone says hocus-pocus, they may not be aware that they are actually offering up a garbled version of a powerful incantation, '*Hoc Est Corpus Meum*' – 'Here is My Body'. Behind the rhyming party trick tag line lies a suppressed longing for transubstantiation – for turning bread into flesh, and wine into blood. Discourse, in a curatorial setting, is truly hocus-pocus.

The secret, that thing of flesh and blood, surges through.

IR

Insert ~ Residue
Insert: *to add, place, fit, or, a thing that has been added, placed, fitted.*
Residue: that which is left behind.

To insert can be to sneak something in, to interpolate, to occupy, to incrementally add to an existing sum without being noticed. The residual is that which gets left behind, which doesn't get counted, which remains in the shadows. Both the insert and the residue occupy a space in the margins of the calculation, hidden deep within the folds or under the radar of the figure, and yet they change the count.

Sometimes, to add beyond necessity is to create a surplus. Every subtraction yields a residue. The relationship between an insert and a residue also straddles this delicate paradox. The curatorial remains a game of thinking about proportion.

JQ

Jailbreak ~ Quiddity
Jailbreaking: the liberation of a device from the straightjacket of its prescribed
 mode of operation.
Quiddity: the inherent nature or essence of something, its 'what-ness'.

One can jailbreak an appliance, a phone, a computer, a tablet to do things that it was not meant to do. Curatorial action can be a form of jailbreaking. One can coax a work out of its accustomed frame, provoke a situation into yielding

results other than what its authors, actors and agents intended, create conditions for it to be released from what might be seen as its essence, its what-ness.

Sometimes, the jailbreaking we are attempting to describe here is simply a change of qualia, from quiddity (what-ness) to haecceity (this-ness). To do this is to shift from one leg to another, to ask 'What is THIS?' instead of 'WHAT is this?'.

KP

Kumbhakarna ~ Proposition

Kumbhakarna: *a warrior in the Sanskrit epic* Ramayana, *remembered for his ravenous appetite, enormous strength, ethical doubts (he did not want to fight in a needless war, but did so when pressed, out of duty and loyalty) and his preference (given to him as a boon) for hibernating half the year away.*

Proposition: *a word that can vary in its meaning, depending on the context in which it is used, ranging from an assertion to a proposal to an attempt at seduction.*

The Kumbhakarna Proposition is a proposal to view the curatorial as the cultivated hibernation of a reticent strength, whose awakening has consequences. Like Kumbhakarna's prowess, which some attribute to his preference for sleep over wakefulness, the curatorial may derive its strength from gestation. To assert, propose or desire seduction into a long period of invisible ferment may be seen as a curatorial strategy to linger or loiter over thinking as opposed to making haste for the purposes of execution. Deliberation is at times preferable over deliverance.

LO

Labia ~ Okul

Labia: *lips – of the mouth or the vagina; one half of a hinged, bivalve structure that can open and shut at will.*

Okul: *traditional name for Pi Capricorni, a twin star in the constellation Capricorn, derived from the Latin for eyes,* oculus.

In Bengali, one of our languages, O-kul can also mean 'that further shore', inviting thoughts of stellar voyages. In Latin, the oculus *is the window through which the elements, wind, rain and sunshine, pour into a structure.*

Organs of sensation, appetite, egress and effulgence. Bearers of fluids, means of intercourse, indices of feeling, custodians of secrets, pleasures and shame. That which closes in against the world can also open out to the world. By being the secret hinge that opens a disposition to light as well as shuts it down to darkness. By being the light that takes time to travel from a distant star. By being the container of tears, the doors of speech, the transport of waste as well as the fulcrum of desires.

MN

Morphic ~ Nirvana
Morphic: pertaining to forms
Nirvana: the liberation that arises from the extinction of bonds that tie you
 down.

The arrangement of forms with a view to the discovery of patterns makes for an accumulation of resonances played off against the concentration of contrasts. It can also be a paring down, a shaving off, a distillation. The curatorial is an exercise in metamorphosis.

The relationship between different forms can be revealed to be one of interdependence: causal, collisional and consequential. Artworks arise and are consequent on each other in a situation where their emergence and existence are predicated on the presence of other works, processes, sensibilities and even accidents. It is to weave these complex networks of co-present suspension that calls in the curatorial sensibility. A form's attachment to itself is severed within this process of mutuality.

The acrobat on the trapeze has to let go of the fear of reaching for the other's hand. What is at hand is the liberation of forms from themselves.

We could call this possibility, the curatorial; at least for now.

Theses in the Philosophy of Curating[1]

Jean-Paul Martinon

Certainly one may say, 'Freedom to speak or write can be taken from us by a superior power, but never the freedom to think!' But how much, and how correctly, would we think if we did not think, as it were, in common with others, with whom we mutually communicate?

Immanuel Kant[2]

Gift

The curatorial is a gift, a gift from me to you. It is, first and foremost, a gift to oneself and then a gift between ourselves. This gift is not a little parcel that one passes to another. We all know that gifts-as-parcels are necessarily part of a contractual agreement: I'm giving you this (a present, a body of work or thought) in exchange for this or that (friendship, love, or entrance ticket, reviews and honours). However, in order to have this contractual agreement or this gift-as-parcel, you first need a more primary kind of gift, you need a preliminary decision, a generosity beyond all forms of generosity. The curatorial is this first gift, a gift *before* the subject/object or curator/viewer relation, *prior to* any contractual determination, and therefore *before* politeness. In this way, and before any proper curating has taken place, the curatorial first establishes itself as gift structured by a radical law[3] without which no gift-as-parcel would be possible. Inevitably, the problem, as Georges Bataille teaches us, is that this originary gift cannot effectively be assigned any mode of presence.[4] To think this first gift, this generosity, and therefore the curatorial, is to stop short at the necessity that makes a show happen (e.g. 'do we really need this show?'). In this way, to think the curatorial, this gift, is to stop short at a necessity prior to any form of sociocultural or political urgency,

a necessity that is impossible to contain, constrain or sublate. The curatorial as gift is thus concerned, deep down, with a logic of fantasma[5] (of what *needs* to be ex-posed or ex-hibited), that is, with a fantomatic irreducibility from which there is no escape. Nothing will ever stop the curatorial. No ex-position or ex-hibition would take place without this originary gift.

Embodied knowledge

The curatorial is an event from which nothing can be gained because, contrary to curating, which is a constitutive activity, the curatorial is a disruptive activity. It disrupts received knowledge: what we understand by art, art history, philosophy, knowledge, cultural heritage, that is all that which constitute us, including clichés and hang-ups. In this way, the curatorial is, as William Carlos Williams tells us with regards to poetry, a disruptive embodiment against received knowledge.[6] How is one to understand this? Our bodies take space and this taking of space disrupts what frames and impedes us: these bodies of knowledge that we take for granted. As our bodies move in space, the curatorial proceeds by inventive steps or missteps from space to space. As such, the curatorial is a disruptive generosity (a gift as defined above) that can never be properly translated into language and always gives the slip to the economy of received and exchanged knowledge. Nothing can indeed be gained from this event that we call the curatorial. The curatorial is really an unnecessary disruption of knowledge, that is, paradoxically, but necessarily, the birth of knowledge.

The other of narrative

The Dutch art historian Mieke Bal says that the activity of curating stands for the act of *pointing*: "'Look!" "That's how it is!'"[7] As such, the activity of curating is reminiscent of these little narratives we, humans, formulate to make sense of ourselves. We *point*, often with a little cry: '*Ego Sum!* [I am!]' or more precisely because we *must* not forget the other, we (now) point '*Ego Cum!* [I am with (you)!]'. A thought, an utterance, an assertion, in other words, a good old modern fable: I think therefore I am (Descartes) or, again, to update it: I am because we are (Mogobe Ramose.)[8] That's how it is! Of course, we all know that no *pointing* has ever managed to establish a fixed and recognizable 'point of view' (a recognizable 'I') or a determined horizon of understanding (a recognizable 'thought'). But we

should not despair. Among all this pointing ('me', 'me and you', 'me and this object') we remain curatorial, that is, we remain a disruptive generous effort to think beyond all this pointing. Point. Rethink. Point. Rethink. A frustrating effort for we always end up with new assertions and fables that need to be rethought and challenged. More effort. More pointing. Contrary to curating ('Look!' 'That's how it is!'), the curatorial is therefore the always renewed effort (this gift) of rethinking all this pointing, all these narratives that artists, curators and viewers make when encountering bodies of knowledge.

Spacing

The curatorial is the spacing of concern for the other. This does not mean that exhibitions always expose a specific concern for the other or for this or that political or social problem. Because curating always says 'Look!' and 'That's how it is!', it can only fail to expose a concern for the other even if it has altruistic and moral motives. It fails because curating exposes *first* a concern for the exhibition, the artist, the curator and above all for the objects on display *and then* for the other or the audience, for example. Museum curators would not be so fearful of the viewer's potentially erratic behaviour if this were not the case. Curating is indeed above all self-preservation and this without even having mentioned the word 'conservation'. No, the spacing of concern at stake here is that of the curatorial. Unlike curating, the curatorial spaces its concern for the other as the bodies of the artist(s), viewer(s), curator(s) move in the exhibition space. There is no moral code of conduct here. There is the ex-*posure* of an ethical spatiality, the im-*position* of the body as it proceeds (or as it voices itself) in space over, against and towards the other – with all the problems that this entails (from respect to murder). The curatorial is the spacing of concern for the other before any moral code or standard has been set in place. It is the spatial response that never gets scrutinized, evaluated, or monitored (by any funding, regulatory, or ethical committee) for it obeys, as Emmanuel Levinas tells us,[9] a radically different law; a law[10] that knows no legislation or jurisprudence.

Mapping and playing chess

John Tagg tells us that curating is mapping.[11] It is an attempt a) to take the measure of a world (art, artists, generation, geography, etc.), b) to figure the measure

(translate it in a common language: art history, ethnography, history, sociology, etc.), c) to give it an ideological character (to slant the translation with a set of common principles or political beliefs), and finally, d) to hide from the viewer the method that led to this measurement, figuration, translation and ideology (never reveal the secrets of the trade, especially if these are based, as is often the case, on haphazard or nepotistic decisions!). As such, curating, in its desperate attempt to *ex-hibit* is, like mapping, always already outdated. The curatorial, by contrast, is, as Hubert Damisch clearly shows, to play a game of chess with what has been measured, figured, idealized and hidden.[12] To play a game of chess is not to play in order to win, but *to offer* a deal to what one sees, hears, feels or senses. This does not mean to draw up an agreement or to set a transaction with the viewer's senses. This simply means to give oneself freedom, to allow oneself to evade linear paths, sequential numberings, oblique logics, crooked narratives and straight attitudes. The curatorial is the freeing up of curating, of what exposes (argument or objects). In other words, it is the freeing up of what is exhibited, of what shows itself as measured, figured, idealized and hidden.

Send-Off

The curatorial is a send-off that can never belong to the institution. It is a send-off, not in the sense of a farewell in the hope or dread of a return, but in the sense of a challenge to the limits of both the institution and that of curating. In other words, the curatorial is a send-off because it pushes curating *out* of its comfort zones. As such, the aim of the curatorial, the aim of this send-off, is paradoxically to avoid at all cost proposals and projects, plans and designs, targets and objectives, strategies and tactics, programmes and platforms, that is anything that aims to circumscribe the future, to render it ever more future-present. The curatorial is allergic to any attempt to circumcise what frames, organizes or freezes understanding. With this aim in mind – if such a thing can be said – the curatorial therefore articulates itself by always rendering the future always more futural, to futurize it so that it becomes not delusional or utopian, but radical, of a radicality that knows no projection or protection. This is not intended to disrupt curators' (carefully) planned projects, (career) plans, schemes of destination or destinies, but to distract them, that is, to keep the door open and to maintain, as Jacques Derrida says, the possibility of the other to remain precisely that, other, unknown, that is, at once alluring and dangerous.[13] The curatorial is a send-off, a breaking of rhythm, a disruption of order, that is

what causes worry in the exhibition. If curating is a(n) (institutional) practice, the curatorial is its send-off.

Warrior of the imaginary

The curatorial begins when there is an appreciable surplus that calls for disruption. This does not mean that it begins when comfort is reached. This simply means that the curatorial begins as soon as a line is drawn, a fullness is recognized or a horizon of understanding is acknowledged. Once this is reached, the curatorial ventures itself to disrupt it, but not by displacing the line, bursting what appears replete or shifting horizons. The curatorial disrupts in a different way. It disrupts by thickening the lines, weighing down the overloaded, intensifying the horizons. Overall, this densification has only one aim: to avoid the avant-garde project of marching aggressively against an enemy line, detonating opulence or dealing head first with confining limits. It intends instead, following Patrick Chamoiseau's work, to densify in order to multiply the potential for the imaginary.[14] Why the imaginary? Because the imaginary is the only thing that can never be drawn with any certainty, can never be satiated or simply confined by a discipline or practice. As such, the imaginary remains a pure political tool untainted by the stench of politics. This is no idealism. This is on the contrary, the most concrete battle conceivable because it knows neither rhetoric nor spin and therefore neither deceit nor dishonesty. So if the curatorial can be seen to encourage something, it will be to encourage artists, curators, and viewers to retain the vertigo that heightens the *un*-known: to be a warrior of the imaginary, abandoned to extremes and working without magnetic north or compass.

A place that isn't one

The curatorial always takes place in the middle, between promise (a coming reflection, contemplation, or action) and redemption (intellectual achievement, aesthetic emotion or political resolution). As such, it takes place in a locality that does not know itself: not the museum, the gallery, the exhibition the alternative venue, the collector's parlour, the theorist's classro battleground, or the virtual environment, but something ent It takes place on an indefinite, but finite horizon. How is one t

this curious place? Let me take each word one at a time. It is *indefinite* because like consciousness, it can never be fixed or limited:[15] it always goes off, giving, disrupting, challenging preconceived orders, unsettling the firmly established. It is *finite* because it is necessarily structured by death: the curatorial, like consciousness, is always already a dying body, a finite thought. As such, the curatorial is indistinguishable from the work of mourning as Jacques Derrida understands this expression.[16] Finally, it is a *horizon*[17] because it necessarily involves invaginated topologies (bodies and minds), that is, topologies that can never be limited or circumscribed (where indeed does the body or mind stop?). The place of the curatorial, this middle that can never be identified as such, is therefore what offers itself without end, but paradoxically remains finite, thus clearly confirming that it is indeed an event.

The ignorant body

As we have seen, the curatorial disrupts knowledge in order to invent knowledge. As such, its aim is to *give* the possibility for more lines of demarcation to be drawn, for the fullness of meaning to be achieved and for horizons of understanding to be set. In doing so, the curatorial doesn't concern itself with bodies of knowledge (artworks, for example) placed as if a pile of dung – real or metaphorical – on a space, field, street, or stage set up by the curator and ready to be scrutinized or analysed by the viewer. As we have seen, the curatorial is concerned with the densification of these lines, masses and horizons that define these bodies, these piles of dung. The hermeneutic aim – if there is one – behind this odd concern is *not* to totalize or singularize these piles (of knowledge) and therefore confirm them, ready for viewing and teaching, as either true or false. The aim is simply, and however disappointing this will seem, to sustain their continued formation. As such, and perhaps unbeknownst to itself, the curatorial cherishes ignorance, not as an aspiration towards stupidity, but in a Bataillean sense, as a letting go of what calls (sometimes desperately) for possession.[18] In other words, the curatorial cherishes what (sometimes stubbornly) resists knowledge. On its way, the curatorial can therefore only leave the pile of dung or knowledge behind and (re)invent itself again as body, that is, as ignorant body. In its perambulation, the curatorial thus moves not from one exhibition space to another or from one dung-pile to another as if on an erratic apian journey, but simply in an effort to let go of knowledge, that is, in an effort to sustain the disruption of knowledge.

Thought

We often complain that it is impossible to limit the field of the curatorial because it always actively engages more than one discipline or practice (art and architecture or art and anthropology, for example). But the real question behind this complaint is this: is it at all possible to limit thinking? This does not mean that thought (and therefore the curatorial) is necessarily unbound because always already performing. On the contrary, thought (and therefore the curatorial) forms itself, as Martin Heidegger would say, as the shifting possibilities of a structural variation present themselves.[19] In other words, thought is that which forms the contingent while (being) in the throes of contingency. In this way, one does not curate or view an exhibition by stumbling across limits (a work of art, for example). These limits (and these works) form themselves unexpectedly as we create them. Is it not the case that curating today, as an activity, increasingly moves towards participation, the sharing of responsibility for what is being exhibited? The curatorial is therefore this activity of always engaging disciplines or practices and of transcending them beyond their supposedly invariable appearances. The question, which no doubt will be on everyone's mind while reading the above nine theses, is how is one then to distinguish between the curatorial and thought? To do so would be, as we have seen, to stop both thought and the curatorial, that is, to shift the possibilities of structural variations in such a way that they no longer recognize themselves. But is this possible? Would that not simply imply stepping outside of thought (and therefore the curatorial)? If this were possible, thought would no longer be able to re-present (and therefore curate) itself and the curatorial would no longer be able to think itself. Their interdependence is irreducible and this is what creates significant phenomena.

Notes

1 The title of this essay is obviously intended to reference Walter Benjamin's famous 'Theses in Philosophy of History'. However, this is not made here in order to comment on the contents of Benjamin's theses or to parody (or parrot) its idiosyncratic allegorical style. Benjamin's theses are one of the most exemplary analyses of history in philosophy. To evoke them in the title of this essay should only be seen as a modest nudge in their direction in the context of the curatorial. For Benjamin's Theses, see: Walter Benjamin, *Illuminations*, ed. Hannah Arendt, trans. Harry Zorn (London: Pimlico, 1973), 245–6.

2 Immanuel Kant, *Critique of Practical Reason*, trans. Lewis White Beck
 (Indianapolis: Bobbs-Merrill, 1956), 303.

3 I explore this particular Levinasian law in two previous books: *After Rwanda* and
 The End of Man. Because this law is referred to here on several occasions, I feel
 obliged to sum it up: The law referred to here is that of absolute heteronomy, what
 can never be anticipated, identified or left aside. It is the law that breaks time and
 space apart. It is the falling out of time that always prevents us from being 'in
 time'. For more on this topic, see Jean-Paul Martinon, *After 'Rwanda'* (Amsterdam:
 Rodopi, 2013) and *The End of Man* (New York: Punctum Books, 2012).

4 See Georges Bataille, *The Accursed Share*, vol. 1, trans. Robert Hurley (Cambridge:
 MIT Press, 1991).

5 I deliberately use here the Latinate word fantasma and not the English phantasm.
 The former refers to ghosts, the latter to imaginary illusions or apparitions. The
 driving force of necessities and needs are often fantomatic, without necessarily
 appearing phantasmagoric.

6 See William Carlos Williams, *The Embodiment of Knowledge* (New York: New
 Directions Books, 1974).

7 See Mieke Bal, *Double Exposure: The Subject of Cultural Analysis* (London:
 Routledge, 1996).

8 Mogobe B. Ramose, *African Philosophy Through Ubuntu* (Harare: Mond Books,
 1999).

9 'To this command continually [*sans relâche*] put forth only a "here I am" [*me
 voici*] can answer, where the pronoun "I" is in the accusative, declined before
 any declension, possessed by the other, sick, identical. Here I am – is saying with
 inspiration, which is not a gift, for fine words or songs.' See Emmanuel Levinas,
 Otherwise than Being, trans. Alphonso Lingis (Pittsburgh: Duquesne University
 Press, 2004), 142.

10 See endnote 3.

11 John Tagg, 'A Socialist Perspective on Photographic Practice', in *Three Perspectives
 on Photography: Recent British Photography* (London: Hayward Gallery & Arts
 Council of Great Britain, 1979).

12 Hubert Damisch, 'Moves: Playing Chess and Cards with the Museum', in *Moves*
 (Rotterdam: Museum Boijmans Van Beuningen, 1997), 73–95.

13 For the send-off, see Jacques Derrida, *Eyes of the University, Right to Philosophy 2*,
 trans. Jan Plug (Stanford: Stanford University Press, 2004).

14 See Patrick Chamoiseau, *Écrire en pays dominé* (Paris: Gallimard, 1997), 301–10.

15 The comparison curatorial/consciousness should be understood here with Husserl's
 work in mind. See Edmund Husserl, *Ideas Pertaining to a Pure Phenomenology
 and to a Phenomenological Philosophy: First Book: General Introduction to a Pure
 Phenomenology*, trans. Fred Kersten (Dordrecht: Kluwer, 1983), especially 192–5.

16 The work of mourning is here neither the process of getting rid of the dead nor the process of repetition or fetishization. The work consists in embodying the death that structures us – our death, the death of the other. As such, this work can never be accomplished because no attempt can be successful. See Jacques Derrida, *Memoirs for Paul de Man*, trans. Cecile Lindsay, Jonathan Culler, Edouardo Cavada and Peggy Kamuf (New York: Columbia University Press, 1986), 35.

17 The word 'horizon' does not have here the same meaning as in thesis VII. It does not stand for the place where earth meets sky or for a line marking the separation between heaven and hell or a subject and an object. The word 'horizon' is here neither an abstraction nor a reductive figurative limit, but what cannot be limited, not because it is infinite, but because it is structured by my embodiment of a limit, by what my body *makes up* as limit as it goes along. See also the entry 'Boundary-Yorick' in Chapter 2, 'On the Curatorial, From the Trapeze'.

18 See Georges Bataille, *The Unfinished System of Nonknowledge*, ed. Stuart Kendall, trans. Michelle and Stuart Kendall (Minneapolis: University of Minnesota Press, 2001).

19 See Martin Heidegger, *Discourse on Thinking*, trans. John Anderson and Hans Freund (New York: Harper & Row, 1966).

3

Whence the Future?

Alfredo Cramerotti and Jean-Paul Martinon

I once had a colleague, Maria, who used to read two-year-old newspapers every evening at home.[1] Everyone at the office, including myself, would often joke about this rather peculiar pastime of hers.

Today, I see things differently. It seems to me that the whole matter of reading newspapers from the past is actually a wise move: an act of foreseeing the future rather than a retrospective one. But how is this possible? What is it about old news that allows a glimpse of the future? And most importantly, what does this have to do with curating or the curatorial?

Reading an old daily broadsheet can actually give you a chill – whether out of fear or excitement – about how actuality no longer feels 'actual'. But what do we mean when we talk of actuality? In general, a newspaper puts forward a series of accounts, stories, narratives or commentaries about the previous day. As such, a broadsheet comes across as having a truth-value in as much as they pretend to portray the reality that is apparent immediately after the event occurred.

Inevitably, as the days go by, this apparent truth-value loses its worth. The events are progressively read in the light of other accounts, stories, narratives and commentaries. Facts are placed in different contexts. Remember, for example, when 9/11 first appeared in newspapers: 'Who on earth is Osama Bin Laden?' We all know now. 9/11 can no longer be understood with the same naivety as that displayed by newspapers on the morning of 12 September 2001.

The problem with this loss of truth-value, which is also a temporary loss of naivety, is that there is never a position in which events can be grasped in their totality. This is true both at the time of edition and two years later. By this I do not mean to say that – something we will all agree on – newspapers are always already biased. By this, I simply mean that newspapers are never able to grasp 'a

day' from all its angles. There is no perfect or comprehensive vantage point from which to write or observe the present or the past. Both the present and the past are effectively ongoing constructs.

This is what distinguishes newspapers from the live coverage of television or new-media newsfeeds (Twitter feeds, for example). Unlike these recent modes of communication, the narratives put forward in newspapers effectively always belong to the past *communally* understood as an ongoing construct. As long as newspapers remain printed objects using paper and ink, they can offer no vantage point that would allow me or anyone else to *witness* the present as if a live recording of events.

As such, one would think that an old newspaper holds no potential. It is always already past and useless; it can only be discarded. One cannot anticipate anything from it. The only thing that really counts is the 'live' transmission, the latest Tweets. These are the only things that give us the possibility of action. Remember, for example, the number of people who depended on Tweets to determine their journey at the time of the Icelandic ash cloud. Remember the riots in London or the Arab Spring. Besides seeking people's opinions, reading newspapers were, in these specific cases, a useless activity. The latest Tweets were the only things that not only held truth-value; they also and above all, opened the future because they fostered action.

And yet, besides all this commotion, Maria continued to read her two-year-old newspapers. In doing so, she showed us something else.

Reading old newspapers tells us that, in fact, the future does not always appear on phones, tablets or computers. The future also comes instead from the old print. This does not express regret for the disappearance of newspapers or nostalgia for a world free of hyper-connectivity. Reading old newspapers exposes instead the question: whence comes the future?

Unlike newsfeeds, an old newspaper reveals in fact a certain ambiguity. It does not just reveal 'the past'; it also exposes what is missing from the past: its urgency. In other words, the papers of yesteryear reveal that something is indeed missing: what made the event worth reading. In this way, the events of old newspapers are basically hollowed out of their pressing demand and this emptiness reveals an ambiguity about the past.

But how is one to understand this hollowness, this loss of importance, this emptiness? Instead of criticizing newspapers for being unable to perfectly freeze the urgency of events over time, it would probably be simpler to admit that their unsatisfactory account of time reveals instead an essential ambiguity about *the present itself* – whether lived or narrated a day or two years later. Old newspapers

reveal in fact that 'actuality' is effectively neither fully present nor totally absent, but both at the same time.

As such, newspapers (old or new) are really an incredibly fuzzy *boundary* between a recognizable present (we all recognize events as having taken place) and an unrecognizable present that escapes representation (the impossibility of ascribing a fullness to these events). This can also be said in this way: newspapers lose their urgency because, as boundaries, they prevaricate between recognition and oblivion. Who, for example, has not expressed amazement at the unnecessary worries of previous centuries? Think, for example, of how Victorians worried about the increase in horse manure before the invention of cars or the overwhelming presence of fog in London before the invention of central heating systems.

Old newspapers therefore tell us that the present is never simple or in tune with itself. There is always a breach in the present, something that never coheres; a lack of coherence that makes the present not only appear odd or awkward, but also unable to prevent its own disappearance. If this were not the case, the present would be unbearable, all of it gathering itself into memory. In this way, an old newspaper presents the past or the present as undecided, incomplete, frustratingly ambiguous and as a result of this, always ready to fall prey to an immemorial past.

There is a fabulous consequence to this: the ambiguous and unsatisfactory nature of old newspapers show that, basically, time is *not* a continuous flow of instant presents. In other words, old newspapers are there to disturb the supposed homogeneity of the succession of time as a series of presents. To use a philosophical vocabulary, one could also say that old newspapers tell us that time can never be teleological. Their print rubs off a time that does not belong to our own present, thus wrecking the possibility of thinking history as a series of recognizable instants.

But what am I supposed to do with such a realization and what has this got to do with curating?

Well, instead of lamenting how old newspapers unhinge the supposed homogeneity of the present and wreck the continuity of history, I should really take up Maria's task and, with her, partake also in the process of further wrecking and unhinging the present and the continuity of history. In other words, I should really use this 'gap' or anachronism to my advantage by also undermining and reconstructing both my past and my present. This is what this realization brings about.

In fact, thinking back, Maria's discrete reading was really a specific form of curatorial activity: by reading old newspapers, she curated for herself a different

present, a different future. Tangentially, she reorganized the past, rewriting old stories, attributing a new angle to old events and giving old urgencies new leases of life. Her curatorial work may not have been object-based, socially or spatially constructed, but in her mind and life, the world appeared suddenly other. And isn't this precisely what every curator dreams of? Giving the possibility of seeing the world differently? With her unusual lateral reading of the urgencies of the past, Maria knew this better than any.

Through such an unusual curation, the future does not therefore come from what can be anticipated, projected, predicted or prophesized. The future comes from the 'gap' or anachronism that is at the heart of the past or present: both there and not there, impossible to pin down and this is precisely what allows us to read current and past events (artworks or events in history); this is what allows us to curate shows. To the question, 'Whence the future?' the answer is really old newspapers and magazines, histories and events, artists' stories and fables. It is there, in this ambiguity of 'actuality', that the curatorial takes place.

With this knowledge, I am therefore able to get on with my work. It gives me an insight into what to do next. Except for my own death, there is nothing stopping this ever-renewed wealth: the 'gap' or anachronism always remains, thus allowing me to reinvent my daily reality,[2] that is, to curate my life anew. With this thought in mind, I am now able to read artworks, facts or situations for their real potentials. History and the present are always begun again. Is this not the essence of participation?

Through her evenings spent curating the past, Maria has thus taught me, in a great yet subtle way, that life is not so much about who I am now or what is urgent today, but who I will become, how I will curate my next show. I can forget androids, tablets and computers. By spending time with an actuality devoid of urgencies, I can project myself towards the future, not as a way of resurrecting or resuscitating the past, but as a way of taking advantage of breaches in the present and in history. I am no longer the forlorn result of a cause or an always-already defunct agency of the past. Even if I don't possess time, I can write and curate the future, each time anew.

And perhaps the same goes for you, reader. While you read these – no doubt, now, very old – words, I *am* your time. I hereby give you the opportunity to read me or curate me otherwise, to find the gap or breach in this text and start life anew. The writing and curation are now yours. Reality, and the reality of this essay specifically, is not a fact to be understood, but rather an effect to be produced, in which you and me are embedded.

So, when I go home tonight, I will take a 2010 edition of *La Repubblica* or *The Guardian*, I will spread it out on the floor; perhaps skip the weather report (but you never know), and then read the articles that will tell me *how* my life is going to change. I will reorganize or curate events, thoughts and opinions in order to open the future, thus forcing the present and the past to remain always already *in progress* and this without having been able to remove myself from it. Just like now.

Notes

1 A single-authored short version of this text by Alfredo Cramerotti appeared in *Transmission,* a temporary journal published on the occasion of SI Sindrome Italiana, MAGASIN-CNAC Grenoble, 2010.

2 I wrote in another text that we start to get closer to the core of our reality not when we represent it (or absorb its representation) but when we consider it as a possibility among many others and not as a given, irreversible fact. See Alfredo Cramerotti, *Aesthetic Journalism: How to Inform without Informing* (Bristol: Intellect, 2009).

4

The Expanding Field

Irit Rogoff

We work in an expanding field, in which all definitions of practices, their supports and their institutional frameworks have shifted and blurred. But the fact that we have all left our constraining definitions behind, that we all take part in multiple practices and share multiple knowledge bases, has several implications.

On the one hand, the dominance of neoliberal models of work that valorize hyper-production have meant that the demand is not simply to produce work, but also to find ways of funding it, to build up the environments that sustain it, to develop the discursive frames that open it up to other discussions, to endlessly network it with other work or other structures so as to expand its reach and seemingly give it additional credit for wider impact. So in this context the expansion is perceived as a form of post-Fordist entrepreneurship.

On the other hand, the dominant transdisciplinarity of the expanded field of art and cultural production has entailed equal amounts of researching, investigating, inventing archives from which we can read in more contemporary ways, finding new formats, self-instituting, educating, organizing and sharing. Most interestingly, it has dictated that each idea or concept we take up must be subjected to pressures from other modes of knowledge and of knowing – it cannot simply stay within its own comfortable paradigm and celebrate itself and its achievements. And so in this other context, the expanding field is one of broader contemporary knowledge bases and practices.

Seemingly in each of these two cases the emphasis is on *'more'*, but in order to come to terms with this duality which is often less than compatible, I need to think through what has happened in the field recently and of ways this might or might not be quite the opening or loosening up we had previously taken it to be.

What on earth do they mean?

On occasion, within the discussions we are all part of, one will hear someone say the word 'art' and wonder: what on earth do they mean by that?

- Do they mean 'collectibles' and 'displayables' and 'catalogueables' – objects and entities that can be known; that can be captured by these logics and fit neatly into the economies of institutional, foundation or private assemblies?
- Or do they mean 'artists' who are working in the community or the field, trying to make complex the simple-minded politics of representation practised by the media – make them complex by layering intricate and contradictory strata and performances as the cumulative affect of a place or a group or an event?
- Or do they mean the operations of new modes of research by which creative practitioners enter the arena of archival knowledges and posit other protagonists or other events, not main ones and not even marginal ones, but ones whose very articulation will trouble the subject of the archive, challenge its *raison d'être* – an innocent vegetable within the archive of a genocide, the design of a refugee tent rewriting the narrative of custodial roles, the aerial shot as the amalgam of centuries of governance through surveillance – non-symbolic and non-representational ways of navigating a cultural entry point into the production of knowledge.
- Or do they mean the group that has set itself up as an immigrant smuggling entity, or as a time bank or as the repository of mutations in the wake of genetic engineering or genetic modification, or as the fake company representatives of a multinational corporation offering a settlement to the victims of a disaster? The mimicry of structures and protocols that, by virtue of their daring to enter the field of aid and support, produce a critical gesture.
- Or do they mean a small group of, usually young, people huddled in a basement reading some smudged photocopies, insistent on their need to know something of urgency and to gain an unspecified set of tools by which to tackle the world and to make their engagement a performative manifest?

All of these make up an 'art world' as I have experienced it over the past decade. What was a trajectory that led *to* a final product or emanated *from* this final product in terms of curating or collecting or reviewing or critical assessment, has opened up to inconclusive processes whose outcome might be learning or researching or conversing or gathering or bringing a new perspective into circuits

of expertise. The discrete boundaries of the product that enabled its capture by various economies or teleologies have fragmented into strands of knowledge, of affect, of structure or of action which insist on presence in relation to other presences. What was 'art' has assumed the status of 'the manifest', the ability to alert us to the emerging of a presence in the world.

It is not simply that the world of 'art' is one of multiple practices and a proliferation of incommensurate protocols that awkwardly coheres, resulting in the inevitable confusion of one word which has contradictory meanings for so many of the stakeholders within the field. But I would say that this goes far beyond a simple evacuation of stable meanings of this or that form or practice, and is actually a part of living through a major epistemological crisis.

So here is the beginning of my argument: I am not interested in understanding the expanded field of art as a multiplicity, as a proliferation of coexistent practices, as a widening of what might have previously been seen as a somewhat narrow arena defined by fine art practice. In addition to art I would designate the terms: 'practice', 'audience', 'curator', 'space', 'exhibition', 'performance', 'intervention', 'education' and many other terms as subjected to this same disorientation – a historically determined meaning which has been pushed at the edges to expand and contain a greater variety of activity – but never actually allowed to back up on itself and flip over into something entirely different. The hallmarks of an epistemological crisis in the way in which it interests me here are not the trading of one knowledge or one definition for another more apt or relevant one, but rather the question of what happens when practices such as thought or production are pushed to their very limits. Do they collapse or do they expand? Can they double up on themselves and find within this flipping over another set of potential meanings? When Stefano Harney and Fred Moten wrote a text on debt and study for a special issue of *e-flux* on education, they took the maligned notion of 'debt' at the heart of a financial crisis of irresponsible fiscal marketization of debt, and flipped it over into something else: 'But debt is social and credit is asocial,' they said. 'Debt is mutual. Credit runs only one way. Debt runs in every direction, scattering, escaping, seeking refuge. The debtor seeks refuge among other debtors, acquires debt from them, offers debt to them. The place of refuge is the place to which you can only owe more, because there is no creditor, no payment possible. This refuge, this place of bad debt, is what we would call the fugitive public.'[1]

These are the hallmarks of an epistemological crisis, exiting from previous definitions, refusing former meanings, refusing moral inscription, refusing the easy stability in which one thing is seemingly good and the other potentially

threatening. Risking a capacity for misunderstanding: What is it to declare debt social at a moment when millions of people are experiencing eviction or financial ruin due to the capitalization of debt? It means that one can no longer be content with taking positions within a given definition, but one has to make it stretch and twist itself inside out to become significant again.

The limits of multiplicity

Would it not be simpler to settle for a celebration of multiplicity? A proliferation has about it a measure of happy mutuality, a multiplicity of things coexisting and not disturbing one another, multiculturalism being a fabled example of such happy harmony! But the confusion about what the hell do they mean when they say 'art', the epistemological disorientation, has to imply a contested ground and if this ground is contested then each mode of understanding is grounded not just in vested interests – the neoliberal art market and its evil twin, cultural diplomacy – but in differing ways of knowing the world and its practices. However, while the antagonistic mode of differentiation may be crucial for the initial moment of distinguishing between this mode of practice and that one, between the vested interests that sustain them and their operations – for me, ultimately it serves to reinforce the divisions between hegemonic and alternative activities, a distinction that is unhelpful in the task of reconfiguring the field as a set of potentialities.

There is a discussion by Derrida in his book *The Eyes of the University*, the book in which he reflected on the founding of the College International de Philosophie in Paris in the 1980s, in which he says, 'Boundaries, whether narrow or expanded, perform nothing more, than establishing the limits of the possible.'[2]

So not wanting to operate in this impoverished mode of 'the limits of the possible', I need to think of how to go beyond the pluralistic model, an additive mode at whose heart is a very old Enlightenment conceit that cultural institutions are universalist and infinitely expandable – that they can stretch and expand to include every one of the excluded, elided and marginalized histories. This conceit updated to the realm of post-slavery, postcolonialism, post-communism insists that we must deal with issues of cultural difference and cultural exclusion by practising their opposite, namely inclusion and compensation. Of course the problem with this infinitely expandable model is that it promises no change whatsoever, simply expansion and inflation.

So an epistemological crisis seems a much more fertile ground from which to think the notion of an emergent field. An epistemological crisis would allow us to think not competing interests but absent knowledges, it would allow us to posit a proposition that would say that if we were able to find a way to know *this*, it might allow us to not think *that*. So it is a question of the loss or the sacrifice of a way of thinking, as opposed to the cumulative proliferation of modes of operating.

For both curating and the curatorial, the notion of an epistemological crisis is paramount, since they are largely fields grounded in a series of work-protocols with little cumulative history or a body of stable empirical or theoretical knowledge at their disposal. Thus the temptation to hurriedly build up a body of named and applicable knowledge that would dignify the field is probably great. While such absences allow for a flexibility of operating and for the possibility of considerable invention, be it of archives or subjects or methodologies – there is an ongoing demand for an end product that coheres around an exhibition, around the act of revealing and concretizing, and that belies all the loosening that had gone into its curatorial operations.

Our work on the 'Curatorial/Knowledge' programme addressed precisely such an epistemological crisis, one in which we would not determine *which* knowledges went into the work of curating but would insist on a new set of relations between those knowledges. A new set of relations that would not drive home the point of an argument, as in much academic work and would not produce a documented and visualized cohesion around a phenomenon, as in much of curatorial practice. So rather than say, '*this is the history of curating and it will now ground the field professionally*', we have tried to map the movement of knowledges in and out of the field and how they are able to challenge the very protocols and formats that define it: collecting, conserving, displaying, visualizing, discoursing, contextualizing, criticizing, publicizing, spectacularizing, etc. If curating can be the site of knowledge to rehearse its crises then it has the potential to make a contribution rather than enact representation.

Going back to the question I began with, asking 'What on earth do they mean when they say art?', this epistemological crisis allows us not to choose between different definitions, but to make the curatorial the staging ground of the development of an idea or an insight. Ideas in the process of development, but subject to a different set of demands than they might bear in an academic or in an activist context – not to conclude or to act, but rather to speculate and to draw a new set of relations. To some extent that has resulted in an understanding that it is not that the curatorial needs bolstering by theory, philosophy or history,

but rather that these arenas could greatly benefit from the modes of assemblage which make up the curatorial at its best, when it is attempting to enact the *event of knowledge* rather than to illustrate those knowledges.

Contemporaneity as infrastructure

In our department at the university we often say that our subject is contemporaneity and that this is not a historical period. Rather we think of contemporaneity as a series of affinities with contemporary urgencies and the ability to access them in our work. Such an understanding of contemporaneity is equally significant for the curatorial, demanding that it finds ways of conceptually entering contemporary urgencies rather than commenting upon them, taking them up as 'subject matter': the endless exhibitions about terrorism or a globalized art world we have endured in recent years being a case in point. And not only is contemporaneity about the engagement with the urgent issues of the moment we are living out, but more importantly it is the moment in which we make those issues *our own*. That is the process by which we enter the contemporary.

So finally I would like to put forward a very tentative argument, not fully and deeply worked through yet, about the relation of our expanding field to infrastructure, and about this conjunction's central importance to the understanding of contemporaneity.

When Okwui Enwezor was curating *Documenta 11* he said again and again, in an effort to ward off the constant tedious questions about which artists were going to be included in the show, that it mattered less which artists or works he would be including than which archives we would be reading them out of. His efforts to privilege the archives and the reading strategies at our disposal have stayed with me as an important principle of contemporaneity.

When we in the West, or in the industrialized, technologized countries congratulate ourselves on having an infrastructure – properly functioning institutions, systems of classification and categorization, archives and traditions and professional training for these, funding pathways and educational pathways, excellence criteria, impartial juries and properly air-conditioned auditoria with good acoustics – we forget the degree to which these have become protocols that bind and confine us in their demand to be conserved or in their demand to be resisted.

Following Michel Feher, thinking about the impact of NGOs as modes of counter-governmental organization, the shift from consumers to stakeholders

has significantly shifted our understanding of infrastructures. From properly functioning structures that serve to support something already agreed upon, to the recognition of ever-greater numbers of those who have a stake in what they contribute to or benefit from.[3] Much of the more activist-oriented work within the art field has taken the form of reoccupying infrastructure: using the spaces and technologies and budgets and support staffs and recognized audiences, in order to do something quite different: not to reproduce but to reframe questions.

We think of infrastructure as enabling, we think it is an advantageous set of circumstances through which we might redress the wrongs of the world, to redress the balance of power within a post-slavery, postcolonial, post-communist world of endless war. When MOMA New York gets around to putting on an exhibition of contemporary Arab art, it is either celebrated as a great step against Islamophobia or decried as the cooption of such work into hegemonic systems of market patronage. But whatever the position, there is a sense that the incorporation of this work within an august context, into the ultimate infrastructure, that ignored its very existence for so long, is a benchmark – a contested benchmark, but definitely one.

So if we keep in mind Achille Mbembe's question, 'Is the edge of the world a place from which to speak the world?',[4] we might reflect about what the absence of infrastructure does make possible, which is to rethink the very notion of platform and protocol, to put in proportion the elevation of individual creativity, to further the shift from representation to investigation.

Thinking about the links between collectivity and infrastructure, the obvious necessities of mobilizing as many resources and expertises as possible at a given moment in order to not only respond to the urgencies of the moment, but also in the need to invent the means, protocols and platforms which will make that engagement manifest among strata of stakeholders – then the decentering of the West is not only the redress of power within a post-slavery, postcolonial, post-communist world but also the opportunity in the absence of infrastructure to rethink the relations between resources and manifestations.

In order to understand the potential of a particular condition we do not mythologize or romantically glorify it, but rather extract from it a revised set of relations – from Tucuman Arde to Collectivo Situationes, from Chto Delat to Raqs Media Collective to Kharita, from Public Movement to public school, from Oda Projesi to X-Urban – these shifts have and are occurring all around us, and while I would not claim that they are models to be reproduced within far more privileged conditions, I would suggest that they are the archive from which we need to read our own activities.

Speaking for myself, I can honestly say that being lectured about the limits of the possible seems to me to be as impoverished a condition as working without the means of a dignifying infrastructure – nothing more, as Derrida says, than the means of containment. So perhaps the necessary links between collectivity, infrastructure and contemporaneity within our expanding field of art are not performances of resistant engagement, but the ability to locate alternate points of departure, alternate archives, alternate circulations and alternate imaginaries. And it is the curatorial that has the capacity to bring these together, working simultaneously in several modalities, kidnapping knowledges and sensibilities and insights and melding them into an instantiation of our contemporary conditions.

Notes

1 Fred Moten and Stefano Harney, 'Study and Debt', in *e-flux Journal* (2010). www.e-flux.com/journal/debt-and-study/ Accessed 30 August 2012.
2 Jacques Derrida, *Eyes of the University: Right to Philosophy 2,* trans. Jan Plug and others (Stanford: Stanford University Press, 2004), 44.
3 Michel Feher, (ed.), 'Introduction' to *Non Governmental Politics* (New York: Zone and MIT, 2007).
4 Achille Mbembe, 'At the Edge of the World: Boundaries, Territoriality, and Sovereignty in Africa', in *Public Culture* 12, no. 1 (Winter 2000): 259–84.

5

Dear Art, Yours Sincerely

Natasa Ilić for What, How and for Whom / WHW

In 1999, the artist Mladen Stilinović – who, since the 1970s, regularly works with language and its underlying ideological content – wrote a letter to art. 'Dear art', he wrote, 'I am writing you a love letter to cheer you up and encourage you to come and visit me some time.'[1]

His letter is a typical example of his approach to art; one which is based on simple execution, cheap, found materials and objects of everyday use. His approach to art allows him, now for more than three decades, to engage with questions relating to artistic autonomy and how to retain independence from the system in terms of both the production and the presentation of artworks.

Stilinović started his practice as part of what was then called the *New Art Practice*, a generation of artists who, on the Yugoslav art scene of the late 1960s and 1970s, challenged the officially accepted art of high modernism by questioning the 'autonomy' and 'originality' of art and by adopting a strategic use of media, creating new models of self-organization and taking the production of art outside of the confines of the institution in order to reach new audiences.

In the 1970s, he became a member of the Group of Six Artists (along with Boris Demur, Vlado Martek, Sven Stilinović, Željko Jerman and Fedor Vučemilović). This group of artists explored the ways in which conceptual art could achieve more autonomous modes of production and distribution. This led them to present in public spaces what they called 'exhibitions-actions', collaborative events of exhibiting on streets, in parks, riverbanks, etc.

In the 1980s, Stilinović was running the hugely important artist-run but city-owned space Gallery of Extended Media in Zagreb. His engagement with the gallery ended in a highly symbolic moment when it became occupied by paramilitary troops thus marking for many artists the start of the war.

In the early 1990s, he started organizing exhibitions in his apartment on a regular basis. Like his previous gallery projects, his apartment exhibitions contain an implicit critique of official art institutions and rely on what Viktor Misiano in the context of the Russian 'Apt Art' movement called the 'institutionalization of friendship'. This approach implies creating a community that consciously works on redefining the rules of conduct and power relations in a specific art scene. Applied to the Croatian art scene of the 1990s, a scene characterized by a total lack of regard for a critical approach to artistic production and its contextualization, this approach left a strong mark on the younger generation of artists.

Although he continued to exhibit in galleries and museums, Stilinović kept his critical stance, refusing to lapse in order to attain an unachievable purity in art, and always aware of his own complicity and involvement. As he repeatedly points out, the role of the artist is to oppose art.

In his love letter addressed to the art of 1999, the idea of opposing art is not an attempt to come up with a utopian notion of anti-art or to merge art and life. His real aim is not only to intimate a set of troubled, poetic, enigmatic and certainly more modest observations on the place of photography in contemporary artistic production, reception and distribution, but also to question the value of art, this value that, far too often, gets translated exclusively in terms of money, or as he puts it: 'quick manipulation, quick money, quick oblivion'.

His thoughts touch upon photography and the way photography manages to usurp the place of art by providing a kind of trace ready to be converted into a marketable object (without mentioning the word 'documentation', one cannot help but imagine drab black-and-white photos trying hard to convey a sense of authenticity).

His point is that 'naturally, there's no memory of art, just like there is no memory of photography'. This does not lead him to a nostalgic longing for some fleeting moments that could not be captured and preserved in photography. He also does not long for some kind of exclusivity or a supposed authenticity of first-hand direct experiences. His point in fact is an attempt to endorse instead the usurpation of photography as a way of hiding art, keeping it safe from prying eyes, recognizing it as a possibility of escaping and moving elsewhere. As he says:

> I think you should take photography as the good fortune of history, although it is the misfortune of the moment. The good fortune of history doesn't exist, but words are sometimes beautiful regardless of their cover. Besides, you are always somewhere, regardless of photography.

Although hopeful and abstaining from any moralistic stance, his musings on photography leads him to 'another matter', that of the price of art. He writes: 'Money is money. Art is art. This form of tautology satisfies many people and you are happy in this paralysis.'

In the postscript to his letter, he proposes to 'cheer up' art a little by putting self-censorship up for auction. In his view (a view also expressed through number of works that deal with the subject) self-censorship contributed greatly to the erosion of freedom that is particular to art. By suggesting auctioning self-censorship, he does not hope to get rid of freedom as much as he tries to contain or tame it. With a respectful acknowledgement and recognition of art, his aim is to probe once again the transaction between money and art: 'Your name is value, not you.'

And indeed, his reading performance within the framework of the exhibition *Worthless (Invaluable), The Concept of Value in Contemporary Art*, curated by Carlos Basualdo in the Museum of Modern Art in Ljubljana in 2000, ended in a lively auction in which his self-censorship was exchanged for money offered by the highest bidder among an undaunted audience. (Alas, his action hardly exhausted the well of self-censorship.)

Stilinović's direct address to art – his love letter, as it were – was written at a time when the countries of the former Yugoslavia were progressively settling into a process of normalization. This process was not only ideologically constructed (imposing a supposed normality in which social conflicts are harmonized and effects of war are swept under the carpet); it was also a genuine turn towards the possibilities offered by a non-dramatic pace of life-as-usual, a deeper assessment of the upheavals of the last decade, renewed contacts and a hope to regain a more solid ground. Stilinović's letter was also written at a time when the museum in Ljubljana was considered the only institution with an international arts programmes able to address not only its growing collection, but also the local context, and was therefore seen as something of a role model in comparison to the other sluggish and bureaucratized institutions of the other capital cities of the former Yugoslav republics.

However, at the same time, the process of normalization also acquired clearly darker undertones, operating exclusively as a euphemistic term for the unstoppable march of economic, political and cultural transformation along the lines of the neoliberal model. A little over a decade later, the flexibility and inclusiveness of the foundation sector as the most prominent material system for the production of contemporary art in the region appropriated critical discourse, and a string of new buildings for contemporary art institutions were inaugurated throughout the ex-Yugoslavia.

The year 2009 saw the opening of the new building for the Museum of Contemporary Art in Zagreb. In 2011, the Museum of Modern Art in Ljubljana moved into a new building and displayed its collection. And the new building for the Museum of Contemporary Art in Belgrade is in the process of being reconstructed.

The transition to a new post-Fordist regime seems to be finalized. The countries all now have lively critical art scenes taking place in strong non-institutional frameworks principally sustained by the enthusiasm of their members, which makes their future questionable. There is a growing sense of exhaustion and fatigue and a growing realization that notions such as participation, knowledge sharing, networking, managing and cooperation, which intend to realize human potential and abolish the formal division of labour, could turn up in fact to be exploitative moments of production.

In 2011, upon the invitation to curate an exhibition in the newly opened Museum of Modern Art in Ljubljana, we – the curatorial collective What, How and for Whom / WHW – revisited Stilinović's letter to art, hoping that his humorous approach, lack of cynicism and cautious irony could offer some kind of new orientation.

This was a moment when our collective curatorial practice, after more than a decade of navigating pressures brought upon by the transition to a post-Fordist regime and avoiding betrayal, cooption and assimilation, grew somewhat disenchanted with the virtues of collective work and less assured of its mission to extricate the political potentials of art through projects that translated into different contexts of Croatian symptoms (i.e. nationalistic ideologies that permeated public discourses, feeding anti-communist rhetoric that exclusively defended an identity-based understanding of culture). Stilinović's letter was a way of moving away from this.

Perhaps it's just that the 'idea' of our collective got exhausted. I use the word 'idea' in the sense developed by Siegfried Kracauer in his essay 'The Group as a Bearer of Ideas'. Siegfried Kracauer is the father of what would later be called Cultural Studies. His essays, originally published in Germany during the Weimar Republic in the newspaper *Allgemeine Zeitung*, were reprinted in German in the 1960s and later translated into English in the 1980s under the title *The Mass Ornament*, certainly make timely reading today.

In his essay, 'The Group as a Bearer of Ideas', Kracauer writes about how the corporeality of a socially effective 'idea' is produced by the individualities making a group, carefully delineating 'the communities of life and fate from those groups that actually bear the ideas'.[2] His aim is to show how an 'idea' imposes itself on a group and how, in turn, it creates individualities.

Kracauer's account of how the group penetrates into reality and simultaneously experiences the power of that reality and how the logic of reality replaces what he calls 'a logic of idea' results in a rather pessimistic diagnosis. According to him, a group either immerses itself in bitter inner conflicts between 'reformist and radical wings' or manages to get a grip on reality (thus securing their position and power), but only to lose it, transforming their original 'idea' into pure decoration. As he says, in the latter case, the idea of the group 'becomes pure decoration, ostentatious facade for a partly rotten interior (. . .) and the idea takes sublime revenge on the now powerful group'.[3]

With the growing recognition of our own curatorial work being the agent and symptom of the process of normalization we stood against, and with the realization that critique was being institutionalized and produced through self-referential fields of art, Kracauer's questions on the duration and role of a group acquired for us a new urgency. Obviously, our positions are not as clear-cut as they are portrayed in Kracauer's analysis, and the power gained also came with an increasing precariousness and further and further pressures 'to produce', a situation that is certainly not unique to Croatia.

In another essay, 'Those Who Wait', Kracauer proposed to avoid the 'either-or' impasse that intellectuals as they relate to community leave us in, by endorsing a position of waiting. As he says: 'Perhaps the only remaining attitude is one of waiting. One waits, and one's waiting is a hesitant openness.'[4] One could hardly be blamed for objecting that, for Kracauer and his generation, this waiting did not end up all too well. However, on a more positive note, the waiting he proposed could also be seen as a strategic move that is not simply passivity, but involves sustaining a certain openness in order to test the modalities of art production and critical thinking within and at the edges of the existing systems.

In that sense, the invitation from the Museum of Modern Art in Ljubljana, itself struggling with drastic cuts imposed within the austerity measures that in recent years have swept through Europe, offered an opportunity to pursue the questions Stilinović addresses in his love letter to art. The point was not to expect an answer, however promissory and instantly gratifying the answer might be, but to take the opportunity to take a break, catch a breath and start again from the beginning. What is it that we expect to get from art today? What is its promise, and what do we promise it in return? And what happens when this promise gets broken, betrayed or just plainly exhausted?

As in several previous shows curated by WHW, the exhibition, planned for late 2012, will take its title from a work by Mladen Stilinović, 'Dear Art', thus insisting on the obstinate repetition of what has become the curatorial method. Amidst the disillusionment created by the persistent feeling of failure (coming

from the fact that attempts at a radical reconfiguration of art and cultural production in general always become almost immediately spectacularized) and thus relying on the very nature of art's 'inefficiency', the exhibition *Dear Art* will therefore attempt to ask a brazen, and yet absolutely necessary question: Why do we still need art, and what is it that makes contemporary art actually and truly contemporary in society?

The exhibition will attempt to address this issue by looking at art's own reflection upon its practice. At the moment of writing the form in which the exhibition will actualize itself in the end still hesitates between numerous options nonetheless limited by what is commonly understood as the framework of a museum exhibition. In any case, the exhibition will try to acknowledge the extremely limited material base of exhibition production, and bowing to Stilinović's assessment that 'the time has come for you (i.e. art) to hide and keep a low profile for a while', it will most probably do so through a series of proposals abstaining from realization (hopefully) *generously* shared with us by artists, writers, curators, activists and theoreticians, whose works have inspired our practice throughout the years, and whenever heavy-handed treatment of copyrights allows for it, relying on copies and easily reproducible media.

The outcome of the process thus imagined is bound to result in revisiting a text whose title is appropriate to close this account of an exhibition still completely imaginary (i.e. more imaginary than exhibitions always are and never cease to be, even when their actual realization follows carefully devised and closely overviewed plans every step of the way). This text is Rosalind Krauss' 'Sincerely Yours', her seminal contest of notions of singularity, authenticity, uniqueness and originality.[5]

But maybe this time around, 'Sincerely Yours' will look less into the 1980s obsessions with originals and copies, and will rather focus on simply reasserting allegiances, affirming endurance, enduring indecisiveness, basking in contradictions, facing misunderstandings, not knowing what to do, letting art happen all over again.

July–August 2012

Notes

1　Mladen Stilinović, 'Dear Art', in *Worthless (Invaluable): The Concept of Value in Contemporary Art* (Ljubljana: Editions Museum of Modern Art, 2000).

2　Siegfried Kracauer, *The Mass Ornament* (Harvard: Harvard University Press, 1995), 144.

3 Kracauer, *The Mass Ornament,* 167.

4 Kracauer, *The Mass Ornament,* 138.

5 'Sincerely Yours' was published in response to the attack by Professor Albert Elsen
 on Krauss' discussion of the notion of the original in relation to casts of Rodin's
 sculptures in a previous text entitled 'The Originality of the Avant Garde'. See
 Rosalind Krauss, 'Sincerely Yours', in *The Originality of the Avant Garde and Other
 Modernist Myths* (Cambridge: MIT Press, 1983), 151–94.

Part II

Praxeologies

Individual human beings . . . do not simply 'move', as do unmotivated atoms or molecules; they act, that is, they have goals and they make choices of means to attain their goals. They order their values or ends in a hierarchy according to whether they attribute greater or lesser importance to them; and they have what they believe is technological knowledge to achieve their goals. All of this action must also take place through time and in a certain space. It is on this basic and evident axiom of human action that the entire structure of praxeological economic theory is built. We do not know, and may never know with certainty, the ultimate equation that will explain all electromagnetic and gravitational phenomena; but we do know that people act to achieve goals.

Murray N. Rothbard*

*Murray N. Rothbard, 'Praxeology as the Method of the Social Sciences', in *Phenomenology and the Social Sciences*, ed. Maurice Natanson (Evanston: Northwestern University Press, 1973), 31.

The Curator Crosses the River: A Fabulation

Stefan Nowotny

In twentieth-century philosophy, the following fable by the Latin author Hyginus has attracted considerable attention: Cura, an allegorical character whose name could be translated as 'Care' or 'Concern', once crossed a river. On reaching the other side, she saw some clay on the banks and began to mould it into a figure. As Jupiter came by, she asked him to bring her artefact to life by granting it 'spirit': which he readily did, requesting though that it be given his name instead of hers – a request vigorously opposed by Cura. Hearing the two of them arguing, Tellus, the primeval earth-goddess, appeared on the scene and insisted that the creature bear her name since she had given it part of her body. The issue was eventually settled by Saturn, who had been called upon as a judge. He decreed that, at the creature's death, Jupiter should be given back its spirit just as Tellus should retrieve its body – while Cura was to possess it for the duration of its lifetime. The creature's name, however, was decided to be *homo*, for it had been shaped out of *humus* ('earth' or 'soil').

The starting point of philosophical discussion on this fable was certainly the way Heidegger referred to it in *Being and Time* when he unfolded his interpretation of (human) existence ('Dasein', 'Being-in-the-world') as a structural totality of 'care' rather than as being grounded in a sovereign, autonomous and constitutive 'subject'. I want to pick up here, however, the thread of an observation by Hans Blumenberg.[1] In his rereading of Hyginus' fable, Blumenberg shrewdly pointed out that no indication whatsoever is given to explain why Cura had to first cross the river in order to mould her figure, while in all probability she could just as well have found clay on the riverside from where she came. A *curious* fact, indeed. Not only because it may incite our curiosity about Cura's river crossing itself (rather than what happened after it) but also because it might also tell us about Hyginus' decision to omit giving an explanation for the importance of that

crossing. The fable also says that Cura's name suggests that it might be 'curious', and even more so because we are told that this being becomes the creator and 'possessor' of another quite curious being, a mortal being called *homo*.

Given that both the omission and the reason for the omission need to be expounded, Blumenberg's solution to the riddle is inevitably twofold. On the one hand, he explains that the significance of Cura's crossing of the river is based on an early Gnostic myth for which, as opposed to older Greek notions of creation, a moment of self-mirroring is necessarily inscribed in the very act of creation: according to this myth, Cura first had to see her own image reflected on the surface of the water and simultaneously perceive the clay on the river's ground, as only then could she be driven to take up the clay on the banks in order to shape a creature 'in her own image'. On the other hand, when it comes to explaining the fable's silence on that crucial point, Blumenberg first speculates that the reason for this silence could be that Hyginus considered it no longer appropriate for an allegory about care and concern to be characterized by what might also be understood as an act of mere vanity or 'narcissism'. In this respect, Blumenberg goes as far as to propose that Cura would have to be imagined as 'marked by sorrow' rather than beautiful. This being stated, he quickly moves on to suggest a second possible explanation: Hyginus wanted his 'lowly heroine' Cura to take the place of the titan Prometheus; yet as Cura's capacity for creation was dependent on a model or prefiguration and thus could be considered to be comparatively inferior in contrast to the latter's unrestricted way of shaping humans out of clay, the author of the fable preferred to keep silent about this dependency, for it would also have alluded to a 'low' origin of humanity.

I will not discuss all of this here in detail, even though a whole set of evaluations might attract our critical attention. Yet, on a more general level, an element of interest in Blumenberg's suggestions can be seen precisely in the way they highlight the relative lowliness of Cura, such as her double inferiority in relation to her Greek precursors; the powerful, if self-indulgent, demiurge Prometheus and the beautiful, if self-entangled, demigod Narcissus. Indeed, the main thread of Hyginus' fable tells a story of 'lowliness', despite – or perhaps rather accentuated by – the encounter of gods it describes: even the earth that *homo* is made out of is no longer the primeval Earth that may arise and present its mighty claims, but just a profane and dumb piece of soil, *humus*, that immediately evokes the contingent and transient character of Cura's creature.

But there is something else that is of interest and that I would like to address in the form of some questions: What if we took Hyginus' silence about the significance of Cura's river crossing not so much as imposing on us the task of

reconstructing what was omitted by an author who had invented a figure that didn't quite fit any longer into the existing imaginaries – but rather as an invitation to deploy our own imaginative capacities in order to somehow re-narrate Cura's story, and especially its unaccounted part? What if we took advantage of that silence in order to disengage the fable, and – even more so – ourselves, from the suggestive and persistent regimes of both 'high' creation or 'high' origins and self-mirroring (which alone cast a shadow of 'lowliness' on Cura and her offspring, and at once involve them in an ambivalent, if not vicious circle of representation and creation)? What if we tried to free our understanding of Cura's fable from the grammar of immoderate self-indulgence and un-convivial self-entanglement, and hence also from the insinuation that an existence of 'care' would have to result in being 'inferior in capacity' or 'marked by sorrow', rather than powerful and beautiful? And what if we did so by referring the fable to some of Cura's descendants, specifically those who might not owe their existence to Cura's 'own image', yet all the more hauntingly evoke her name: 'curators'?

<p style="text-align:center">* * *</p>

The first 'curators' seem to have appeared, under the name of *curatores rei publicae*, around the year of 100, about a century after Hyginus had written his fable. These 'curators of public affairs' were in fact representatives of the Imperial Roman government, whose main task was to maintain public order and look after the finances of the city they were deputed to govern. This name was especially used in more 'remote' places such as the African provinces. These first 'curators' thus had a well-defined responsibility and, even though their responsibilities were oriented towards the good of the 'public' and the 'common wealth', were nonetheless travelling agents of a governmental power that wanted to preserve its power even in the most dispersed sites of its implementation.

By contrast, the task of modern 'curators' – especially those whose activities came to be related to places like museums – was for a long time confined to an apparently much more limited concern: the taking care of things, or rather of artefacts or objects that were considered to have some kind of extraordinary value or bear some kind of extraordinary significance, based on their meaningfulness to 'human knowledge' or on the fact that they testified to an exceptional human capacity of creation. While this narrower responsibility appears to be well defined, it nonetheless accounts for a blurry field of complexities, complications and complicities. First, it is impossible to separate the tasks of overseeing valuable and significant objects or artefacts from specifically designed procedures

of valorization and signification, and hence from a historical production of specific object-types and of specific subjectivities who endorse them. Second, these procedures were also closely linked to not only a broader constellation of economico-political powers and dominations, but also to the emergence of new fields of knowledge (from comparative anthropology to modern aesthetics) and of new practices of appropriation and dispatch, display and contemplation. Finally, there is little need to stress here that the 'caring' of things exercised by curators – insofar as it concerned not only the preservation of certain objects, but also the legitimation of their acquisition – made itself complicit in a substantial number of cases in profoundly careless and uncaring acts of ruthless robbery and abstraction.

Are we then to consider 'curators' not only as descendants of Hyginus' Cura, but also as her modern manifestations? Crossing many rivers and even oceans (albeit not necessarily in person, as modern times require an enhanced division of labour)? Producing, out of what they can find, figures identified with the name *homo* (even though the material is no longer clay and the creation no longer quite as inceptual as Cura's, but rather drawing upon the multiplicity of existing images of *homo* and upon what is conceived of as the creativity of the human imagination)? And yet still perhaps dependent on a moment or momentum of self-mirroring that is better kept out of the narration, as it could bear witness either to the limits of the capacities of the 'curatorial' or to the somehow inappropriate traces of self-indulgence and self-entanglement inscribed in them?

'Something's wrong,' Blumenberg wrote when contemplating the course of Hyginus' fable. And it appears as if this assessment could cogently also be applied to Cura's later descendants and avatars. But what is it that's wrong, after all? Is it only an unnamed, and indeed perhaps hardly expressible, 'narcissism of care' (Blumenberg), a narcissism that for some reason has to be disassociated from the story or at least disguised through a captivating narrative? Or are there signs that in the (hi)story of Cura (care, concern, curators . . .) something else should be imagined to have taken place on the rivers she crossed: something different from a necessarily elusive and yet presumably decisive glimpse of a reflected image, then taken as a model for 'creation'?

I wouldn't feel encouraged to take the second suggestion as an actual possibility, if it were not for the fact that the most recent prominence of 'curators' appears to be closely linked to an open series of investigations and interrogations into various components of Cura's story and curators' history, simultaneously manifesting a desire to break free from the frameworks set up by those components in order to give new accounts of care and concern. I won't go

into the various attempts to reconstruct how this came about, nor will I discuss
any 'examples'; I am also fully aware that, time and again, there are manifold ways
to re-enact and re-articulate a 'narcissism of care'. However, what is remarkable
about the investigations and interrogations in question is that they suspend,
as it were, Cura's journey across the river instead of just contributing to new
variations of its outcome while keeping silent once again about why it ever had
to be undertaken. It is as if Cura's movement from one riverside to the other had
come to a halt in the very middle of the river: but only to be drawn into another
kind of movement unhinging the components of the initial one in order to make
them investigable, interrogable, questionable, newly discernable and criticizable,
but also perhaps newly mistakable, re-composable, even re-inventable.

It is probably a shared experience that suspending an activity one had been
tied to can involve a serious and not easily compensated disengagement from
a whole set of hitherto existing motivations and purposes, from the values and
meanings that have so far been tightly concatenated with that activity. Hence,
what we might imagine to open up in the interruption of Cura's journey is not
simply a new set of orientations, a new imaginary, but rather a new field of possible
explorations into both the objects and the potentialities of disengagement:
the uses and disputed status of pictoriality, the materiality at hand and on the
ground, creativity and the ways it is enabled or absolutized, contingency and
animation, orderings of 'high' and 'low' and their horizontalization, the (re- and
de-) configurations of the human, the non-human and the *humus*, the debates
about the origins and properties of common names, the fragile commonality of
those involved, concerned, making claims, etc.

A new field of knowledges? Rather a new epistemology if we recall that
the formation of knowledge might also have to be freed from its narcissistic
implications: after all, the Gnostic myth that Blumenberg laid open as being
implicated in Hyginus' fable applied above all to *sophia*. A new field of practices?
Rather a new praxeology, or even ethics, given that it is precisely not about
mere compensations of former engagements or simple replacements of older
activities through newer or more 'contemporary' ones, but about the condition
of engagement as such and the 'untimely' opening of new temporalities.

* * *

Let me finally superimpose another image onto Cura's river crossing, an image
that evokes not only later conceptions (or rather imaginations) of 'history', but
also critically responds to them. This other image reminds us of the fact that

movements on rivers are not solely determined by those who cross them; but it also reminds us of the fact that it will not suffice to complement one linear movement with another linear movement that, as it were, crosses the crossing. I borrow this image from one of Walter Benjamin's 'thought figures', which reads as follows: '[. . .] history cannot be sought in the riverbed of a process of development. Instead [. . .], the image of the riverbed is replaced by that of a whirlpool. In such a whirlpool earlier and later events – the prehistory and post-history of an event, or, better, of a status – swirl around it.'[2]

Whether Cura had a boat or a raft at her disposal when crossing the river and whether she had to wade or swim; we don't know. Neither do we know how deep the river was or how strong the current were. We also do not know whether the water was agitated by strong winds and full of whirlpools. We don't even know whether Cura travelled alone or, as her name would perhaps suggest, together with others unaccounted for. All of this remains part of our curiosity: the careful curiosity of those being 'possessed' by Cura, for the length of their lifetimes and no matter whether they are considered to be curators or not. Why not call the matter of concern that this curiosity relates to – the curatorial?

Notes

1 See Hans Blumenberg, *Die Sorge geht über den Fluss* (Frankfurt on the Main: Suhrkamp, 1987).

2 Walter Benjamin, 'Diary from August 7, 1931, to the Day of My Death', in *Selected Writings, Vol. 2, Part 2, 1931–1934*, ed. Michael W. Jennings, Howard Eiland and Gary Smith, trans. Rodney Livingstone and others (London: Belknap Press, 2005), 501–6.

Becoming-Curator

Suzana Milevska

When and how 'becoming-curator' takes place has intrigued me for quite some time.[1] However, it is important to emphasize that this question is not directly related to the personal decisions that lead someone to choose the vocation and profession of curating, at least not in the context of the argumentation provided by this text. In other words, to investigate the event 'becoming-curator' is not the same thing as to ask how a woman or man decides to become a curator or to investigate the circumstances that have helped their decision – although these questions are also important for the conceptualization and development of a curatorial career. In this essay, I will therefore focus solely on the event 'becoming-curator', in the way Gilles Deleuze understands the expression 'becoming'.

I refer to two movements that, according to Deleuze, are always necessary for this 'becoming' to take place.[2] He first stipulates that there must be a certain isolation from the majority (becoming-man), and I interpret this first movement when 'becoming-curator' emerges as a potentiality. Then, according to Deleuze, a certain isolation must also occur from the minority, namely when a curator is recognized as such, he or she is profiled as 'a curator' through the event(s) of curating. These two conditions are predetermined by a complex and rhizomatic grid of relations and knowledge exchange between the curator, the artist(s) and the audience. This does not give the curator a final essentialized position; in order for the curator to remain recognized through each movement in this chain, he or she has to be involved in 'becoming' (isolation from majority/minority).

The event of becoming a curatorial subject

The ongoing result of this complex social and linguistic process of subject-construction is the emergence of a specific curatorial *grammar* – thus making

a difference between 'who is speaking' (which becomes irrelevant) and 'the speaking itself'. Claire Colebrook explains this process by making a difference between the *grammar of Being* and the *grammar of becoming*:

> The very concept of the subject is tied to a strategy of being and essence, rather than becoming. And this is because the subject is not just a political category or representation but a movement of grammar. (. . .) The concept and logic of the subject as such, then, demands or provokes a movement of thought, a specific temporality and, ultimately, a strategy of reactivism, recognition, and being (rather than becoming).[3]

'Becoming-curator' therefore implies a movement of grammar. However, it is obvious that this movement (and therefore subjectivity) cannot be thought only as a majoritarian-type move. Majoritarianism is affected by what Deleuze and Guattari named 'becoming-minoritarian' and the mere possibilities of 'becoming-minoritarian' shape majoritarianism. There are many restraints that culture imposes on normal subjectivity in the form of bio-power and these restraints interfere in this 'becoming'.

Becoming is therefore about negotiating the discursive constitution of subject. However, Patricia MacCormack reminds us to not forget that discourse is always physical or corporeal:

> Discourse is corporeal because we are enfleshed versions of the speech that constitutes us from culture without and from self-regulation or identification within. (. . .) In order for there to ever be a potential for actual becoming, the potential of the body we are now must be recognized.[4]

The relation between body and speech is indeed established through culture, but the potential of becoming is based on a far more complicated set of relations between *being* and *becoming* subject wherein 'becoming' steps in as a kind of destabilization and deterritorialization of subjectivity:

> Becoming is an aspiration for change in thinking the material self. Becoming deterritorializes subjectivity, mobilizing rather than reifying the way we think the self. The familiar territory of subjectivity resonates with sexual territory but more importantly with the familiar territory of how we think our subjectivity.[5]

Claire Colebrook offers a clear distinction between subjectivity understood as fixed *being* and *becoming*. Instead of the subordinate strategy of the subject, Colebrook calls for a sustained 'strategy of becoming'.[6] According to her, 'the self (. . .) is not an essence but an event'.[7] She thus obviously objects to any

conceptualization of the subject as something fixed and pre-given once and forever. She says, paraphrasing Deleuze and his notion of becoming:

> Before there is a genesis that can be tracked back to an origin or condition, there is a multiple and synchronic stratification and structuring, not something located at a single point but a creation of possible points through the event of lines, striations, and articulations.[8]

Becoming, in a Deleuzian sense, is thus not a process that happens through linear time and a result of dialectically overcoming certain obstacles or contradictions, but it is more about becoming the offspring of the event.[9] Becoming-subject is not about (re)creating new identities, but more about coexistence and about expressing differences, but without overwriting them with language; it is about emphasizing the speaking itself.[10]

Therefore 'becoming-curator' could be thought only through such destabilization, this coexistence of different languages and concepts and in relation to the event, that is in relation to the curatorial project or statement in which a curatorial subjectivity emerges as a rhizomatic coexistence of multiple and non-hierarchical differences and lines of thoughts. Thus 'becoming-curator' does not just happen through a process of education or with a decision to become a curator regardless of how important these two starting factors are.

Truth – Knowledge

Every rhizome contains lines of segmentarity according to which it is stratified, deterritorialized, organized, signified, attributed, etc. as well as lines of deterritorialization down which it constantly flees. There is rupture in the rhizome whenever segmentary lines explode into a line of flight, but the line of flight is part of the rhizome.[11]

Every time I quote this seminal passage on the rhizome, I have in mind the deterritorialized but situated knowledge exchange that fluctuates during each project between curators, artists and audiences. But how is one to pin down the truth of such an event? The truthfulness of the event 'becoming-curator' is indeed difficult to address, for example: which event qualifies and which does not; which statements are 'felicitous speech acts' and which are not.[12]

If we are going to use the concept of 'the real' in order to designate the existing, but unsymbolizable reality that can only be thought retroactively

through truth-procedures, what would then be the truth of 'becoming-curator'? While 'truth-procedures' are required to access 'the real', this 'real' often serves as an external obstacle to the possibility of truth's production. Can curatorial projects then claim that they produce knowledge and truth? Are curators aware that they always already contribute to ever more epistemological constructivist concepts of truth?[13] At the same time, questions relating to the accumulation and production of universal knowledge and the relativization of their effects are equally put forward.

Epistemological constructivism is an unconventional approach to the problem of knowledge and truth and it starts from the assumption that knowledge, no matter how it is defined, rests in the heads of persons and, ultimately, the thinking subject has no alternative but to construct what he or she knows on the basis of his or her own experience. One of the advocates of this unconventional approach is the philosopher Ernst Von Glasersfeld. In this work, he refers to his ideas as 'post-epistemological' because, unlike traditional epistemology, his work posits a different relationship between knowledge and the external world.[14] According to him:

1. Knowledge is not passively received either through the senses or by way of communication, but is actively built up by the cognizing subject.
2. The function of cognition is adaptive and serves the subject's organization of the experiential world, not the discovery of an objective ontological reality.[15]

In this way, the truth of the event 'becoming-curator' remains dependent on the subject actively building up her or his cognizing subject. In other words, the curatorial cognizing subject (and therefore curatorial knowledge, overall) is not a fixed object; it is constructed by an individual through his or her own experience (of that object).

Three moves

How is one then to see this as taking place? I will give here three examples.

The translational performance of the curatorial 'event' resides between two different ends of knowledge: the epistemological and the critical. For example, archives as supposed venues for storing truth can be disappointingly 'empty', thus confirming the old philosophical adage that truth is always already somewhere else. Nevertheless, curatorial archives, research projects and texts differ from epistemological methodologies of other constructivist sciences because a) they

obey a different kind of methodology in comparison to those found in the social sciences and the humanities and b) because they rely on the production of specific artistic and historical knowledge and the critical use of these newly produced knowledge(s).[16]

The concept of 'critical curating' was developed in the late 1990s, out of a need to differentiate curatorial projects aiming at research, knowledge production and critical theory from the managerial and promotional models that dominated curating at the time.[17] In a response to various urgent issues related to contemporary art, culture and politics, 'critical curating' focused on a profound critical and theoretical set of enquiries that challenged and contextualized conventional contemporary art curating. While aiming to expand the curatorial field and reflect on its philosophical, critical and social relevance, curators who today advocate 'critical curating' no longer see the exhibition as the ultimate format for their curatorial practice. At the apex of their manifestations, they place above all their own research processes and the theoretical and critical formats provided by conferences, seminars, interviews, close reading workshops, projections, public debates and other events. 'Critical curating' is essentially linked to institutional critique, art for social change, curatorial knowledge, curatorial agency, etc.[18]

Linked to 'critical curating' is 'curatorial agency'. It is a concept that is indebted to the recent critical rethinking of the curator's role in the context of contemporary art, culture and society. Drawing on Alfred Gell's concept of 'art as agency', which states that art has the power not only to passively represent the world, but also to act, 'curatorial agency' assumes in the same vein that the curator is no longer considered to be the 'author' of an exhibition or a mere presenter of an already existing set of artistic concepts and projects. The curator is rather assumed to be an active societal agent that contributes towards a cross-referential understanding of art between different artistic, cultural, ethnic, class, gender and sexual camps and works, moreover, towards the improvement of society in general.[19]

'Curatorial agency' has become one of the major cultural policy concepts able to address the urgent need for translating lesser known art and cultural traditions beyond the prism of postcolonial critique and theory. Thus it calls for bridging the gaps and incommensurable differences between differently conceptualized art practices in order to strongly oppose the hegemonic model of curating that blindly imposes itself onto 'subaltern cultures'. 'Curatorial agency' entrusts its intellectual and theoretical capacities in curatorial knowledge production, art for social change and collaborations among curators, artists and activists.

Conclusion

By way of a conclusion, I want to emphasize the usefulness of emphasizing 'becoming-curator' as a way of questioning power structures within both curatorial and art worlds. 'Becoming-curator' is effectively a new form of institutional critique, not as a way of pitching subjectivity against the institution, but as a way of intertwining the construction of subjectivity with that of institutions, especially when it focuses on 'curatorial translation', 'critical curating' and 'curatorial agency.'

In this way, and as intimated at the start, 'becoming *a* curator' has nothing to do with 'becoming-curator'. While the former is a pragmatic decision not only to make a living out of one of the 'sexiest' professions available in the international art world (one that focuses on singling out emergent art concepts, art objects and artists who produce either those concepts or objects), the latter is fundamentally related to one's own position in the world as a thinking subject. Although there is nothing wrong with the profession itself – even when conceptualized in a pragmatic way – 'becoming-curator' allows a more profound approach: it opens up a new route in understanding contemporary art and the way both curators and artists position themselves in the contemporary art world and world in general.

Notes

1 For example, in 2007 I curated the research and educational project *Curatorial Translation* (26–30 September, Skopje). Some of the workshops that were realized in the framework of this project were specifically dedicated to discussing the issue of real and truth in 'becoming-curator'. See Suzana Milevska and Biljana Tanurovska-Kjulavkovski, eds, *Curatorial Translation* (Skopje: Euro-Balkan Press, 1998) and the *Curatorial Translation Blog*:http://curatorialtranslation.blogspot.com/2007/08/curator-as-translator-of-theory-into.html

2 Gilles Deleuze and Felix Guattari, *A Thousand Plateaus: Capitalism and Schizophrenia*, trans. Brian Massumi (Minneapolis: University of Minnesota Press, 1987), 291.

3 Claire Colebrook, 'A Grammar of Becoming: Strategy, Subjectivism, and Style', in *Becomings: Explorations in Time, Memory, and Futures,* ed. Elizabeth Grosz (Ithaca: Cornell University Press, 1999), 117–18.

4 Patricia MacCormack, 'Perversion: Transgressive Sexuality and Becoming-Monster', in *Thirdspace* 3, no. 2 (March 2004). www.thirdspace.ca/journal/article/view/maccormack. Accessed 5 March 2012.

5 MacCormack, *Thirdspace*.

6 Colebrook, 'A Grammar of Becoming', 118.

7 Colebrook, 'A Grammar of Becoming', 132.

8 Colebrook, 'A Grammar of Becoming', 132.

9 Gilles Deleuze, *The Logic of Sense*, trans. Mark Lester (London: Continuum, 2004), 170.

10 Deleuze, *The Logic of Sense*, 89.

11 Deleuze and Guattari, *A Thousand Plateaus*, 9.

12 J. L. Austin, *How to Do Things with Words* (Cambridge: Harvard University Press, 1975), 133–47.

13 Ernst von Glasersfeld, 'Questions and Answers about Radical Constructivism', in *The Practice of Constructivism in Science Education,* ed. K. Tobin (Hillsdale: Lawrence Erlbaum Associates, 1993), 24.

14 Von Glasersfeld, 'Questions and Answers', 24.

15 Ernst von Glasersfeld, 'The Reluctance to Change a Way of Thinking', in *The Irish Journal of Psychology* 9, no. 1 (1988): 88.

16 See Milevska and Tanurovska-Kjulavkovski, *Curatorial Translation* and Suzana Milevska, 'Cultural Translation and Agency', in *Cultural Policy: New Paradigms, New Models – Culture in the EU External Relations* (Ljubljana: Peace Institute, Slovenian Academy of Arts and Sciences, 2008), 21–8.

17 See Steven Rand and Heather Kouris, eds, *Cautionary Tales: Critical Curating* (New York: Apexart, 2007).

18 Dorothee Richter and Rein Wolfs, 'Institution as Medium: Curating as Institutional Critique?' in *On Curating* 2, no. 08 (2012). www.on-curating.org/documents/oncurating_issue_0811.pdf. Accessed 30 January 2012.

19 See Suzana Milevska, 'Curating as an Agency of Cultural and Geopolitical Change', in *Continuing Dialogues,* ed. Christa Benzer, Christine Bohler and Christiane Erkharter (Vienna: JRP/Ringier, 2008), 183–91.

An Exhausted Curating

Leire Vergara

Being exhausted is much more than being tired,[1] clarifies Gilles Deleuze at the beginning of *The Exhausted*, an essay written as an expansion of the ideas developed in his previous work 'From Sacher-Masoch to Masochism' of 1961. With this sentence, Deleuze makes clear from the start that, for him, someone exhausted is not a tired person, that is to say, someone who is willing to rest in order to recover the strength to keep going, but on the contrary, someone who cannot go on any longer and for that reason turns his own state of collapse into the opportunity of reassessing the limits of any given convention. In this respect, the exhausted is not a passive agent who suffers from the alienation of a demanding situation, but an active one, capable of interrupting a set of conditions and creating new forms of engagement with reality. In this way, the oppositional character of the concept of exhaustion for Deleuze does not lie in its own capacity of interrupting a process, but in the actual potentiality of examining the way 'language states and names the possible'.[2]

In order to illustrate the differences between the tired and the exhausted, Deleuze refers to *Quad* and *Ghost Trio*, two plays written by Samuel Beckett for television in 1984 and 1975 respectively.

His first example is *Quad*. In this piece, the elements are simple: four characters (wrapped in cowls) occupy a quadrilateral empty space. The action simply consists of a series of combined movements driven by the actors who, following a strict choreography, traverse the small stage producing a repetitive outline that highlights the vertices of the space, while avoiding the centre. The obsessive choreography makes clear the play's intention: that of generating exhaustion by using up all possible combinations of movements made available by the space. In this sense, the piece 'exhausts itself in exhausting the possible and vice-versa.'[3]

His second example, *Ghost Trio,* is also concerned with space, and with exhausting its potentialities. For that, Beckett employs the strategy of fragmenting the stage into three elements: a door, a window and a pallet. From this division, a chain of close-ups generates a repetitive filmic passage from one element to the other, thus producing a strong dependency between all three elements. The fragmentation of the space in this piece is interpreted by Deleuze as a resistance against falling into the strict rules of representation by disconnecting the parts from the whole as a way of distinguishing and finding new connections. In fact, the strategy employed in *Ghost Trio* seems to break down the way plays were staged at the time for television: pretending as if the recording cameras were not there. Beckett's piece exploits the possibilities offered by both devices, theatre and television, questioning thus their own staging constraints and using this relational condition as a new potentiality.

Following the above, Deleuze's strategies for the exhausted should be considered more than a simple impulse to block an ongoing dynamics. The exhausted, as a method, consists in examining the procedures of production and representation that comprises any cultural practice. In this sense, the exhausted surpasses the act of saturating what is offered as possible on the cultural sphere, in order to reach a limit and thus renew the sphere's given conditions. In that respect, an exhausted approach could help to reassess any contemporary mechanism that may entrap a cultural practice.

To transpose this reflection onto the field of curating contemporary art exhibitions means to consider reassessing the conditions in which this practice operates. It is in this context that I would like to propose the idea of an 'exhausted curating'. An 'exhausted curating' should be about demanding a new dynamics capable of setting in motion an inner reflexivity of its working procedures as well as its public contexts. In other words, an 'exhausted curating' should be about acknowledging what is considered today to be possible within the field. Not unlike Deleuze's proposition for the exhausted, that is, someone who is caught by exhaustion is also able to exhaust its own exhaustion, an 'exhausted curating' should unravel its own exhaustion as a way of stimulating new possible forms of curatorial production.

To address the curatorial outside of the proper limits of curating entails expanding its privileged domain of visibility: the exhibition. In order to do so requires that a curatorial practice steps into other fields of knowledge and creates new possibilities for thinking the relationships between objects, bodies, subjects, politics and display.[4] At first sight, the distinction between curating and the curatorial could be as negligible as the tired and the exhausted, despite

the fact that the demand for this differentiation offers the opportunity to claim new commitments to the practice. However, in order to trigger the difference between both procedures, there should be a moment of disruption, a purposeful stoppage that intentionally alters the conventional flow of curating.

A similar logic can be recognized in the work of André Lepecki entitled *Exhausting Dance*, dedicated to formulating a new understanding of the work of some contemporary choreographers, namely, the question of the identity of dance as a being-in-flow.[5] Lepecki dedicates his study to examine how recent choreographic strategies exhaust the relationship between dance and movement and how this disruption represents an ontological turn within contemporary choreography. This exhaustion corresponds to the breakdown of a preconceived idea from early modernity that dance and movement are bound together and that, as a consequence, the body of the dancer is a total-being-into-movement. Lepecki acknowledges this association as a modern symptom, taking into consideration that the modern project is fundamentally kinetic. So the idea of exhausting the constituent element of dance means in fact directing a critique towards the production of a disciplined body that moves according to strict commands.

This idea might be difficult to imagine, but this is really an unavoidable requirement for allowing self-reflexivity in choreographic practice, which, as Lepecki argues, is really a form of betrayal. (Lepecki doesn't think this is a betrayal, but the majority of practitioners from contemporary choreography understand it as such.) So what about saying something like this: What seems to be an unavoidable requirement for allowing self-reflexivity in choreographic practice can be broadly understood not as a form of betrayal, but as disloyalty. Disloyalty provokes choreography to neglect movement as its major defining character in order to highlight its linguistic condition. In fact, it is this particular troubling disassociation that offers the opportunity to conceive 'the body not just as a self-contained and closed being, that follows directions within the choreography text, but as an active linguistic entity capable of setting up dynamic systems of exchange'.

The performance theorist Bojana Cvejić in her essay, *Learning by Making and Making by Learning How to Learn: Contemporary Choreography in Europe: When did Theory Reach Auto-Organisation?*[6] exposes the specific conditions for contemporary choreography within this exhausting logic. She introduces the transformations that contemporary choreography has gone through since the 1990s, when choreographic practices emancipated themselves from modern dance. For Cvejić, choreography's emancipation is promoted by the influence

received from the visual arts and from a deepening interest in the theory and philosophy that have influenced art production since the 1960s. However, for the theorist, choreography will actually gain autonomy through a direct speech act that proclaims this practice to be there where it was not expected to be. In her opinion, to state publicly 'this is choreography and this is not' implies a positive exercise that goes beyond the dialectical critique against the theatrical apparatus where supposedly dance and choreography are bound to happen. This means that Cvejić's approach tries to go beyond the mere logic of taking exhaustion as the critical strategy to help her substitute one representational regime for another. In this respect, her reflections distrust the type of negative critique that argues that something should be dismantled, namely the theatrical apparatus, the spectator or the movement of the performer. Moreover for the theorist, the promise of exhausting the old technologies in order to gain new ones should not be enough, at least, not if this does not redirect the critique into experimental and creative propositions capable of producing new conditions, practices, forms of work and life for contemporary choreography.

Learning from Cvejić's demands that choreographic practice should overtake the dialectical critique, it is interesting to envision the scope of possibilities that the strategies of exhaustion may offer. In choreography, this means not only to specifically undo the rules, gestures and behavioural protocols established for the stage, but also to allow for the awakening of a consciousness of the processes of subjectification that give shape to the subject involved in the practice.

André Lepecki in *Exhausting Dance* defends the argument of considering modernity as a form of subjectivity. For him, 'modernity's periodization would be predicated on identifying not a particular period, nor a particular geography, but processes of subjectification that produce and reproduce this particular form.'[7] In addition, to admit that modernity produces specific forms of subjectivity entails acknowledging the elements and proceedings that conform to it, for example, the way that subjectivity is entrapped within the solipsistic captivity of the individual subject. In fact, Lepecki asks in his book to concretely disassociate the term 'subjectivity' from the fixed notion of 'the subject'. For this, he puts the stress on understanding subjectivity as a dynamic concept, capable of generating modes of relationality, such as, for example, political, affective or choreographic. In other words, he proposes to conceive subjectivity as the possibility for life to be constantly invented and reinvented.

As is well known, the time frame of modernity is arbitrary and malleable. Raymond Williams, in his text *When was Modernism?*, introduces the notion of self-consciousness to the debate on the modern,[8] requesting us to pay attention to

a tendency that insists on the constant reassessment of the critique of modernity. In this work, Williams rejects anchoring the term 'modern' to a rigid period of time and the consequent fixing of modernism within the institutionalized cultural forms that have been conventionally agreed upon. In his own view, these forms 'quickly lost [their] anti-bourgeois stance, and achieved comfortable integration into the new international capitalism'.[9] For this reason, he refuses to fix modernity in order to regain its original critical force beyond the modern formal rhetoric. With this actual refusal of establishing a canonical time for modernism, Williams tries to reactive and resituate the forgotten aims of the modernist project, which was in fact driven by a fierce attempt to break down bourgeois forms of life.

A spatial manifestation crucial to modernism is the exhibition space. The white cube, this space where windows have been obliterated, walls whitened, floors polished and light sources placed on the ceiling, exemplifies the process of isolating art exhibition spaces from the outside world. This separation of the exhibition space has privileged the aesthetization of the formal qualities of life in its transference to the art object. However, as Brian O'Doherty suggests,[10] it is precisely the confinement of the exhibition space to that modern canon that is the actual trigger for the formation of a body of reflexivity around the work of art and its public exhibiting constraints. In fact, this is the context from which curating arose as a critical practice capable of projecting creative modes of exhibition making that in turn were able to contest the limits of that modern canonical space. In this respect, the debates and artistic practices that have taken place since the 1960s as a critical response to the white cube, struggle to break with that supposed neutrality.

In this way, the critique that has emerged since the irruption of the white cube should still claim a rupture with the bourgeois ideology implicit in the neutral form that shapes the white cube. However, the fact is that time and again, its qualities, whiteness and silence, attempt to erase the evolution of that struggle. Consequently, this constant erasure can be acknowledged as a true exhaustion of the actual possibilities of the practice of curating, an exhaustion that calls for a disruption in the aim of allowing new proceedings within the visual regime of the exhibition. This idea of envisioning a disruption within the practice of curating can perhaps now be stated under the notion of 'the curatorial'. However, it is worth situating the task of the curatorial within the need of transcending the dialectical critique towards its devices, in the same way that Bojana Cvejić has rightly asked of contemporary choreographic practices. In this sense, an 'exhausted curating' should make way for the curatorial as a creative disruption

within the procedures that constrain the artistic experience. This means that the artistic experience should imply a process of actualization of all those qualities of the work of art discarded by bourgeois rhetoric.

With this line of thought, it is perhaps interesting to recall again Deleuze's strategy of connection and disconnection proposed in *The Exhausted* with the example of Beckett's play *Ghost Trio*. It is indeed interesting to see how the philosopher claims a continuity of production beyond a discontinuous reality, as if he was proposing an inseparable alliance between continuing and disrupting. Thus, the exhausted may be the un-fitting subject who can no longer inhabit an a priori designed space. The exhausted is someone then that needs to reinvent life as an indissoluble way of thinking which confirms him or her as subject.

Notes

1 Gilles Deleuze, 'The Exhausted', in *Essays Critical and Clinical*, trans. Daniel W. Smith and Michael A. Greco (London: Verso, 1998), 152.
2 Deleuze, 'The Exhausted', 152–3 and 159.
3 Deleuze, 'The Exhausted', 152.
4 André Lepecki, *Exhausting Dance: Performance and the Politics of Movement* (London: Routledge, 2006), 5.
5 Lepecki, *Exhausting Dance*, 1.
6 Bojana Cvejić, 'Learning by Making and Making by Learning How to Learn', in *A.C.A.D.E.M.Y.,* ed. Angelika Nollert et al. (Frankfurt a M: Revolver, 2006), 193–7.
7 Lepecki, *Exhausting Dance,* 10.
8 Raymon Williams, 'When Was Modernism', in *Politics of Modernism: Against The New Conformists* (London: Verson, 2007), 31–5.
9 Williams, 'When Was Modernism', 35.
10 Brian O'Doherty, *Inside the White Cube: The Ideology of the Gallery Space* (Berkeley: University of California Press, 1999).

Eros, Plague, Olfaction: Three Allegories of the Curatorial

Jenny Doussan

Autistic doxology

If, as has been suggested, we use the term 'spectacle' for the extreme phase of capitalism in which we are now living, in which everything is exhibited in its separation from itself, the spectacle and consumption are two sides of a single impossibility of using. What cannot be used is, as such, given over to consumption or to spectacular exhibitions.

Giorgio Agamben[1]

In his essay 'Notes on Politics', Giorgio Agamben states, 'The plane of immanence on which the new political experience is constituted is the terminal expropriation of language carried out by the spectacular state.' Developing a sentiment expressed in a slightly earlier text, he advises that the task at hand is to seize the positive possibility within the conditions of living in the spectacular state – our newly acquired access to communicability in its spectacular expropriation as bare language – and use this possibility against it.[2] In its fusion with experience and visuality, language, *exposed* as a generic function in the service of the spectacle, equally reveals communicability itself in its separation from real acts of communication.

Agamben has more recently expressed this formula in an imagistic rather than linguistic lexicon with an embodied visuality that addresses these very same concerns of, to employ his later terminology, the capture of the spectacle's *apparatus*. In 'The Glorious Body', he articulates the spectacular in terms of the corporeal and questions whether, in the theologically grounded conception of

the resurrected soma, there can today be thought a 'different possible use' for the body. Rather than condemning the spectacular function of glory that separates the body's organs from their vital functions into an exhibition value, Agamben instead suggests a dualistic mode of glory:

> Just as in advertisements or pornography, where the simulacra of merchandise or bodies exalt their appeal precisely to the extent that they cannot be used, but only exhibited, so in the resurrection the idle sexual organs will display the potentiality, or the virtue, of procreation. The glorious body is an ostensive body whose functions are not executed but rather displayed. Glory, in this sense, is in solidarity with inoperativity.[3]

This separation of the potential body from the functioning body, however, only *permits* rather than *guarantees* a new use. Despite its formal identity with inoperativity, Agamben, echoing his claim some 15 years prior of the capture of the *sovereign ban*, alerts us to the danger of the liturgical sense of glory that 'does nothing other than incessantly capture inoperativity and displace it into the sphere of worship'.[4] Despite its liberation from instrumentality, this glorious body serves to invigorate the apparatus rather than enjoy itself in itself.

The *new use* that Agamben thus attempts to devise must exclude *instrumentality*. In this difficult formulation, not only must the new use of an entity – or in this case a body – differ from its prior functionality whose exhibition value is retained, it must itself be non-instrumental, 'not directed towards an end'. Likening the proposed new use of the 'naked, simple human body' to the 'illegible writing' of dance, he asserts, 'The glorious body is not some other body, more agile and beautiful, more luminous and spiritual; it is the body itself, at the moment when inoperativity removes the spell from it and opens it to a new possible common use.'[5] It would then seem that, locked in an inverted sequence, new use must always remain *potential* rather than *actual* to avoid the capture of the apparatus.

While Agamben insists that this new use must be 'common', it nonetheless tends towards self-gratification, his example of the glorious non-procreative genitals being a case in point. This inclination, evidenced elsewhere by his cryptic advocacy of the *happy life*, has led some to question the real difference between Agamben's thought and that of the 'contemporary democratic materialism' that he criticizes, accusing him of a 'dandyish semi-autism'.[6] Though his critique of instrumentality as the expropriation of means and evacuation of content in the capture of the apparatus may be the centrepiece of the programmatic aspect of his philosophy, it begs the question of how its deactivation could be universally

implemented, and why? Must we all become bulimics, deactivating the instrument of nourishment to render eating inoperative, exposing its exhibition value as pure means with the hope of putting it to new use?[7]

In this shift from the linguistic to the corporeal, Agamben seems not to have established any distinction of note between the two. Despite a more precise delineation of the exact mechanism of the apparatus and an exposition of its simultaneously emancipatory and annihilative double valence, there is ultimately little difference between the *homo sacer* and the *glorious body*, at least in terms of its status as a corporo-linguistic entity. This in itself is not grounds for criticism, but it does leave open the question of a properly corporeal embodied subjectivity. Is there a way to think an embodied subjectivity that is not ancillary to the spectacular, itself ancillary to the linguistic? Can this embodied subjectivity evade the prohibition of instrumentality that Agamben associates with the capture of the apparatus? Must exhibition and instrumentality forever be opposed?

The following three allegories challenge this very premise, and point towards the possibility for exhibition to not be bound by such strictures.

Eros: Sensual epistemology

During the drinking party of Plato's *Symposium* at which each guest must eulogize Eros, Socrates performs a restaging of his tutelage by the priestess Diotima from whom he claims to have learned everything he knows about love, utilizing her *maieutic* style of question and answer (derived from the word *maia* meaning 'midwife'), the pedagogical strategy for which he himself is renowned. Whereas the preceding speakers praised the heroic qualities of the god Eros in their encomiums, Diotima/Socrates quickly establishes that Eros, conceived of the drunken Resource and the opportunistic Poverty on the birthday of Aphrodite, is not a god but a *daemon*, the relation as such – the love *of*. More specifically, Eros is a *love of* the good, thus the lover desires to have the good in perpetuity.[8]

Not only does love disrupt the reductive opposition of beauty/ugliness – the desire for beauty is not ugly just as the love of the good does not make one bad – but it also indicates the structure between man and god that fills the gap between the earthly and the heavenly, welding together the universe into a single interconnected whole.[9] Eros' daemonic function between man and the gods is duplicated in his medial state between earth and heaven, and particular and general – the latter only accessible through the former. In perhaps the text's

most famous passage, Diotima/Socrates explains how Ideal Beauty is attained progressively, beginning with an appreciation of beautiful bodies. It is in a carefully guided procession through increasingly less individual experiences of beauty that one reaches its universal form:

> Like someone using a staircase, he should go from one to two and from two to all beautiful bodies, and from beautiful bodies to beautiful practices, and from practices to beautiful forms of learning. From forms of learning, he should end up at that form of learning which is of nothing other than *that* beauty itself, so that he can complete the process of learning what beauty really is.[10]

While the process of accessing the immaterial form of Beauty is incrementally less dependent on the individual body, the individual body nonetheless offers the crucial first glimpse of it. Likewise, the individual beautiful body is not separated from Ideal Beauty so much as in its ideal state Beauty is no longer restricted to a corporeal manifestation. The beautiful body may thus be understood as a *means to the end* of immortal Beauty, which then, in a pristine autonomy, illuminates everything beautiful.

As Diotima/Socrates instructs, however, Eros is 'a longing not for the beautiful itself, but for the conception and generation that the beautiful effects'. Indeed, while Ideal Beauty is the stuff of immortality, man's share in this Beauty is always limited by his corporeal mortality and his participation in Beauty takes place as its reproduction. Just as all creatures are compelled by erotic desire to achieve immortality through procreation, the erotic desire for Beauty compels humanity to 'give birth in beauty and in mind', expressed by Diotima/Socrates in bodily terms as pregnancy:

> Beauty is the goddess who, as Fate or Eileithyia, presides over childbirth. That's why, when a pregnant creature comes close to something beautiful, it becomes gentle and joyfully relaxed, and gives birth and reproduces. But, when it comes close to something ugly, it frowns and contracts in pain; it turns away and shrivels up and does not reproduce; it holds the foetus inside and is in discomfort. That's why those who are pregnant and already swollen get so excited about beauty: the bearer of beauty enables them to gain release from the pains of childbirth.[11]

Again, we encounter the necessity of the corporeal within the corporeal analogy; it is the 'bearer of beauty' that catalyses the reproductive process, the one aspect of our mortality in which the finite partakes in the eternal.

Diotima/Socrates forges an interesting union here between the corporeal and the spiritual with the incorporation of knowledge into the discourse on Eros,

coupling the procreation of the body with that of the mind to found a sensual epistemology. In a construction that resonates with not just the question of the mortal and the immortal but the parts and the whole, just as the cellular body is constantly dying and reproducing itself simultaneously, so is our knowledge. While one is said to be the same person throughout her/his life despite a constant material flux, attributes of the mind such as character traits, beliefs and fears undergo the same process without one's identity being called into doubt. How this function operates in terms of knowledge is through the process of forgetting and remembering, or anamnesis:

> Not only do some of the things we know increase, while some of them are lost, so that even in our knowledge we are not always the same, but the principle applies as well to every single branch of knowledge. When we say we are studying, we really mean that our knowledge is ebbing away. We forget, because our knowledge disappears, and we have to study so as to replace what we are losing, so that the state of our knowledge may seem, at any rate, to be the same as it was before. This is how every mortal creature perpetuates itself.[12]

Perhaps the most captivating element of the discourse is this point on the changeability of substance and the Ideal form, expressed as anamnesis. This construction of Diotima/Socrates/Plato permits a possession of the good through the fulfilment of desire, but this is not a terminal exertion that results in ossification. The resurrected knowledge is not limited to subsistence as an inoperative typology but, rather, embodies a new life as the fulfilment of that which it replaces, but only so far as it itself persists. Eros may be the means by which to access Ideal Beauty, but this process happens through a constant state of flux, a self-renewing vitality that transcends the Agambenian operation of a singular separation of the common into the sacred. Platonic Eros may thus be an instrumental use, but this instrumentality is a *labour of love*.

Plague: Affective contagion

By contrast, in the modernity of Antonin Artaud, the procreative 'freedom of life' manifest in Platonic Eros has long since vanished, replaced by the dark true freedom of the *libido*, 'which is identified with all that is dirty, abject, infamous in the process of living and of throwing oneself headlong with a natural and impure vigour, with a perpetually renewed strength, into life'. It is this invigorating

quality that Artaud attributes to plague, his metaphor for an essential theatre in the 1938 collection of writings, *The Theatre and Its Double*. The 'Double' that the title refers to is precisely this dark force of reality manifested by plague, as opposed to the hypocritical and vacuous quotidian reality.

A model for the theatre, plague is a primordial and authentic reality that interrupts the torpid everyday, 'shaking off the asphyxiating inertia of matter'.[13] Going to great lengths to describe plague's physical effects in which the 'crazed bodily fluids' seek exit from every orifice as the body putrefies, Artaud likens this experience to a volcanic eruption homologous with the historical circumstances in which plague occurs, such as political upheavals, deaths of kings and cataclysmic events. During an outbreak – the time of the plague – all social order disintegrates, a libidinal craze overcomes all and a 'frenetic gratuitousness' prevails.[14]

Dismissing any notion of contagion by contact, Artaud asserts that plague, disruptive on every front, is instead 'the direct instrument or materialization of an intelligent force in close contact with what we call fatality'. Indeed, plague bears a mysterious kinship to both destruction and sovereignty. The affliction, which Artaud characterizes as a 'psychic entity' rather than a virus, is a form of communication, and is in particularly close communion with the depraved and the despotic. Beyond the historical examples by which this phenomenon is demonstrated, Artaud points out that it is not merely the sovereign in name who communes with plague psychically; it is a sovereign gesture in itself to commune with the malady unscathed:

> No one can say why the plague strikes the coward who flees it and spares the degenerate who gratifies himself on the corpses. Why distance, chastity, solitude are helpless against the attacks of the scourge (. . .) From these peculiarities, these mysteries, these contradictions and these symptoms we must construct the spiritual physiognomy of a disease which progressively destroys the organism like a pain which, as it intensifies and deepens, multiplies its resources and means of access at every level of the sensibility.[15]

It is precisely the notion of a 'spiritual physiognomy' that defines the form of plague as a theatrical form. Artaud likens the plague victim to the actor; both are struck with the paroxysm of a spiritual force, but whereas the plague occurs in a state of 'physical disorganization', in the theatre this force is entirely *sensual*. Gratuitousness here is essential. He writes, 'The dregs of the population, apparently immunized by their frenzied greed, enter the open houses and pillage riches they know will serve no purpose or profit. And at

that moment theatre is born. The theatre, i.e., an immediate gratuitousness provoking acts without use or profit.[16] This gratuitousness infuses the form of the actor's inexhaustible fury that 'negates itself to just the degree it frees itself and dissolves into universality'. The contagion of plague is, in fact, *by example.* Artaud declares, 'If the essential theatre is like the plague, it is not because it is contagious, but because like the plague it is the revelation, the bringing forth, the exteriorization of a depth of latent cruelty by means of which all the perverse possibilities of the mind, whether of an individual or a people, are localized.'[17]

Plague is thus an affective contagion that is transmitted 'without rats, without microbes, and without contact', but, rather, actualized in *spectacle.*[18] This dematerialization from an individual sensibility to a collective universality is precisely how spectacle operates. As Artaud explains, 'Practically speaking, we want to resuscitate an idea of total spectacle by which the theatre would recover from the cinema, the music hall, the circus, and from life itself what has always belonged to it.'[19] Contrary to Agamben's post-Debordian understanding, however, Artaud's spectacle is not a spectral absence of signification or a disembodied glorious soma as image, but, rather, a total and collective embodied sensual experience, a corporo-spectacular subjectivity.

Though one may discern a certain empowerment in this taking hold of the spectacle, Artaud's philosophy is quite distinct from Agamben's formula of inoperativity. The spectacular plague/theatre populates rather than empties gestures:

> The plague takes images that are dormant, a latent disorder, and suddenly extends them into the most extreme gestures; the theatre also takes gestures and pushes them as far as they will go: like the plague it reforges the chain between what is and what is not, between the virtuality of the possible and what already exists in materialized nature. It recovers the notion of symbols and archetypes which act like silent blows, rests, leaps of the heart, summons of the lymph, inflammatory images thrust into our abruptly wakened heads.[20]

Unlike Agamben's typological gestures of the *commedia dell'arte*, 'subtracted from the powers of myth and destiny' in which 'the mask insinuates itself between text and execution', in Artaud's theatre, the masks fall away to reveal 'the lie, the slackness, baseness, and hypocrisy of our world'.[21] The gratuitousness of the corporo-spectacular subject in the throes of plague/theatre does not *permit* new use, it *is* new use. It is 'an intensive mobilization of objects, gestures, and signs, used in a new spirit'.[22]

Olfaction: Being sense

The sense of smell, once believed to be the organ of transmission of plague, is taken by the *philosophe* Étienne Bonnot de Condillac as the primary evidence for the sensual basis of the soul in his *Treatise on the Sensations* of 1754. Condillac advances a first philosophy of sensuality through the hypothesis of a statue to which each of the senses are added, one by one, beginning with scent, demonstrating that all aspects of cognitive capacity, including pleasure and pain, memory, comparison, judgement, imagination, desire and will can all be derived from the most primitive of the five senses.

While olfaction may be the ground for all cognitive function, it does not disclose any knowledge of being in extension. This is the very first premise of the *Treatise*, followed by the logical consequence of the unity between the sensing statue and the fragrance that it smells: 'If we give the statue a rose to smell, to us it is a statue smelling a rose, to itself it is smell of rose. (. . .) It cannot be anything else, since it is only susceptible to sensations.'[23] In this critical inquiry into the nature of human consciousness, cognition, therefore, is derived from sense, irrespective of knowledge of objects, and this bare cognition comprises a subjectivity immanent to its stimulus, a *being-sense* of olfaction.

Indeed, though the statue may have no idea of *matter* it nonetheless constitutes an ego that has *ideas* acquired through an incremental accumulation of experience *in time*, beginning with the faculty of attention from which memory and imagination are derived. This triad of cognitive activity engaged in olfaction provides the foundation for the embodied subjectivity manifest in the statue that recognizes temporal as much as material difference in its state of self. Describing the orginary fracture of attention, Condillac explains, 'When our statue is a new smell, it has still present that which it had been the moment before. Its capacity of feeling is divided between the memory and the smell. The first of this faculties is attentive to the past sensation, whilst the second is attentive to the present situation.'[24]

This temporal experience nonetheless bears a qualitative relationship to sensibility. Condillac asserts, 'Ignorant of any objects acting upon it, ignorant even of its own sense organ, it usually distinguishes memory of a sensation from a present sensation only insofar as it feels the one feebly, the other vividly.'[25] With the term 'usually', Condillac here underscores that this relationship is not fixed, and the sensations borne of memory can be, although not always, stronger than those of the present. This is where *imagination* comes into play. *Memory* recalls things past as past whereas *imagination* recalls things past as

present, wielding the force of recollection to 'arrest' the present and substitute for these sensations a feeling beyond the extended reality that it is unknowingly influenced by.[26]

Memory and its modal variant imagination are therefore the temporal and experiential ground for the generation of ideas. From this primary experience of time, which is essentially an experience of difference, the statue acquires an understanding of succession and duration as memory becomes 'habit'. Comparison and judgement follow, which in turn give rise to desire, preference and boredom in the statue's ability to recognize pleasure and pain. Through a process of self-recognition, the statue moves from the particular idea of its own pleasurable modification to the general idea of pleasure. Memory is thus a sequence of ideas that form a chain, a 'connection which furnishes the means of passing from one idea to another, and of recalling the most distant'.[27] This chain, though progressive, is nonetheless fluid thanks to the disruptive function of the imagination that reorders the ideas constructed from the comparisons made from the accumulation of experience into new sequences.[28]

Like its ideas, the statue's ego too is generated in temporal difference, though it is not restricted to a pure present. Condillac writes, 'Our statue being capable of memory, there is no smell which does not recall to it that it was once another smell. Herein lies its personality. If it is able to say "I" it can say it in all the states of its duration; and at each time its "I" will embrace all the moments of which it might have preserved recollection.'[29] Here and elsewhere, the *philosophe* reminds us, however, that the statue cannot differentiate itself from the extended world, and the statue is a strictly temporal individuation. Its subjectivity and cognitive function are entirely derived from its simple confrontation with time. Just as it cannot recognize the difference between imagining a sensation and having one, it cannot differentiate its own faculties as an active force from its total passive reception of the extended world. Indeed, the statue can only love itself, as 'the things which it loves are only its own modifications'.[30]

Is the embodied subjectivity of Condillac's smelling statue thus an example of a glorious body, or, rather, an autistic doxology? Quite simply, no. Though Condillac separates olfaction from the other sensual faculties, he does not separate it from its function. Olfaction is the instrument par excellence. Through its very instrumentality – its *being* instrumentality – olfaction hyperextends its sensual use to encompass all cognitive faculties. Further, though there is an emphasis on sensual *consciousness* in Condillac's treatise, the statue manifests a very particular *embodied* relation with matter in extension, despite the impossibility of its recognition. The statue *is* the scent of the rose; it is an olfactory *being-sense*.

This immanence mirrors that of Condillac's construction of the relation between body and soul. He writes,

> Pleasures and pains are of two kinds. The one kind belong more particularly to the body; they are sensible. The other kind are in the memory and in all the faculties of the soul; they are intellectual or spiritual. But it is a difference which the statue is incapable of noticing. This ignorance will guard it from an error which we have difficulty in avoiding: for these feelings do not differ as much as we imagine. Of a truth, they are all intellectual or spiritual, because, rightly understood, it is only the soul which feels. There is, indeed, a sense in which we can say they are all sensible or corporeal, because the body alone is their occasional cause.[31]

Operative play

If we can identify one thread that connects Platonic Eros, Artaud's plague, and Condillac's statue/rose, it is that they are all embodied subjectivities that are not reducible to Agamben's 'dandyish semi-autism' of the profane *happy life*, a merely introverted visuality that must dwell in the senselessness (or endlessness) of the stutter of signification, despite his arguments to the contrary. They are, rather, thought experiments in which the inoperative use of the pure passivity of Bartleby's body as its own tabula rasa is foregone for an active embodied cognitive experience. The body is not an image; it is a body. There is here no facile inversion of sensuality and cognition, profane and sacred, deactivation and instrumentality. Exhibition, and by extension curatorial strategies, need not be confined within an infinite sabbatical, means without end, palaver in a white cube. Inoperative use gives way to operative play.

Notes

1 Giorgio Agamben, *Profanations,* trans. Jeff Fort (New York: Zone Books, 2007), 82.
2 Giorgio Agamben, 'Notes on Politics' and 'Marginal Notes on *Commentaries on the Society of the Spectacle*', in *Means Without End*, trans. Vincenzo Binetti and Cesare Casarino (Minneapolis: University of Minnesota Press, 2000), 115, 84–5.
3 Giorgio Agamben, *Nudities*, trans. David Kishik and Stefan Pedatella (Stanford: Stanford University Press, 2009), 98.
4 Agamben, *Nudities*, 100.

5 Agamben, *Nudities*, 102–3.

6 Lorenzo Chiesa and Frank Ruda, 'The Event of Language as Force of Life: Agamben's Linguistic Vitalism', *Angelaki* 16, no. 3 (September 2011): 174.

7 See the chapter titled 'Hunger of an Ox: Considerations on the Sabbath, the Feast, and Inoperativity' in Agamben, *Nudities*, 104–12.

8 Plato, *Symposium*, 206a; trans. Christopher Gill (London: Penguin Books, 1999).

9 Plato, *Symposium*, 202a–203c.

10 Plato, *Symposium*, 211b–c; cited in Gill, 49.

11 Plato, *Symposium*, 206c–e; cited in Gill, 43–4.

12 Plato, *Symposium*, 207e–208a; cited in 'Symposium', trans. Michael Joyce, in Plato, *The Collected Dialogues Including the Letters*, ed. Edith Hamilton and Huntington Cairns (Princeton, NJ: Princeton University Press, 1973), 559–60.

13 Antonin Artaud, *The Theater and Its Double*, trans. Mary Caroline Richards (New York: Grove Press, 1958), 30–2.

14 Artaud, *Theater and Its Double*, 24–6.

15 Artaud, *Theater and Its Double*, 22–3.

16 Artaud, *Theater and Its Double*, 24–5.

17 Artaud, *Theater and Its Double*, 30.

18 Artaud, *Theater and Its Double*, 23–7.

19 Artaud, *Theater and Its Double*, 86.

20 Artaud, *Theater and Its Double*, 27.

21 Agamben, 'Marginal Notes', 79; Artaud, *Theater and Its Double*, 31.

22 Artaud, *Theater and Its Double*, 87.

23 Étienne Bonnot de Condillac, *Condillac's Treatise on the Sensations*, trans. Geraldine Carr (Los Angeles: University of Southern California School of Philosophy, 1930), 3. By contrast, Agamben's 'nose of the blessed' recognizes odour without any material stimulus; see Agamben, *Nudities*, 94.

24 Condillac, *Treatise on the Sensations*, 6.

25 Condillac, *Treatise on the Sensations*, 7.

26 Condillac, *Treatise on the Sensations*, 18.

27 Condillac, *Treatise on the Sensations*, 11.

28 Condillac, *Treatise on the Sensations*, 20.

29 Condillac, *Treatise on the Sensations*, 43.

30 Condillac, *Treatise on the Sensations*, 28.

31 Condillac, *Treatise on the Sensations*, 12.

Part III

Moves

The categories of 'empty' and 'floating' signifiers are structurally different. The first concerns the construction of a popular identity once the presence of a stable frontier is taken for granted; the second tries conceptually to apprehend the logic of the displacements of that frontier. In practice, however, the distance between the two is not that great. Both are hegemonic operations and, most importantly, the referents largely overlap. A situation where only the category of empty signifier was relevant, with total exclusion of the floating moment, would be one in which we would have an entirely immobile frontier – something that is hardly imaginable. Conversely, a purely psychotic universe is not thinkable either. So floating and empty signifiers should be conceived as partial dimensions – and so as analytically distinguishable – in any process of hegemonic construction.

Ernesto Laclau*

* Ernesto Laclau, 'Floating Signifiers and Social Heterogeneity', in *On Populist Reason* (London: Verso, 2005), 133.

10

The Task at Hand: Transcending the Clamp of Sovereignty

Ariella Azoulay

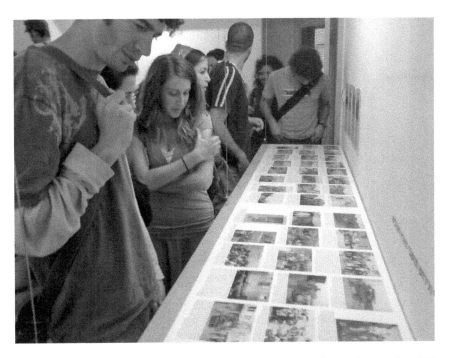

Figure 10.1 Presentation of the archive *From Palestine to Israel* at Zochrot Gallery, Tel Aviv, 2009, photo: Aim Deuelle Luski.

The archive 'From Palestine to Israel' includes 214 annotated photos classified in seven divisions. The archive was shown in Tel Aviv and London and was published as a book in Hebrew and later in English.[1] The photos record the violence and tragedy that led to the creation of the state of Israel. However, at the same time, they also show the unavoidability of the coexistence of Jews and Arabs

as actors in that violence thus transforming their relations and impacting their lives ever since. The challenge of the archive was to make these photographs, the documents of an incomplete past in a way that potential history could be written out of them. Here are the tools that shaped the process of curating this archive.

Rejecting the outcome of the partition fantasy imposed violently in 1947–50 and then appearing as a fait accompli, a law, the law of the sovereign nation state.

Refusing to participate in the violence required ever since to preserve the Israeli political regime and the monopoly of Israeli Jews over the power to shape political life in Israel/Palestine.

Historicizing the emergence of the national divide and acknowledging the violent, forced separation of Jews and Arabs in Palestine.

Transforming the violence involved in the partition of the local population as *governing* and *governed* into a civil obligation, a necessity, a precondition for the recovery of civil life.

Creating a photographic archive, a new 'surface of appearance' (in Michel Foucault's words) through which a new civil discourse emerges and through which a fantasy of a complete partition in a mixed land would always appear as a form of violence and oppression.

Reconstructing from the photographs the various mechanisms used to impose the 'national divide' on many other forms of Jewish-Arab relations and refusing to participate in them.

Shaping the archive as a civil archive – neither Jewish nor Palestinian – that enables us to account for the entire governed population and look at Jews and Arabs as parties to the violence that transformed their relations and has been inscribed in their lives ever since.

Using the medium of photography and the concept of citizenship in order to write history that would be free of the perspective of sovereign nationality, while placing this perspective itself as an object of study and understanding its role in representing and preserving the 'national conflict' as unavoidable.

Restoring, imagining and **inventing** seeds of possible futures where forgiveness can be asked and granted on the basis of a shared understanding of what is universally unbearable, that which should not be done, that which should never be violated.

Extracting from the past its unrealized possibilities as a necessary condition for imagining a different future.

דחייה של תוצאות פנטזיית חלוקת הארץ שנכפו על תושבי הארץ באלימות במרוצת השנים 1947–1950 ונעשו לעובדה מוגמרת, לחוק – החוק של מדינת-הלאום.

סירוב לקחת חלק באלימות הנהוגה מאז כדי לשמר את המשטר הישראלי והמונופול של ישראלים-יהודים על הכוח לעצב את החיים הפוליטיים בין הים לנהר.

היסטוריזציה של קו החלוקה הלאומי ושחזור של האלימות שנדרשה כדי לכפותו על האוכלוסייה המקומית.

טרנספורמציה של האלימות שכוננה את החוק הריבוני לחוק של הב-משותף (in common) תנאי מקדים לשיקום של חיים אזרחיים.

יצירה של ארכיון מצולם, 'מישור הופעה' (מושג פוקויאני) חדש שמבעדו יופיע שיח אזרחי שיקעקע כל פנטזייה לחלוקה של ארץ מעורבת.

שחזור מתצלומים של המכניזמים השונים שכפו את 'החלוקה הלאומית' על תצורות היחסים המורכבות בין יהודים לערבים.

אזרוח של הארכיונים – לא יהודים ולא פלסטינים – כך שניתן יהיה לשחזר מהם את האלימות המכוננת כמעצבת של יחסים שאותם יש לעצב מחדש כצורה של שותפות.

שימוש בצילום ובאזרחות כדי לכתוב היסטוריה שאינה כפופה לפרספקטיבה של הריבונות הלאומית, תוך הפיכת הפרספקטיבה הזו למושא מחקר והבנה של התפקיד שמילאה בהפיכת ה'קונפליקט הלאומי' לבלתי נמנע.

שחזור, דמיון והמצאה של זרעים של עתיד לפיו מתאפשרת סליחה כתהליך של בנייה מחודשת של שותפות תוך הבנייה של פשעי העבר כבלתי נסבלים, בלתי נסלחים, ומוכרים ככאלה באופן אוניברסאלי.

החייאה של תצורות חיים ושותפות – מרקמים עירוניים, סביבות של ידע הנושאים אפשרויות שלא מומשו ובאמצעותן יצירת רציפויות מורכבות בין עתיד לעבר.

نفيُ نتائج مُخيِّلَة تقسيم البلاد والتي فُرضت على سكان البلاد بالقوة في غضون الأعوام ١٩٤٧-١٩٥٠ وأعتبرت كحقيقة خالصة، كقانون – قانون الدولة القوميّة.

رفضُ المُشاركة في العنف الجاري منذ حينها للحفاظ على النظام الإسرائيليّ والإحتكار الإسرائيليّ-اليهوديّ للقوة من أجل تصميم الحياة السياسيّة ما بين البحر والنهر.

إقتفاء أثر النشوء التاريخيّ لحدود التقسيم القوميّة وإعادة بناء العنف الذي تم إستخدامهُ لفرض هذه الحدود على المجتمع المحليّ.

تحويل العُنف الذي وطّد القانون السيادي إلى قانون مُشترك، شرط مسبق لإصلاح الحياة المدنيّة.

إنتاج أرشيف مصوّر جديد، ''حقل التجليّات ' (Surface of appearances) وهو مصطلح لفوكو، يبرز من خلاله خطاب مدنيّ يُفكّك كل مُخيّلة مُرتبطة بتقسيم بلاد مختلطة.

إعادة بناء بواسطة الصور التقنيات المختلفة التي فرضت'التقسيم القوميّ'' على أنواع العلاقات المُركبة التي جمعت ما بين اليهود والعرب.

صياغة الأرشيف كأرشيف مدنيّ – ليس يهوديّ وليس فلسطينيّ – هكذا لنتمكن من إعادة بناء العنف المؤسسّ كمصمم للعلاقات، العلاقات التي يجب إعادة تصميمها كنموذج للشراكة.

إستعمال الصور والمواطنة لنكتب تاريخ ليس خاضع لوجهة النظر السياديّة القوميّة، من خلال تحويل وجهة النظر هذه لموضوع للبحث وفهم الدور الذي لعبته وجهة النظر هذه في تحويل ''الصراع القوميّ'' إلى صراع لا سبيل لإجتنابه.

إعادة بناء، تخيّل وإبتكار بذور المُستقبل والتي تُمكِّن من المُصالحة كسيرورة لبناء متجدد للشراكة بينما يتم تفسير جرائم الماضي على أنها غير مُحتملة، لا تُغتفر، ومعترف بها على هذا النحو على صعيد عالميّ.

إحياء لأشكال من الحياة والشراكة – أنسجة مدينيّة، أوساط من المعرفة والتي تحمل إمكانيات لم تتحقق وبواسطتها يمكن إنتاج إستمراريات مركبة بين الحاضر والماضي.

Note

1 Ariella Azoulay, *From Palestine to Israel: A Photographic Record of Destruction and State Formation, 1947–1950* (London: Pluto Press, 2011).

The Simple Operator

Sarah Pierce

Foreword

In autumn 2012, I joined the faculty at Bard College in upstate New York for one semester as an artist-in-residence at the Center for Curatorial Studies.

The invitation sparked memories of living in New York City in the 1990s when several of my friends left to attend respective MA curating courses offered by a handful of institutions internationally. At the time, curating was largely considered an administrative activity associated with making exhibitions in museums and arts organizations. We laughed: *why do curators need MAs in curating?* It was like imagining artists getting PhDs. Some curators had doctorates in art history. Some artists had MFAs. The MA in curating signalled a turning tide, not just in the field of curating, but in the ways that both curators and artists were beginning to understand the relationships between research, art-making and exhibition-making and how these fell outside or in between Art History's specialist knowledge and the media-specific specialization of Fine Art.

Fifteen years later there I was, an artist undertaking a PhD and teaching a group of MA-level curators.

The laughter had come full circle.

Now, I find myself speaking with others about the curatorial, writing when asked about the curatorial, and reading other people's writing about what the curatorial 'is' and what the curatorial 'is not'. I can't help wondering: how did we get here? How did we get to a place where the curatorial matters *so much*? Does it matter? How? To whom? Is the curatorial a condition? A device? Is it a field or subject? How does it claim certain conventions around curating, while also claiming that one operates *differently* through the curatorial? Are curators who are attentive or 'interested' in 'the curatorial' *different* to curators who aren't? Are they *better curators*?

As I wonder how we got here, of course, I am really asking: Is this where we want to be?

Over the past several years at Goldsmiths, despite myself, I vowed never to define the curatorial. I began not knowing what an investigation of the curatorial would produce. I sensed that it would not produce 'better curators'.[1] Cautiously regrouping along the way, the premise for an inquiry looked something like this:

a. The curatorial needs interrogation independently of curating;
b. The curatorial may or may not be a field of study or even a subject;
c. The curatorial is not a domain or a discipline where one can gain expertise;
d. The curatorial produces in different ways, including theoretical and material.

I'll now add:

e. The curatorial is qualitative; it is not inherently 'good'.

To illustrate these points, I've come to think of aspects of the curatorial that operate similarly to aspects of the word 'transparency'. I am not suggesting that they *mean* the same thing, or that the curatorial is 'like' transparency, yet it is useful to set up a momentary analogy between the two in order to understand how they function as terms, rhetorically, as descriptors and as conditions. One cannot become an expert in transparency. It may occur with or without intention, and levels of transparency run through different relationships, but only those relationships that have some degree of *publicness*. (We don't expect or desire transparency at all times, in all relationships.) Transparency operates within the limits of bureaucracy and institution. We come to understand it in relation to certain processes. And here is the crux of it: transparency implies an ethical dimension, but does not guarantee it. How acts are *read* is more crucial to the *claims* on which they stand. This is important to keep in mind when considering the curatorial, specifically so that we may begin to understand how critical operations of the curatorial hinge on *acts* that are public and plural, unpredictable and evolving.

We are in the middle of the curatorial. This is where I'd like to begin.

The rise up

In 'The Struggle with the Angel', Roland Barthes in speaking of beginnings, describes the 'rise up' as 'a simple operator' within a schema of sequences.[2]

Structurally, it can be understood quite quickly: it gestures the moment when 'discourse gets underway'. A beginning then, rather than presenting an origin, is a point where something is taken up.

A beginning then, more than marking a point in time or space (an origin), indicates a *process being brought into being*. Beginnings move – they shift *what is already* towards *what will become,* and this epistemological/existential agency connects beginnings to knowledge production. More than *what we know,* knowledge production is *how we know* – how we engage with knowledge. Understanding how engagements with knowledge production emerge as practice and how practice moves through and effects codes that order, at any given time, the procedures, methodologies, systems and institutions that bring knowledge into being, are central to understanding the curatorial.

Rather than thinking about the curatorial as behaviours that one can perform or occupy, or call for, or lay claim to, we can think of it more plainly, and more modestly, as a simple operator for a beginning.

Crossing over

The English edition of *The Order of Things* begins with Foucault asking, by way of hypothesis, what if empirical knowledge, with all of the speculations, distortions, old beliefs and practices, errors, naive notions, as well as genuine discoveries, obeyed 'the laws of a certain code of knowledge?'[3] Taking this premise as a basis for thinking about curatorial knowledge, that is, knowledge produced through an engagement with the curatorial, how might we account for all of the discursive layers in an exhibition that fall outside the intentions and designs set forth in word and deed by the curator? The point is not to inventory these layers as traceable 'events' within the curatorial, but rather to consider how we arrive at different, potentially radical articulations of knowledge (what Foucault might call a system of 'non-formal knowledge') that are not identifiable through, let alone attributable to the *act of curating.*

My immediate concern is to disengage the curatorial from the professional work of the curator. That is, to dissociate *the curatorial* from *curating.*

My reasons are partly tactical: First, it frees us from continually returning to discussions that define the curatorial through the systems and structures of curating *as they exist* (what might be considered 'curatorial conditions') and second, it moves the discussion away from 'curatorial work' – the methodologies, administrations, and activities enacted within the realm

(professional, institutional, intellectual) of the curator – towards ways of producing that do not involve (or include) a curator. Hence, the shift is also a deflection. It purposefully diverts from current preoccupations about *what curating is* and *whose work the curatorial refers to*, so that we may consider the realm of 'the curatorial' as something *other* than ordering codes and modes of being embroiled in curating.

Insofar as 'dissociation' (in psychiatry) implies a *functional* separation of normally related processes (leading to potentially extreme disorders), we can acknowledge that the curatorial 'normally' relates to curating. Let us say, for now, contiguity exists, and that is all.

The other

To begin, to 'rise up', often paradoxically implies an ending – a destination. In this paradox, because of it, we sometimes set up problems, things to address or achieve that help us 'see' where we are going – what Derrida might call the hegemony of a problematic – the disguised 're-centrings' that reassure us that we are on the right path.[4] So often, when we talk about the curatorial, we limit our discussion to the staging of exhibitions. What does it mean to have this end in mind? This limit or destination? Is the narrative of the curatorial bound to the end point of the exhibition?

What is the *object* of the curatorial?

Barthes identifies a point in Jacob's struggle with the angel when the primary goal or destiny of the story – to reach the safety of the river's other side – appears both dependent upon and frustrated by the lengthy diversion of a fight, where strangely, it is unclear who Jacob's 'opponent' is – God? Man? A stranger? The ambiguity of this moment captures its meaning: when circumscribing one's future, one encounters the other. And most importantly, this encounter is *part of the story*. Its ambiguity is the source of centuries of scholarly study. It is a diversion, a conflict that undoes the dominant narrative of the text, and – left unresolved/unresolveable – opens the text up, to use Barthes's words, to multiple interpretations.

An example of beginning

Las Meninas is a beginning. It is a beginning that starts in the middle. The painting serves as the frontispiece of *The Order of Things*, and is the subject of

its first chapter. An artwork, it arrives through an inherent *visuality*. Historical markers, resemblances, representations and gestures within the image convey a narrative – *what we know* about *Las Meninas*. On the level of *what we know*, our engagement is fairly passive. The artist is Diego Velázquez. The painting dates from 1656. The child in the foreground is the Infanta Margarita, and she stands amidst an assembly of figures, each traceable to a proper name that gives the scene a historical time and place – it is the court of King Philip IV. Velazquez, the court painter himself, occupies a place in the foreground to the left of the Infanta. Brush poised, from behind a large canvas – the reverse side is only partially visible – he looks at a spot outside the frame, where the Infanta also looks. With this collective gaze, the scene expands and a narrative comes into play. The artist is in the act of making an artwork; a mirror in the background reflects the recognizable forms of the king and his wife, Queen Margarita; figures have gathered to observe the king and queen as they have their portrait painted.

A scene expands – and on the level of *how we know,* our engagement with *Las Meninas* deepens. The visual construction of the painting is such that, even without access to the historical codes of representation that determine *Las Meninas* as a court painting, any viewer can navigate its sightlines and reason that the figures reflected in the back of the room are the subjects of the large canvas' other side. A conscious artifice of veilings and unveilings leads to a subject *outside the frame*. For Foucault, this artifice constitutes a sudden change in the way painting, as a discipline, previously organized the relationships between artwork and viewer, artist and subject. The artifice that leads us to a subject simultaneously displaces all subjects. The artist directs his gaze to a spot outside the canvas, and remarkably, our eyes meet. With the immediacy of this encounter, I enter a spectrum of others – other viewers, and other subjects. The king's authority over representation, over all 'subjects', disperses into multiple perspectives occupied by countless others.

Every gaze outward multiplies in return, and yet, 'No gaze is stable, or rather, in the neutral furrow of the gaze piercing at a right angle through the canvas, subject and object, the spectator and the model, reverse their roles to infinity.'[5] As we consider the large canvas before us, not the one that exists materially, but the one represented, we enter the instability of our role as 'viewers'. The ground of signification is no longer 'about' pictorial space, but involves the unstable ground of fluctuating human connections included in *Las Meninas*'s meaning. With this shift, the *visual* emerges as a new *episteme:* a way of engaging with knowledge production that carries the language of visual representation, yet is not exclusively about what is visible, observable, or even *representable*. The uncertainty that we

enter into through *Las Meninas* produces a visual 'knowledge' that carries with it a void, an 'other side', that is neither discoverable nor definitely established. *Las Meninas* is a beginning. It takes up other histories, other positions, other encounters *being brought into being*. And, radically, the cognitive traces of these successive forms of representation, what Foucault calls 'residuum', necessarily interrupt the content of what is happening at any given moment.

Naming

For Foucault, when we attempt to reconcile the theoretical and material differences that emerge between language and vision as ways of knowing, we risk losing that 'space where they achieve their splendour'.[6] Where language enters to 'explain' the visual, the visual 'cancels out' what is said. Foucault views this difficulty as a 'starting point for speech'. The theoretical and the material produce through dependencies, 'in an infinite relation', that which traverses inside and outside, the peripheral and the frontal, what is seen and what remains out-of-sight. It is not that words are insufficient or inadequate in the face of images. It is that our desire for a work of art to 'say' something locates that 'something' *within the image*. As soon as we name that something, we change it – that is to say, we make a decision to change, to mutate what is inside the frame.

The setting down

Barthes concludes 'The Struggle with the Angel' like this: 'The problem, the problem at least posed for me, is exactly to manage not to reduce the Text to a signified, whatever it may be (historical, economic, folkloristic or kerygmatic), but to hold its *signifiance* fully open'.[7]

In linguistics, *signifiance* is the emergence of meaning in the receiver. For Barthes (through Kristeva), *signifiance* holds a level of creative, transgressive meaning. How to keep the *signifiance* of the curatorial open at the very moment when we arrive at its meaning?

Returning to the idea of the curatorial as a simple operator for a beginning, perhaps we can think of the endpoint of the exhibition as a mere 'setting down'. It is a moment where one thing is let go and in letting go, it allows others to take it up. Hannah Arendt, who wrote eloquently about such activities that orient us towards a future, developed a concept of 'action' that consists of a similar setting

down and letting go. Action is when an individual puts something out into the world through speech or deed, and in doing so, cannot predict or determine how it will evolve. Arendt places emphasis not only on action's necessary *publicness*, but its unpredictability.[8] We venture to put our words and deeds into the world in recognition that someone else will take them up – misuse and reuse them, changing what *I* have done into something plural – and this unpredictable quality of action is also its community.

As the curatorial enters a lexicon of institutional practice, its meanings arise from beyond the work of curating that carries out a plan or produces an end product, beyond the person who curates and the potential methodologies and rethought institutional practices that bind the curatorial to individual 'acts' of curating. To think about radical formations of knowledge that occur through the curatorial is to undo its functional, structural relationship to curating – whether as a potential methodology or as a mode of operating – so that we might begin to address the curatorial as a political engagement, as it connects to knowledge production in ways that are neither good nor bad, but are unpredictable and difficult to manage.

In the language of the unconscious, what Barthes calls 'metonymic logic', the curatorial hides away in the background as we foreground all of the ideas and theories that appear to be moving us towards self-awareness and deeper understandings, when really, *really* our present study is a dissemination, not a truth.

Notes

1 Galit Eilat wisely offered this caveat in one of our very first group seminars in 2006: Our goal as researchers in Curatorial/Knowledge was not to become better curators.

2 Roland Barthes, 'The Struggle with the Angel: A Textual Analysis of Genesis 32: 22–32', in *Image Music Text*, trans. Stephen Heath (London: Fontana Press, 1977), 129.

3 Michel Foucault, *The Order of Things*, trans. Charles Ruas (London: Routledge, 2002), ix–x.

4 I have found the thinking of Jean Paul Martinon, especially his formulation of the curatorial in a seminar on Jacques Derrida's 'Send-Offs', extremely useful here.

5 Foucault, *The Order of Things*, 5.

6 Foucault, *The Order of Things*, 10.

7 Barthes, 'The Struggle with the Angel', 141.

8 See Hannah Arendt, *The Human Condition* (Chicago: University of Chicago Press, 1958), 175–246.

Three Short Takes on the Curatorial

Doreen Mende

Blinding

The curatorial takes place in the middle of a contradictory web of relations. How is one to think these contradictions while being implicated in them? A point of entry is perhaps the blind spot: It is a point on our retina where the optical nerve prevents the act of seeing. This physiological condition makes us all equal (everyone has a blind spot) and yet it also distinguishes us from each other (no two blind spots can be identical). The blind spot fractures the supposed unity of our subjectivities (suddenly, not everything is visible) and yet it activates our subjectivities through (visual) relations. This does not mean that the pairings 'you' and 'me', 'now' and 'then', or 'here' and 'elsewhere' cease to exist. This only means that the blind spot acts as an 'in-between' – an 'and' – that disturbs synchronous spatiality and temporality (not everything is in one place and time).

This blind spot is what throws us into the arena of the curatorial, this a-synchronous world full of ambivalences. While curating helps us to programme located public events, the blinding effect of the blind spot makes us enter a place (the curatorial) where we lose control and orientation because, as Jean-Luc Godard says,

> . . . an image is never an image, but a contradiction of images. And it's the same for a sound. Okay. We return to the just contradiction within the people, reflected in their representation. No, not representation, but presentation. Not a show, but a struggle.[1]

The blinding effect of the blind spot therefore goes against the activity of curating because it is a way of fracturing what is exhibited and this without

breaking or removing any object on show. This blinding effect is like a missing word, the black strip between the frames of a film, the white space between the letters in a text, the silence between the sounds of words or the immeasurable space that separates an action and the manifestation of that action. This blinding 'moment' cannot be reified, replaced, or represented because, in the moment of exposure, it escapes the creative action of exposing. It is a moment in which 'exhibiting' is not there yet, but is in the process of being constituted. In other words, this blinding 'moment' is the one that detects and disturbs the conditions in which 'meaning' emerges. Or to put it differently: While the blind spot is a point of entry into a contradictory set of relations, the blinding 'moment' is the danger that shatters the jurisdiction of meaning.

Inhibiting

For quite a few years now, I have been working with the term 'inhibiting'. This term functions neither as a model nor as a theme. I consider it a condition (or an enabling element) to rethink exhibiting. Its use is crucial because, for me, it helps to question the paradigm in Western culture of always shedding light on what is discovered, analysed and displayed. In other words, 'inhibiting' helps to question the predominance of light in exhibition practice. This questioning has a political dimension because 'inhibiting' helps to open up the relation between heterogeneous forms of practice and theoretical thinking and to unfold the possibilities of cultural differences. This does not pitch exhibiting against inhibiting; the two neither fight nor compete against each other; and they do not stand for their representational counterpart.

Exhibiting and 'inhibiting' exist through each other as a set of relays with different points of departure: In contrast to exhibiting, 'inhibiting' starts from a non-common ground, it has neither a common language nor a predetermined knowledge. It also has no history, properly speaking. When it comes to 'inhibiting', history exists in the form of an unsettled type of knowledge, slowly sedimented in bodies, a sedimentation that takes place without any form of articulation, archival or presentation in public institutions. When it comes to 'inhibiting', culture moves in a mazy geography of memories. In the field of the curatorial, 'inhibiting' disrupts the methodologies right when the exhibition reaches a significant point and begins to formulate a critique.

In this way, and in contrast to institutional critique (of the 1970s, for example) or the conceptual practice of analysis of the institution (in the 1990s, for example),

this approach to exhibiting via 'inhibiting' sabotages all those knowledges that give the impression of having been secured. It liberates us from the Western imperative to always shed light on things and it confronts us with the limits of our thinking, thus, with our own foreignness.

Symptom

When a piece of work has been successfully exhibited, it does so because, in the process, it manages to cover its 'origin' and to open up an endless stream of 'narratives to come'. As such, any interpretation of the work can only fail because it is effectively a symptom of the missing origin.

Sigmund Freud defined a symptom as the success of the process of repression. A symptom therefore insists to be interpreted and yet, at the same time, it resists any form of interpretation. In a way, a symptom is a bit like a concise description of a contemporary art exhibition, especially in the context of its economy. The market value of an artistic practice increases just when its aesthetic manifestation resists interpretation (its value renders it beyond interpretation) while, at the same time, insisting on being analysed (its value calls for an explanation). The symptom has a life: that of always reinventing the unexplainable origin that led it to become an event.

In the field of the curatorial, in which exposure is always at stake, the irreconcilable relation between 'origin' and the 'narrative to come' can be unfolded. However, instead of adopting the one-on-one model put forward by the discipline of psychoanalysis, the curatorial chooses a different model. In order to make sense of this, I would like to alter its space-time registers: When it comes to the curatorial, the analysis cannot look for the place of origin of the symptom. Instead, the symptom takes place when there is a transfer of a body of thought – into the future and into an unfamiliar space. The symptom happens through a practice of displacement. It takes place when the *topolitical*, as Jacques Derrida proposed in *Echographies of Television*, indicates that there is a transformation from 'origin' to 'arrival':

> . . . the border is no longer the border, images are coming and going through customs, the link between the political and the local, the *topolitical*, is as it were *dislocated*.[2]

The aim of the curatorial then is not to cure a symptom (finding the origin of what has been exposed, for example), but to highlight the *topolitical*, this shift

between origin and arrival or narrative to come. As such, the curatorial is what gives the possibility of making use not only of a potential, but also of the trauma and loss that takes place in displacement.

Notes

1 Jean-Luc Godard, *Le Gai Savoir*, Anouchka Films, 1968/9.
2 Jacques Derrida and Bernard Stiegler, *Echographies of Television: Jacques Derrida and Bernard Stiegler*, trans. Jennifer Bajorek (London: Polity Press, 2002), 57.

Aku menjadi saksi kepada – What I am Thinking

Roopesh Sitharan

Aku nak menjadi saksi kepada pemikiranku. Aku cuba mencatatkan apa yang aku saksikan. Aduhai, bilalah aku akan sedar? Aku asyik memandai nak berhujah tentang segala benda. Bila tiba masanya untuk serahkan bahan, pening kepala aku nak fikir – apa benda nak tulis dan sebut . . . sungguh malas aku nak cuba berlakon pandai dengan kata-kata yang asing bagiku. Aik, apa sebenarnya yang aku sedang lakukan? Dengan segala ketulusan dalam menulis, akanku terikut hakikat bertutur dan berfikir dalam bahasaku, sambil mengasingkan kebanyakkan pembaca teks ini. It now seems appropriate for me to switch to English . . . but what the heck? All of a sudden, I feel an immense burden: why do I ever convince myself to carry this burden over and over again – to emancipate my thoughts by means of engaging the other? The necessity to communicate whatever I am thinking (regardless of form) and convey what is running through my mind in language (English in this case). I am oscillating between Tamil, Malayalam and Malay to perform in English. I am so annoyed . . . and tired. Tired of constantly having to confine my unruly imaginations (thinking) in specific ways, bringing up what I want to say to whomever I want to speak.

Oh! How can I ever forget my personal violation of language by 'language'. Derrida's words come to haunt me once again.[1] Nothing is outside violence (or if I understand it correctly, language itself is violence). I concur! I submit! I give up! I surrender! But if it is going to be violence that renders me helpless while leaving me without escape, I might as well embrace, acknowledge and express this violence. I want to violate! I want to express violation! I want to practise doing violence in my writing! Nampak gaya aku kini berada di suatu posisi yang selesa (sedikit), atau lebih lena dari rasa resah disebabkan oleh

lingkungan bahasa yang aku guna untuk menjadi saksi pemikiran. Sekarang bolehlah aku menulis dengan suatu kesedaran, iaitu aku dengan sengajanya memilih untuk menulis dengan bahasa pilihan aku, semata-mata untuk mengungkitkan keganasan yang wujud dalam bahasa. Serba sedikit aku terasa bebas (atau kebas?), bukan dari lingkungan bahasa itu sendiri tetapi dari penerimaan secara membuta-tuli akan penggunaan satu jenis bahasa sebagai bahasa sejagat untuk umat manusia.

Of course, I am sure there is a sense of unknown but not loss (if you can acknowledge this as a 'text' in spite of not being able to comprehend all that I am writing) but I am explicitly violent in my writing. I am violent because I deliberately want to oscillate between languages, between Malay and English, between what you can 'make out' (for some) and what you 'can't' (for some), or even perhaps leaving it clueless (for others) for not being able to identify the markings (not recognizing the Latin alphabet in this case). I am adapting violence as a strategy. I am fluctuating between 'I' and 'other' (at certain moments in a text, you become the other to me and, at other times, I become the other to you). Now, I hope you see how I feel when I look at a text written in Spanish, French or in any other language. I know the words, I can make out how it sounds (I can smell the air, eat the food and live the experience) but it remains unfamiliar to me. The feeling of not knowing in spite of perceiving, not because I don't recognize the markings but because I can't articulate what it says. Is it empty? A vacuum is poking me! But nevertheless this is not new or unique to me; we both live with this sort of poking our entire life. When we engage, when we exchange, when we violate each other in space and time. Aku sudah lali dengan rasa keganasan ini, terutamanya berkenaan tentang bagaimana diri ditonjolkan kepada aku. Pening duduk memikirkan hal begini berjam-jam lamanya kekadang. Tak sudah mencari penyelesaian akan tetapi malangnya tiada kesudahan. Aku asyik resah dan lama-kelamaan lali dengan ketidaktentuan yang mejadi intipati diri sejak aku mengenal dunia. Aku dihantui oleh pelbagai klasifikasi sampai aku meragui diri aku ini . . . akan tetapi aku kini sedar bahawa keraguan itu adalah pemangkin untuk sesuatu yang lain. Ianya punca tenaga untuk pencarian saya. Pencarian diri disemak kalbu-dunia yang sentiasa memaparkan pelbagai tabir maya yang cuba menghindar diri dari mengenal dirinya.

Aku mengaku bahawa aku ada cara tersendiri untuk mengubati diri ini. Caranya bukan dengan mencari ubat untuk membendung keganasan terserlah dalam diri (melalui bahasa) tetapi dengan mengubah cara aku melihat dan menanya (menghadapi) cabaran malar ini. Persoalannya adalah apakah yang

dilakukan oleh keganasan ini terhadap diri dari cuba menghapuskan sepenuhnya elemen asas ini.

It's time to shift gear, to move on. It is a vicious loop when I think about it – nothing outside the violence of language thus leaving us no choice but to embrace and live with it, just as we all do – all the time. But I can't live with that, I want more and demand more. Not in a sense of asking for more violence, but in a sense of moving (along) with this poking of vacuum – a form of violence that I embody through this writing. It is a particular sort of doing that I am after, a sort of vacuum that becomes productive. That instigates questions of 'doing' rather than 'knowing'. An attempt to leap from 'who' to 'what', from 'identity' to 'subjectivity'. I want to perform a particular act of violence that allows some poking to coexist with my speaking. The oscillation of language in writing (that actualizes this vacuum) is the traction that sustains my doing. And I insist that this doing should (and could) only be performed and cannot be represented – from writing to doing.

Maka kini jelaslah rasanya apa yang aku cuba lakukan – dilengkapi dengan segala kecanggihan pemikiran. Payah juga nak mengekalkan vakum yang aku cuba laksanakan melalui kaedah penulisan ini. Aku hanya mampu melakukannya kerana mempunyai penguasaan kedua-dua bahasa yang aku gunakan untuk menulis. Tetapi jangan terpedaya, ini bukan suatu percubaan untuk menontonkan kefasihan bahasa melalui penulisan jamak begini. Bahasa adalah ganas . . . tidak kira apa jua bentuk, rupa dan penggunaannya. Adalah lebih berguna untuk aku (kita) memahami dan mengunakan keganasannya dari cuba menyampaikan suatu pemahaman atau ideologi melalui bahasa. Dah tepu kita sebagai manusia dengan segala bentuk ideologi – bermacam ragam, bentuk dan karenah tipu muslihat rasanya. I admit to making some deliberate decisions when I started writing this text. Violence is not exclusive to its method of performing. There are many ways to do it. I can let loose of the syntax and grammar requirements for (any) language that I use. I can see that it's in order. I could have chosen to write in Tamil and/or Malayalam (both use Brahmi Script) not that I know how to read and write in those languages in spite of being able to speak (my personal vacuum). I could even have chosen to sketch/scribble my performance. But I know . . . I intentionally wrote this as a strategic gesture for a meticulous method of performing violence. This is definitely not gibberish.

There is an effort from me to engage (not illustrate). I have my reasons. It is to perform the violence that would function as a vacuum (and violence can only emerge when I engage the other). To create a void that enforces (doing) – the act of sucking everything that is known to fill the void of unknown. I am performing

(vs doing) because I can read/write/speak both languages, but to those who can't, I am assured that the vacuum would press hard on them (doing). The urgency of knowing forces you to articulate the unknown while revealing the very limits of what you know. You struggle to read, make links, connect the dots and even create patterns. This is precisely what I want to force onto you . . . yes, you! The reader of my performance! You can make out the words, you can articulate the sound and you can even read it out loud but you will never know! If you don't know Malay, you simply can't! Just as I simply can't know you regardless how hard I try. Agaknya disini aku kena mengaku dengan penuh kejujuran, bahawa aku teringin sangat untuk bercantum dan membentuk kesatuan sejagat (manusia contohnya) – dikisar halus dan dicampur-gaul oleh pemahaman, pengetahuan ataupun pengajaran, malangnya aku tetap dibendung/diasing oleh hijab daging (keganasan) yang membentuk jasad dari bercampur dan bersatu dengan insan yang lain (selain dari diri sendiri). Aku bertekad untuk tidak melihat situasi ini sebagai suatu halangan tetapi sebagai pemangkin yang 'membolehkan' tindakan mengenal diri.

Tetapi janganlah pula mengganggap bahawa ini adalah satu lagi jenis pembacaan yang membawa pengetahuan yang berlainan. Aku tidak berhajat untuk mengajar atau menggambarkan pengetahuan, tetapi bertindak agar kejadian 'membolehkan' berlaku. Apa, bagaimana, dimana, adalah ditentukan oleh kamu – para pembaca . . . saya hanyalah semata-mata menulis agar pengetahuan yang wujud dengan enakmen keganasan (maksudnya bukan baca, lafaz, ulang) boleh dicipta dengan penulisan sebegini.

Enough of my rambling, I am well aware of the reason for my writing. After all, my text is part of a larger compilation of essays. I dread the idea of becoming part of a monolith of knowledge production. Somehow, I claim that knowing becomes knowledge (precisely because of language).[2] This is perhaps the monolith that has (is/will?) been practised. But I hope that with my performance I am hinting at some obvious loopholes. The usual covering up of the 'what' (doing) so as not to convey the actual event of knowledge is here reversed: to manifest/experience instead the actual event of the act of writing itself (or reading in your case). This manifestation/experience lies in sustaining the vacuum of not knowing; a vacuum that enables the working of knowledge in me (and you hopefully).

Adalah payah untuk membaca komponen bahasa Melayu sahaja, kerana aku dengan sengajanya membuat pautan tertentu dengan bahasa Inggeris. Tetapi harus juga aku jelaskan bahawa tujuan aku menulis begini bukannya untuk memudahkan pemahaman sebaliknya untuk tujuan yang amat bertentangan, iaitu untuk mencipta geseran yang membolehkan kesedaran pengetahuan.

What else could be more exemplary of this manifestation/experience than the curatorial? I have indeed come to believe that knowledge in the curatorial is not in what is represented but in the performance of curating that enables the 'doing' of knowledge (the manifestation/experience of the unknown as it is simultaneously being made known) regardless of what is represented or performed – be it by the curator, audience, artist, art object, exhibition, invigilator, etc. The vacuum becomes alive and intensified in the curatorial as the 'being made known' becomes the object of the whole enactment. In all honesty, I know I can never fully know regardless of how much I claim to know (of what I am curating) and not knowing is an essential part of knowledge. As I started this text, this becomes palpable to me when . . .

I am a witness to pemikiran aku.

Notes

1 Jacques Derrida, 'Violence and Metaphysics', in *Writing and Difference*, trans. Alan Bass (London: Routledge, 2001), 132.
2 Derrida, 'Violence and Metaphysics', 112–13.

Betrayal and the Curatorial – A Testimony for the Committee on the Curatorial

Joshua Simon

Madam Chairwoman, Committee Members, Colleagues, Co-Workers, Readers,

With your permission, I would like to address this Committee by first announcing the topic of this testimony. What is investigated here, what is put on trial here is judgement. As the curatorial is being debated and discussed in the pages of this book, questions arise about the authority of the curator, the authorship of the exhibition and more generally about the many ambiguous relationships that take place with regulated power structures inside and outside the world of art. These are all based on curating as a structure of judgement. And authority and judgement, Madam Chairwoman and honoured committee members, are the core operations of yours here, as well. With this in mind, I would like to propose here a term that will radically change the stakes, injecting curating – and by extension, the curatorial – with ethics, law, legality and violence. This term is Betrayal.

Curating can be seen as a structure of judgement because it is overall a practice of affirmation; it affirms above all the authority of the curator. With Betrayal, processes and paradigms of judgement are re-evaluated and debated. Betrayal is embedded within the structure of judgement. Betrayal troubles the affirmative model of curating, in which curators show things based on their authority and judgement. It becomes a form of criticality by which it locates us paradoxically both within a structure and against it.

The notion of Betrayal I bring forth here stems from my own practice and experience as a curator. This notion is not a term with which to describe events, but a term that acts on, locates within and drives through a set of relations. Betrayal calls for judgements to be questioned. It demands to act on the structures

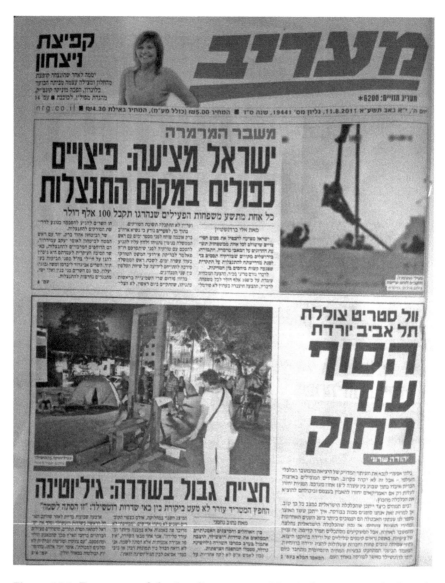

Figure 14.1 Front page of the Israeli newspaper *Maariv* featuring Ariel Kleiner's *Guillotine* installed on Rothschild Boulevard, Tel Aviv, 11 August 2011, photo: Shaxaf Haber.

of judgement: spectatorship and authorship, discourse and interpretation, duration and presence, representation and display, institution and meaning.

Furthermore, Betrayal is loyalty beyond protocols of allegiance. Betrayal goes beyond the given antagonisms that orient us in a given structure of meaning. It is an opening up of trajectories and relations by way of enabling new horizons

to appear. With these new horizons we reorient ourselves and the structure of meaning changes as well.

Let me give you an example that is clearly defined in space and time: the exhibition. The exhibition in a narrow sense is characterized by a suspended duration. With such a suspension, the exhibition conceptualizes singularities. It is a process through which a conceptual framework arises from specific instances. While there is the relative quality of the exhibition as narrative (I see one thing in this while you see another thing in it), there is also the relational nature of the event of the exhibition by which there are scripted and unscripted relations between the various authors of a piece, the worlds, spaces and contexts it connects to, the curated syntax and all that which the viewers bring forth. One way to understand the curatorial in relation to the exhibition can be found in the display itself.

With Betrayal the exploration of potentialities is actualized. In other words, with Betrayal running through the curatorial as a driving force, the displays actualize potentialities. Of course the meaning of an exhibition is never definite, neither is its authorship nor the web of meanings it carries and the readings it calls for. The exhibition, as a retinal and non-retinal viewing mechanism, in fact proposes a wide range of aesthetic experiences. But with Betrayal, the curatorial allows us to consider these displays as a moment and a movement that opens up new trajectories, horizons and traces and entail the potentiality for everything to be otherwise.

Betrayal turns action into acting in the sense that it makes apparent that there is a role that is being played and an actor who is in character; there is specificity and generalization, social role and social actor, presence and representation. This, in no way, should be seen as an encouragement to understand Betrayal as the act of pretending. Pretending would be too simplistic a claim: there is only one role, one actor, one specificity, one presence. With Betrayal, the curatorial enacts antagonisms scripted into the exhibition and goes beyond them to propose new potentialities.

This, Madam Chairwoman, demands some further elaboration in relation to politics and the political. As I understand it, we operate within politics, but the political has to be constantly invented, engineered and produced. The promise of politics is that it has the potential to constantly negotiate its inner-protocols, structures and paradigms. Yet politics has come to mean the opposite of daily life for the many. Especially under so-called democratic regimes, politics has become a narrow field of meaning, separate from life. We all know the common phrase 'don't go into politics' (as if one is not already in it in speech). Claude

Lefort's idea of modern democracies separating out politics from daily life, and therefore becoming prone to totalitarianism, provides a good explanation here. As politics moves towards the administration of society through policing, it has come to carry very little political meaning. Therefore, many political proposals that aim at dealing directly with politics find themselves to be articulated outside politics, seeking refuge elsewhere.

The curatorial is part of this 'elsewhere' of politics, that is this public-political sphere. As such, the curatorial carries a direct political potential. From nation-building to empowering communities or whitewashing financial crimes, curators operate on many different spheres. Yet, with the decline of politics as a political sphere, the curatorial finds itself hosting more and more projects that aim directly at politics. As the curatorial operates within a larger aesthetic economy of appearances, it ends up offering many projects that are realized not only as proposals, but also as politically effective projects in the realm of politics.

Through my practice, I found that the curatorial provides an exceptional framework from which to ignite not only the political dimension of a project, but also its potential as politics. With your permission, Madam Chairwoman, I will locate what I have been discussing thus far with regard to Betrayal and the curatorial. This will hopefully make clear my claim regarding Betrayal as loyalty beyond protocols of allegiance. Furthermore, as you may have already observed, the curatorial here embodies a much wider experience than the limited setting of the exhibition as a mere display of objects. In this way, my hope is also to better explain my idea that the curatorial actualizes potentialities.

Not unlike the archive, the curatorial is able to resurface forgotten histories against the logic of their hosting institutions. But the curatorial does so not so much as potential, but more as an actualization of potentialities, that is, as an opening up of potentials. For example, an exhibition might distort our history, chop it up for our enemy's interests and purposes, but they cannot devour it, they cannot appropriate this history as a whole and make it their own through archiving and display. By operating against the logic of its hosting institution, potentiality here presents itself through the exhibition, not as an alternative, but as a way of changing people's perception of their own history.

With your permission, Madam Chairwoman, I will give here an example from my own experience as curator of how an exhibited object enabled different articulations for potentials to emerge. The exhibition *The Rear* opened in late 2007. It was a show I was commissioned to curate for the First Herzliya Biennial of Contemporary Art. The exhibition included an open-air section in this

suburban city centre not far from the Herzliya Museum of Contemporary Art, part of the Metropolitan of Tel Aviv-Jaffa.

As part of this open-air section, we installed at a junction in the centre of the city a piece by the artist Ariel Kleiner. This piece consisted of a real-size guillotine. Kleiner was invited to develop and build this piece following the 2006 war against Lebanon. For him, as well as for myself at that time, the guillotine was installed as a symbol for the power of the people – a plasticization of the heritage of the French Revolution. At the time, we saw the display of the guillotine as a condemnation of a crazed regime that killed civilians indiscriminately. When we opened the show, we were ready for questions from city officials regarding the specific political gesture against the then regime, which the piece put forward right at the centre of the city.

The reaction was not what we expected. The city officials, as well as the general public, reacted excitedly at the presence of a replica of an ancient artefact. People were photographing themselves with the sculpture using their mobile phones. For them, it seems, the object did not invite a reconstruction of the rule of the people. It was merely a spectacle. Politically, it was akin to an archaeological exhibit. This is how it operated for them.

A few years later, Kleiner's guillotine was shown again. On 10 August 2011, three weeks into the biggest popular protests Israel had known, 120 encampments for social justice were set up around the country. We installed Kleiner's real-size guillotine on the first and biggest of these encampments, on Rothschild Boulevard in Tel Aviv. This time, his piece was installed in the middle of the encampment facing the head offices of the biggest banks in the country. Hours after it was installed on site, the guillotine was suddenly confiscated and taken by the police. The next day, images of the piece appeared on the front pages of all daily newspapers and was debated on TV and radio news shows. Israel's conversation scope on the media is narrow: no one protected the right for freedom of speech in relation to the guillotine and no one supported its proposal. Most commentators were alarmed by the fact that the piece had 'crossed the line', so to speak. The interesting thing here though, Madame Chairwoman, is that they all accepted the fact that it did something – it resonated with a symbolic violence.

The work of articulation made by the social justice movement in the weeks prior to installing the guillotine on Rothschild Boulevard contextualized the guillotine as a potential political proposal. What happened between 2007 and 2011 is that an object suddenly became an idea. From a historical point of view, it became actively political. But there were other things as well that appeared

through the actualization of potentiality here – suddenly the guillotine evoked something we knew we did not have – a revolutionary past. Although Israel does not have a revolutionary past, it was nonetheless formed as a carrier of social rights on the basis of eighteenth- and nineteenth-century nation states. The guillotine reminded Israelis that they were also citizens of a nation state. With all its crimes, and against the logic it operates upon, the state of Israel, through the silencing actions of its police, made us aware of the revolution we did not know we were part of.

This act of muting the piece informed the whole vocabulary around the proposition of the guillotine. Unlike physical violence, which seems for the movement to be counterproductive (especially under the conditions of hyper-violent state apparatuses), it was obvious that symbolic violence can be a powerful tool in the hands of the social justice movement. It highlighted the fact that the guillotine is a symbol and a device that belongs to the people. After decades of identity politics and privatization, the guillotine reinstalled judgement and authority in the hands of its rightful owners: the people.

Although things haven't changed overnight, the guillotine caused layers of sediments that were not available for us on the ground until then to surface. The guillotine mapped new trajectories that until then were not available to the social justice movement. The line that was crossed with the guillotine was the line of 'we, the people'. Legality and violence were plasticized in the guillotine as it restaged a set of structures of judgement – the tribunal, the constitution, citizenry and the revolution. It expanded the horizons of Israel's social justice movement. It articulated the promise of a republic for the first time. For now, this has not yet happened, and the state of Israel is still not a state for all its citizens. But the new horizon has charted a new perspective from which to operate.

Kleiner's guillotine superseded the protocols of allegiance that made it an art object and triggered an unattainable perspective, which its removal only amplified. This new perspective was the revolution we were already part of, but never had gone through. We in Israel did not originate from a revolution, we do not have it in our political heritage. Our notion of citizenship does not come from the fight for citizenry, for the construction of civil society. The state of Israel came first and it granted citizenship based on ethnic background – a state for the Jews. In this way, the guillotine became a form of loyalty towards the idea of citizenry, beyond the protocols of allegiance to the Israeli nation state. It constituted a loyalty to the republic *to come* – that of Jews and Arabs. The republic that was already born in the revolution we did not yet have.

Madam Chairwoman, Committee Members, Colleagues, Co-Workers, Readers: this testimony was given here not as an example of context and meaning, which merely makes it circumstantial evidence. It was brought here as part of my argument regarding the curatorial and judgement, also in relation to this forum, in the hope of establishing Betrayal as a paradigm that troubles the models of curating and judgement.

Part IV

Heresies

Adrift on this dawning chaos, I began to conceive a Warrior of the Imaginary. He is more clear-sighted than others, but only when it comes to the vision this clear-sightedness provides him. He envisions the battle plan. He projects his war onto the template of a folly, onto a stage where he acts against his ascribed role. He imposes himself the task of being a worker, shaker, infestation, inside scrambler, bulldozer, rebel, drifter, a loiterer outside oases, a sower of rotten seeds, a dodger of evidence, a diver of virtualities, a eulogist of the unknown – the end of certainties. He must doubt, abandon himself, and programme unrealistic ends amidst his own conditioning. And eventually, shadows will appear, slivers of light will turn into cluster stars, a celestial roof will be set in motion, all projections from the big-bang of dreams. Warrior of the Imaginary, you will never know when your spirit will be free from this projection. You will never know when you will have achieved the rainbow that animates you. You will continue – heretic – in order to invent other skies, without ends and without moralising tales.

The old warrior tells me: (. . .) Good, good, I finally recognize myself here!

<div align="right">Patrick Chamoiseau*</div>

*Patrick Chamoiseau, *Écrire en pays dominé* (Paris: Gallimard, 1997), 301–10. Translated here by Jean-Paul Martinon.

A Conspiracy without a Plot

Stefano Harney and Valentina Desideri

Today it is not possible to live except by way of a conspiracy. But equally, it is impossible to live today by way of a plot. To live now, to create modes of life, forms of life, we must seek a conspiracy without a plot, a conspiracy that is its own end, a conspiracy for itself. This conspiracy cannot produce a new person, a new world, a new subjectivity, a new consciousness. Much less can it conform to the plot of others, the plot of the police. This conspiracy can only produce more of itself, and those who enter into this conspiracy without a plot produce themselves through a kind of complicity that takes sides against any plot, any attempt to plot a path, a future for others or oneself. This conspiracy calls forth a complicit love, a love on the side of conspiracy and against the plot, against the police who are called into being by the plot. Complicit love, as Paolo Friere might say, is a love 'on the side' that knows which side it is on, a love for those who conspire, a love that calls forth the police for being against the plot, a love against the police and in the conspiracy.

And complicit love angles, as Gayatri Spivak might say, towards others without a plot. To have a complicit love is to be within and against any plot, even a plot of love or revolution. It is to feel the power of conspiracy. Complicity is the mode of living that makes us unsafe by unmaking ourselves with others, but it is the complicit love we find in conspiracy that makes us safe to unmake ourselves, to put ourselves in danger. And we are in danger. Because this conspiracy is not a secret; it is not connected to any hidden plot. It hides in plain sight, a conspiracy open to others, open to the world, unmade in complicity, made in complicit love. Its danger is the invocation, the caretaking, the study of complicity as an available, radical, sociality. This radical sociality is not just a matter of friendship, love, or conviviality, not of hyperconnectivity or logistics. No, this sociality is

an experiment conducted within and against ourselves, with and for others, a constant invention of the form of sociality, not its content, not its plot. This radical sociality is formed by the danger of being against society but together, in a conspiracy, of being against ourselves but filled with a complicit love for our unformed mode of living together.

Our complicity in this conspiracy is what makes the police rotten, as Walter Benjamin called them. The smell of this conspiracy attracts them. The police are drawn to the conviction that there must be someone else, something else, somewhere, somehow, involved, invoked, invaginated in the one in captivity, the one the police senses is more than one, less than one. Because the one who has been captured or sacrificed is somehow, through complicity, not fully caught, not fully contained, not fully containerized. This complicity provokes the rot, what Jacques Derrida calls the contamination of law. Driven insane, made vicious by this conspiracy without a plot, the police make new laws, on the spot, on the body, out of fear, out of paranoia, a paranoia that tells them 'there must be someone else, something else, somewhere, somehow'. Because the one caught is more and less than a captive one, more or less than one. There must be *la complicità*, the accomplice.

The accomplice

And there is. There is someone, something, who must be there, that must be there. If we are to live we must live in this conspiracy, as this conspiracy. The accomplice is the being who is not there and yet by being there makes us more and less of ourselves, unsafe, in danger. The accomplice is the one who guides us unseen, on the side. When we are alone in the cell, in meditation, in exile, in hiding, the accomplice guides us away from being only ourselves, being only one, he is the one who unmakes us as more than one, and guides us to live as other than one. And when we are together with others the accomplice guides us to be less than one, less than others, to be possessed by a dispossession, to give access, to give way and make a conspiracy that does not add up, does not count, is less than the sum of its parts, a conspiracy that can never be the whole conspiracy or the one conspiracy, a conspiracy that remains without a plot.

Although the accomplice guides us, he is a guide without direction, a guide without a plot and because he guides without direction he guides us into danger, not safety. It is an everyday danger made possible paradoxically by the complicit love the guide provides. We know from history, and from the inferno

only blocks away from us now, that to be less than one in the cell, on the streets, in the woods, in the bedroom, is to be subjected to violence by those with a plot, those who count themselves one, those who get together as one, one nation, one law, one race, those who count the police on their side, those the police count. And we also know from history, and as we know from the inferno miles away from us now, how dangerous it is to be more than one, how dangerous to convey that you are not just you, that there is someone else, something else, that you are with others not as yourself, and they are with you not as one. And even though this is a conspiracy without a plot, or perhaps precisely because it is, you will be shackled, goggled, muffled, droned, or renditioned cut off from others as if you were one, the one the police thought they had, the one the army thought led the plot. Or maybe this danger leads to the daily rendition, the daily beating administered to those who must be up to something, at risk of something, at war with some one. Those said by some one to be beyond reason, who need fixing but are beyond help, struck from the plot.

Or maybe again this danger will present itself through the worst of plots, the plot of all plots and no plots, the plot of an extreme neoliberalism that appears to be about nothing and everything, and makes and unmakes oneself and others, a violent making and unmaking, a violent drive towards value as the plot, the plot as value, a violent ownership and appropriation of every plot, of every one. What good is complicit love in the face of all of this, why let the accomplice put us in such danger?

After all, the accomplice is the one who got us into this, the one who by not showing up shows that we are not one, and puts us in such danger. The accomplice is the one who produces idle speculation, wild conspiracies, on what must be there, on who must be there, the accomplice has us seeing and hearing things. The accomplice shows up as another sense, a scent, a slender path, a trail, a fugitive trail. And this trail, the fugitive trail, cannot know its direction, cannot be plotted. It may be lit by a fugitive star, a fugitive fate, or it may be covered by a darkness, hidden in the neighbourhood of those said to have something wrong with them. But however it shows up, this trail guides us to fugitivity, to what Adrian Piper called an escape into the external world, an escape in plain sight, a conspiracy that uncovers itself. This is why we follow the accomplice on a trail without direction, because a fugitive trail goes nowhere, cannot be plotted, but can always be followed, always joined. For the fugitive trail, escape is its direction, its fugitivity is its destination and that means its destination, its direction of no direction, is the elastic distance, the undercommons.

The undercommons

And this is why for all the complicit love you can feel from the accomplice, the accomplice is also a thief, a liar, a fake, a maker of enemies, because the accomplice is herself a fugitive. If we were to find the accomplice, rather than just sense her, we would find her in the undercommons.

The undercommons is not the common. It is what emerges from the enclosure of the common, within and against enclosure. The undercommons is what always escapes settlement, but to nowhere. The fugivity of the undercommons is a matter of deception, misrecognition, faking, mocking, playing. It lies right in front of us, and all around us, and everyone is invited.

In any movement of enclosure, beings from the undercommons unsettle any attempt to occupy them, and persist in a pre-occupation that settlement needs and cannot abide, that escapes and surrounds the settlement in a conspiracy without a plot. The undercommons unsettles in the carnival of masks, of charcoaled faces and dumb insolence. The undercommons is not the common, though you can see it from there. And the undercommons is not the common because the idea of accessing the common, managing the common, or a politics of the common, is foreign to those of the undercommons. Their common is fugitive, hacked, within and against and with and for, full of made-up statistics, false reports, rumours of insurrection and plague. Their common is complicit, conspiratorial, on the run.

The undercommons is the practice of space and time that does not conform to the space and time of sovereign, self-possessed individuals or the states they plot. It is a place and time of beings who experiment with the borders and affects of being other than one, other than the one of the individual and other than the one of the collective. The undercommons is a place of performance, performativity, ensemble, and improvisation with the form of singular and collective life itself. But this performance includes also fakery, magic, fate and deception. Through such acts does a radical sociality emerge, a sociality without the safety sought in the self-determination of the one for the unity of the many. Any attempt to find such a safety is disrupted by what may turn out to be untrue, conjured, a matter of fugitive deception.

But because the undercommons is also where you find the accomplice, the love that must be missing, it is also a place of study, invocation and caretaking. It is a place to study this unforming and forming of modes of living, a place to take care of these modes and those who make them, a place to invoke the conditions of attention together. The undercommons is where you find these operations of

the accomplice. Yet this is study on the run, invocation in the dark, caretaking in a war. Because when the undercommons gets together, we not only make the time and space of caretaking, study, invocating new fugitive paths, new fugitive stars, but also the conditions and forms of radical sociality that bring reaction, that call forth the police.

The police

To study in the undercommons, to caretake in the undercommons, to invoke in the undercommons takes the form of making form itself, and to make form itself is to be open to affect in a way that is always vulnerable, always in need of the accomplice, always in danger. To be immersed in affect, to be so affected, dispossessed and possessed, is to be a maker of form as form emerges from the affect opened in the operations of the accomplice. To be affected to the point of making form itself, to be beyond predetermined form is in turn to be beyond self-determination, beyond the plot of the self, the one. And it is in these states of being affected that those of the undercommons are most vulnerable to the police, but more than that, they are also vulnerable to becoming the police.

Because the role of the police today is to organize such affect into a plot. The role of the police is to plot the course of affect itself. And they organize the affect of others, and of themselves, through the ubiquity of governance on the one hand and policy on the other. Through governance and policy, the police are now as Benjamin predicted, ubiquitous. Governance and policy are the forms of plotting, the forms of crushing conspiracies without a plot, that arise in reaction to the radical sociality of the undercommons today, that arise to confront directly the makers of form, to confront directly the circulation of affect and affected bodies in the undercommons.

It is not that the police do not continue to make law on the spot, as Benjamin observed, with the baton, with the command, with the referral. It is rather that today, this is not enough to ensure the plot, and perhaps it never was. Neither the violence of state nor the science of state, governance works below both government and governmentality. Governance tries to impose a plot on the affect produced by the conspiracy without a plot. Governance tries to plot those who stay affected, who stay not one, who live outside the plot. And precisely because for those in the conspiracy there is no plot, governance must play the good cop. The trick of governance is to ask for the plot, rather than imposing it

through violence or expertise. Governance lies in wait, clothes itself in affect, and asks what do you want, what are your interests, give us your voice, your input, tells us what you think, who you are, and then it offers us a cigarette and a cup of coffee.

But when those in the conspiracy without a plot resist volunteering a plot, when they love the accomplice, when complicit love holds them against the police who hold them, the good cop says, 'OK, then I will turn you loose'. This is a threat, not a gift. Because to be turned loose, turned out on the street, is to face the bad cop, the vigilante, the maker of policy. Because policy today is made by the vigilante, or rather policy today is the return of the vigilante, the return of the nightriders. Policy is the bad cop gone rogue, gone to join all those who are one and take it upon themselves to make policy for those in the conspiracy without a plot, those who, as Edouard Glissant said, consent not to be a single being, not to be one. Today, policy is detached from government, even from governmentality. It is rogue, an everyday terror. Anyone who is one can make policy from anywhere by the simple vigilante act of saying those beings over there have something wrong with them. Those beings are not one. Or this being here in my office, in my bed, at my table, in my yard, in my way, this being has something wrong with her and I take upon myself as one who is one to make a policy for her, to organize her affect, to cut her off from others, to make her one in my image.

Whether as the good cop of governance or the bad cop of policy, the police organize affect today, demand a plot where there is none and see conspiracies everywhere. This is why today the choice is so immediate, especially for those who are supposed to organize others. Today to be a teacher, a performer, or a curator, to be someone who is supposed to organize others is immediately to choose between being an accomplice and being the police.

But how can the teacher who is supposed to organize students, the performer who is supposed to organize audiences or the curator who is supposed to organize viewers, how can this function of organizing others not be, immediately, the police? The answer is that the accomplice operates as an organizer, but an organizer without a plot. Through study, invocation, care and operative modes, the accomplice insists and persists in conspiracy. These are only some of the operative modes of the accomplice, but they are modes that confront the police and confront being the police directly. These operative modes guide us away from the police on a fugitive path, a path that cannot be plotted. These operations of the accomplice elaborate modes of being with and for others, within and against any plot. And these modes call forth complicit love.

Study

The teacher is supposed to transfer knowledge, to set standards, to carry out assessments. The teacher is the one who is supposed to ensure students mature, get credit and graduate. The teacher is supposed to organize the desires, ambitions and dreams of the students. The teacher is supposed to be the police. So how can the teacher instead operate as an accomplice?

The teacher who is the accomplice is the one who makes study possible. Study is a complicit mode, a way of being other than one together. Study takes place within and against the university, the school, the academy. Study is what these places do not permit, and what persists within and against them. Study is what the teacher who is the accomplice does already with others. Study is learning on the side of others, for others. The teacher who operates in study provides complicit love, makes conspiracy possible for others in study.

And study is a form of learning, of seeking knowledge together that begins in the midst of itself and never ends. The accomplice is the one who helps others to see that study is already going on, that study has started and that study cannot finish. He helps others to sense that study is always immature, premature, dependent, indebted, affected. In study, knowledge is not just social but a way to make the social, not just collective but a way to experiment with collectivity itself, not just a debt to the past but an activation of debt as a way to enter the future together. Study is the debt knowledge makes without credit, without attribution, without graduation.

The operation of the teacher who is the accomplice is to guide others to knowledge not as something to be possessed, mastered or accredited. In study, seeking knowledge is a mode of learning that produces other ways of living together. The accomplice makes knowledge fugitive by using it to help others escape into new ways of living. For the accomplice knowledge is a fugitive path, a star that cannot be plotted in the sky, a conspiracy that learns without ends. The accomplice dwells in study and this is why he dwells in the undercommons, because only there is study possible.

From the undercommons the teacher, who is the accomplice, works within and against his classroom, studio, lecture hall. He will fake grades and steal from the institution. He will say that there is graduation, pretend there is credit, list references. And if the police were to enter the undercommons of the classroom to look for the teacher who is the accomplice, he might not necessarily be the one who is talking, but rather the one who is allowing others to study through a complicit love. This complicit love is ready to sabotage, to unsettle and create

danger whenever knowledge begins to be plotted, but this complicit love is also an open secret, an opening in study to a conspiracy that reveals itself to anyone who wishes to enter it with the guidance of the teacher who is an accomplice.

Invocation

The performance artist is supposed to start the rehearsal, organize the audience, begin the show. She is supposed to act out the plot, suspend disbelief and captivate attention. The performer promises a memorable event and a unique experience for the audience. How can she not be, immediately, the police? How can calling an audience to attention, how can the social rehearsal of attention characteristic of the performance, not take the form of governance, of organizing the affect of the audience into a plot?

Perhaps invocation is the mode of operation of the performance artist who is an accomplice, not the police. In the mode of invocation, the performance, the social rehearsal of attention, the plotting of attention, is disrupted. In invocation this disruption does not occur simply by substituting one form of attention for another. Rather in this operation of the accomplice, invocation disrupts the way attention itself is formed and experienced. Invocation focuses attention on what cannot yet be attended to. It conjures not another attention but the social conditions of attention in order to put these social conditions themselves in the category of the 'as if'.

By placing attention itself in question, by invoking that which cannot hold attention, be called to attention, that which stays at the level of intention, that which remains preliminary to plot, premature to plot, not inattentive but pre-attentive, invocation opens up the social making of attention itself to other uses, other experiments. This opening up is what makes radical sociality possible, a rehearsal of another way to make attention collectively, to attend together to another world. The accomplice disrupts not the attention to plotting but the plotting of attention itself. Invocation unforms attention to attend to the not yet seen, the not yet experienced, the not yet rehearsed. The invocation of the performance artist is the rehearsal of the conspiracy without a plot.

To enter this mode of operation, the performance artist uses intention to perform an invocation that keeps the plotting of attention at a distance. She sets the intention to disrupt the plot and this intention opens up the way for the invocation, the active production of a form that allows for a different rehearsal and performance of attention. Her intention is set within and against the plotting

of attention: by setting an intention she is within the plot, she gathers attention and puts herself in the midst of it, and yet her intention is to unplot attention.

But the accomplice does not only place herself within and against, she is also with and for the rehearsal of the conspiracy without a plot. In addition to staying with intention she invokes the making of attention through conjuring, fakery, or deception, ways of performing that block the plotting of attention. With these techniques, she invokes a belief without an object. She activates, opens and risks going against any plot of the senses, intelligences, languages or bodies gathered together to rehearse attention. Instead she dares to ask in public how attention might form without a plot, in conspiracy.

The performance artist who is an accomplice does not produce a different attention, she gathers attention differently. She builds with an audience a conspiracy of radical sociality, she gathers with them new forms of rehearsal, for new forms of attention, for conspiracy without a plot. This gathering is her complicit love.

Care

The curator too can find a mode of operation to make her an accomplice. Within and against the space she is supposed to make, the viewers, artists, buyers and sellers for whom she is supposed to make room, within and against the production of artworks, art markets, art worlds. The curator who is the accomplice is the one that operates through care, an ongoing care to make space, a caretaking of space that extends within and against the situation of the singular exhibitions or events, a space for the proliferation of art-making with others. The curator becomes the accomplice when she becomes a caretaker. The caretaker is the one who cares for a space, who inhabits it but on behalf of others, who works within and against the ownership of that space, the absentee landlord of the space. The curator, who is a caretaker, creates a space for making art, without knowing what art will be made. The caretaker makes something possible, makes more happen, in the space of art-making, through the care of that space, the care with which she fills that space, the care with which she quietly inhabits that space without owning it, lives in it without being at home in it, cultivates it without plotting what it produces.

The caretaker, the accomplice, makes a space safe for proliferating art-making not producing art. Art-making with others becomes a conspiracy without ever producing a work of art that makes a plot, a plot of art history, art trends, art

scenes. The police try to close down the space of art-making, the caretaker's space, when they smell a care without responsibility, a care without end, a care for the space and what can happen in it, what keeps happening in it, not a concern for what is produced. The police demand to know the plot, see the work, interview the artist, establish the reputation, pay the price. But the curator, who is the accomplice, keeps the space open with care, so that art starts to come from conspiracy to make conspiracy.

The caretaker makes a safe space for the complicity already at work in art and allows those who make art together to stay in complicity, to remain dangerous to themselves and each other. The curator who is the accomplice provides the care that allows others to stay in the complicity of making art together, as a form of ongoing conspiracy, rather than seeking the safety of being viewers and artists, of plotting art pieces and their display. She does this through a care that takes care without asking for anything, a care that refuses to take credit, a care that makes an art-making space of unpayable indebtedness. This care makes an unfinished space, an unfinishable space, a space not itself, not one, a space that can exist only in social time, the caretaker's time. And this care can be therefore an uncomfortable care, a care of those who do not quite belong, who have, but do not own, who love, but do not possess, who work, but do not finish, who are together, but not one. The curator becomes the accomplice when she helps to produce this uncomfortable care, a care that is dangerous, made together but open to anyone and anything, a beautiful care that enlivens attention, heightens sense till sense and meaning coincide. This is a care without responsibility, a care without guarantees, placed in danger.

This caretaking joins the caretaking already going on in these spaces, the caretakers already taking care, not by becoming valuable, valued, or valorized, but by making a care that forms value. This is a caretaking of a space for art-making as the making of social forms, of modes of making together that form value itself, that invent value as an experiment made in care, under the watch of the caretaker, the accomplice. Under this watch, art-making can suspend whatever value tries to plot, and invent a practice of valuing for itself, with others, a conspiracy of value for itself, in space of caretaking, in complicit love.

Complicit love

The condition for our entering into conspiracy, our forming of a conspiracy without a plot, is the complicity of life itself, the fact of complicity that so often

produces fear, plotting, the violence of the one and the many, the police. But the activation of this complicity is complicit love. When we act as the accomplice rather than the police, we activate complicity, we make complicit love. Here we have spoken only of three possible modes of operation of the accomplice, but of course there are more, many yet unknown.

Complicit love is a way of hearing things and seeing things others cannot yet hear or see, sense or touch. In these moments of sensation, of complicit love, the forms of the senses open up, and open up for others, with others. Complicit love makes it safe to open, to make and remake the senses for others, to enter the danger of not knowing where one sense ends and another begins, and where one's senses end and another's begin. Complicit love can do this because it is a love on the side. It is on the side, in both senses, on the side because it is so often out of sight, invisible, sensed, and on the side because it is for others in conspiracy and against the police, those who claim to be one, those who plot. It is a love against the enemies of a conspiracy without a plot. When, as accomplices, we make complicit love, we make it possible to live today.

What does a Question Do? Micropolitics and Art Education

Susan Kelly

Questions impose. They load the moment after the question is asked with significance. For this moment is almost always interpreted as a response, regardless of what the respondent says or does. Answering, remaining silent, changing the subject or walking away are all read as gestures or responses directed towards the question and the questioner. This charged moment after the asking of a question might explain why the right to remain silent is so important in law. For this right to insist on the meaninglessness of silence after a question is asked operates as a ban on interpretation. It is clear therefore that questions contain some kind of force, a force that must be regulated as it frames and inscribes the moment after it is asked so powerfully. The question clearly produces something – even if that something is nothing we can pin down. The fields of curating and education are filled with questions. It is nearly a cliché by now to state that one is more interested in posing questions, than in coming up with answers; to state that an exhibition acts as a proposition, not a solution; or that education aims to help students formulate their own questions, and not just fill their heads with inherited answers. But how do all of these questions operate, what is their force and how do these modes of operation produce different kinds of knowledge?

In science, when a question is answered or when a solution to the problem is found, the question becomes redundant. Likewise, in state politics and constitutional law, answers in the form of election polls or referendum results annul the question. By contrast, in philosophy, the claim is often made that questioning operates as a procedure that builds a way not only to a solution that would remove the question, but also to an altered and perhaps critical

relationship to the thing questioned. Heidegger argues that such procedures of philosophical questioning prepare a 'free relation' to the thing questioned.[1] Adorno speaks, however, of the difference between the weight of the question in science and in philosophy. Unlike in science he argues, 'philosophy knows no fixed sequence of question and answer. Its questions must be shaped by its experience, so as to catch up with the experience. Its answers are not given, not made, not generalised.'[2] Rather than simply act as a framework for discourse, a point of initiation for an enquiry or some kind of action, the question might be understood here as a force that organizes and brings into relation the categories of experience and knowledge. If we take Adorno's characterization of the question away from the discrete field of philosophy, and into the broader critical discourses that surround practices of art eduction and of curating, how do questions organize the relationships between experience and knowledge there? And can the experiences that shape these questions be understood simply as individual or as inherently social?

Over the last ten years or so, the art field has become increasingly interested in art education, pedagogy and the institution of the art school. For those who teach in art schools and try to shape the programmes and support the social spaces that make up these often turbulent institutions, it was interesting to try and figure out what it was that curators and critics wanted to learn from the art school, what questions they were asking in this 'educational turn'. In the interim, many papers have been given, conferences hosted, exhibitions curated, panels convened, seminars conducted, artworks constructed and projects made. Yet, in so many cases, the art school and questions of pedagogy were engaged with and performed as a discrete theme, another subject for the art world to play with, devour and regurgitate. Rarely, if ever, were the education departments in museums – many with fascinating radical roots in feminist politics and radical pedagogy – engaged with. And rarely did the debates engage with, reach or influence the internal discussions and battles within existing art schools and university art departments. Within those art schools, the everyday pressures and capitulations to intensifying regimes of managerialism, the total marketization of higher education and subsequent imposition of tripled student fees, meant that in most English art schools at least, these debates were unheard or deemed irrelevant. Discrete projects with students, talks, short courses here and there aside, the debate about the art school within the art world remained detached from both the micro- and macropolitical struggles taking place in these institutions of education. Not unlike many of the critical studies seminars that run alongside fine art programmes, the thematized discourses produced in the

art world were structurally and politically cut off from both the everyday realities and situated imaginaries of art education and from any kind of experience that might have re-formed the questions that were being asked there.

In a recent visit to London, the Argentinian group Colectivo Situaciones made some observations that produced a chill of recognition. They argued that increasingly within academic and broader public and political discourses, 'socially constructed questions are represented as "themes" before which we have to position ourselves'.[3] Questions are allocated and privatized to the research project of the proper name, coming into public existence as unique positions to be agreed with, disagreed with, modified and so on. For Colectivo Situaciones, one of the results of this tendency is that 'we are faced with a paradox today, where at the very moment in which political discourses proliferate, we assist in a progressive de-politicization of the social sphere and of language.'[4] In making these arguments, Colectivo Situaciones were not hankering after some authenticity of speech, but rather hinting at the ways in which the questions we ask are blocked and somehow cut off from the social fields and imaginaries within which they might take shape. They argue that there is an urgent need to navigate through this impasse where our questions and expression have 'ceased to imply an opening of collective imagination . . .'[5] In saying this, I do not think that *Colectivo Situaciones* are simply rehearsing a tired theory-practice debate which tends to either pitch those who 'think' against those who 'do', or perform a too-easy conflation of theory as practice, and practice as theory. Rather, they are pointing to the specific macro- and micropolitical techniques that manage, parse, fragment and block our discourses from having any broader social consequence today. For the separation of knowledge from experience, of content from consequence, seals these discourses off in what Paolo Virno has called a kind of 'publicness without a public sphere'.[6]

Much has been said by now about the macropolitical situation and struggles around university education in England.[7] Here, I will focus instead briefly on the micropolitical aspect of these struggles: the art school as a site of micropolitical conflict, where the collective questions that are constructed struggle to find a public form. After Suely Rolnik, Félix Guattari and Michel Foucault, I understand micropolitics as the psychic, affective and social processes associated with the production of subjectivity. Micropolitics can also describe the techniques of governance, discipline, and control, that produce and mobilize subjects for the macropolitical functioning of neoliberalism today. Félix Guattari reminds us of one of Foucault's central insights: 'Power isn't exercised on people who don't have it, it invests them and is transmitted by and through them, it exerts

pressure on them just as they in their struggle against it, resist the grip it has on them.'[8] Foucault proposes that all political transformations involve processes of subjectivation at their core, and that power should be understood as something that doesn't just come from above, but as something that is reproduced in and through our own bodies and lives. Maurizio Lazzarato, among others, argues that contemporary forms of neoliberal governance and regimes of cognitive capital have made the terrain of micropolitics ever more important to tackle. Taking the example of the schizophrenia produced in the subject through contemporary forms of labour and the mobilization of 'human capital', Lazzarato argues that the contemporary worker sells their labour (and so is exploited like everyone who is bound to a wage relation), but simultaneously becomes a shareholder in the thing that exploits them. He argues that we are at the same time exploited and *interested* in exploitation.[9] Complex techniques of governance and processes of individualization produce deep paradoxes and ambivalences within the subject. If we understand part of the task of educational institutions as the production of subjects for contemporary forms of labour, and if we understand educational processes more generally as laboratories for the production of knowledge and subjectivity, how do these schizophrenic processes become evident in the art school?

I will begin by briefly sharing some anecdotes from the art school. A few years back, an incoming first year calls me a week before term is due to start to ask if it is okay that she misses the first three weeks of her degree to intern for free at the Frieze Art Fair. Later the same year, a second-year student with one of the most thoughtful practices I have encountered tells me he hasn't done or made anything in months. Every time he has an idea or a starting point, he talks himself out of it on the grounds of a most elaborate array of theoretical, philosophical and practical grounds. His equivocation is fascinating, but he spends at least half of every year fighting this inertia and depression. Last year, during a round of mandated bureaucratic student feedback, I noticed lots of specific commentary on the academic courses students have taken ('could have had more copies of the books in the library', 'would have liked to read more Kant' and so on), but that apart from the usual complaints about the blocked studio sink, nothing much is ever questioned about studio practice teaching. I ask a student why that is, and she replies: 'well, our fine art studio work is just down to us really – it's our own fault if it isn't going well.' I suddenly feel that I am in a strange position of power that I did not ask for. Is this what 'student-centred learning' actually produces? The fantastic non-passive art student, filled with desire, intiative and curiosity is the same student who internalizes that absolute responsibility, the one that is

depressed and inert? The paradoxes that are embodied in these experiences of education – paradoxes that play on the promise of freedom and autonomy – are producing increasing and frightening levels of pressure and mental strain.

In *The Soul at Work*, Franco Berardi argues that depression is essentially a pathology of responsibility. Depressed individuals, he argues, are not up to the task, 'they are tired of having to become themselves'.[10] Depression can be understood therefore, not as a privatized illness or a personal failing of the subject who proves unsuccessful at becoming a highly functioning entrepreneur of him or herself, but rather as a form of contemporary knowledge. Seeing these experiences of self-reliance and cycles of depression as forms of knowledge is central to understanding the micropolitical functioning of educational institutions. As with the profound pressure, exhaustion and precarity experienced by many members of staff in such institutions, these cycles of inertia and depression tell us a great deal about insidious forms of governance at work there, and the ways in which power invests the production of subjectivity at these sites. It is crucial today more than ever to pay attention to and analyse the micropolitical dimensions of these institutions and the broader field of art education for any critical engagement to occur. It is crucial in these circumstances to produce a form of analysis that moves back and forth between theoretical knowledge understood through discrete themes and ideas, and a more situated analysis of everyday subjective experience. For such an analysis might make it possible to perceive and at least partially unravel the investments and desires that connect the production of subjectivity that takes place in processes of education, to broader institutional, intellectual, public and political struggles.

In their exploration of the limits of both academic research and militant activism, Colectivo Situaciones introduce the Spanish term *experiencia* taken from practices of radical pedagogy in Latin America in the 1970s. The term can encompass two words in English: first, 'experience' in the sense of an accumulation of knowledges; and second, 'experiment' understood as practice.[11] Bringing together knowledge/experience and experimentation in this way aims to halt the severing of knowledge as theme and insist on a much more specific set of connections and relays between knowledge and practice. This *experiencia* might involve pedagogical, institutional and structural experimentation of all kinds, linked to analysis that does not just look at what is said, but that takes up the forces that are at play in given situations in order to both trace and experiment with the subjective and affective conditions at work.

Crucially, this *experiencia* would also incite the constituent dimension of the question as exposed at the start of this essay. The notion of 'constituent power'

to which this constituent dimension of the question refers is often associated with the Latin root of the word power as *potencia*, the dynamic, constituting dimension of power, the power, force or strength to do something, as opposed to *poder*, the more static dimension of constituted power at work in dominant systems of political representation and government. The question as constituent force would become vulnerable to the unknown and to the complexity of contingent collective processes, subjects, situations and events. Far from the privatized individuated research project where questions often shore up and defend what has already been made, decided and agreed upon, the constituent question would experiment openly in the play of institutional and political forces that seek to manage, parse and block its power.

A constituent question about the relationship between art and education under conditions of intense neoliberal transformation would, for example, produce experiments and analyses in the midst of the messy sites of contestation in the university (occupations, open meetings and so on), rather than reiterate itself at yet another panel discussion on art and education in a neoliberal cultural institution charging £10 a seat.

Two possible politics of the question thus emerge: a politics of interpretation, the production of discrete themes that maintain discursive frames, subjectivities, political and institutional forces intact; or a politics of experience/experimentation, that incites subjective forces, intensities and paradoxes through practices that take up the problem of power at its complex site of production.

The constituent question produced through a politics of experience/experimentation would get involved in the play of forces in given situations, connecting knowledge to experience, content to consequence. Building force and capacity, these questions set to work in sites of contestation, refuse the de-politicization of discourse and the new regimes of neoliberal institutional subjectivation and governance. Instead, these questions compose *experiencias* where concepts acquire power, and where it becomes possible to shape new imaginaries, struggles and social fields.

Notes

1 Martin Heidegger, *Being and Time*, trans. John Macquarrie and Edward Robinson (Oxford: Blackwell, 1967), 16.
2 Theodor W. Adorno, *Negative Dialectics*, trans. E. B. Ashton (London: Routledge, 1990), 63.

3 Colectivo Situaciones, 'Disquiet in the Impasse', paper given at seminar
 Micropolitics Studies in Transversality I: Militant Research, Goldsmiths College,
 London, October 2009, trans. Mara Ferreri, Esther Gabara and Valeria Graziano.
 A version of this text can be found in Spanish in *Conversations on the Impasse:
 Political Dilemmas of the Present*, Buenos Aires: Tinta Limón, 2009, which is a
 dialogue between Colectivo Situaciones, Suely Rolnik, León Rozitchner, Sandro
 Mezzadra, Raquel Gutiérrez Aguilar, Peter Pál Pelbart, Santiago López Petit,
 Michael Hardt and Arturo Escobar.

4 Colectivo Situaciones, 'Disquiet in the Impasse', London, October 2009.

5 Colectivo Situaciones, 'Disquiet in the Impasse', London, October 2009.

6 Paolo Virno, *The Grammar of the Multitude: For an Analysis of Contemporary
 Forms of Life*, trans. Isabella Bertoletti, James Cascaito and Andrea Casson (Los
 Angeles: Semiotext(e), 2004), 40–2.

7 See for example, Des Freedman and Michael Baily, eds, *The Assault on Universities:
 A Manifesto for Resistance* (London: Pluto Press, 2011) or Stefan Collini, *What Are
 Universities For?* (London: Penguin, 2012).

8 Félix Guattari, 'The Guattari Reader', in *The Guattari Reader*, ed. Gary Genesko
 (Oxford: Blackwell, 1996), 177.

9 Erin Manning and Brian Massumi, 'Grasping the Political in the Event: Interview
 with Maurizio Lazzarato', *Inflexions* 3 (2009). www.senselab.ca/inflexions/ Accessed
 10 March 2012.

10 Franco 'Bifo' Berardi, *The Soul At Work: From Alienation to Autonomy*, trans.
 Francesca Cadel and Guiseppina Mecchia (Los Angeles, Semiotext(e), 2009), 23.

11 For a discussion of the translation and use of this term, see Nate Holdren and
 Sebastian Touza, 'Introduction to Colectivo Situaciones', in *Ephemera, Theory &
 Politics in Organization* 5, no. 4 (2005): 595–601. This term is also commonly used
 by practitioners of participatory action research.

Being Able to Do Something

Nora Sternfeld

Figure 17.1 *Not Doing Everything*, Poster, Buenos Aires, 2004 by the Argentinian collective etcetera, photo: etcetera.

A lot has been said about curating as embedded in relationships of power and knowledge. In the last few years, curatorial projects have increasingly been seen as discursive spaces with a potential to intervene in existing power relations. How can philosophical concepts support these practices? Along with some examples of post-structuralist conceptualizations, I would like to understand

curating with the help of deconstruction and in the aim of crossing powerful distinctions and changing what can be seen, done and said.

Under the title 'More on Power/Knowledge',[1] the postcolonial theorist Gayatri Spivak reads Foucault with Derrida and makes us understand that *savoir-pouvoir* – the two French words for power and knowledge – are not only powerful substantives, but also verbs. *Savoir* means 'knowing how to do something' and *pouvoir*, as a verb, means 'being able to'. As in the case of *savoir-vivre*, Spivak connects the two words, and it is exactly in this sense that she rereads Foucault's *savoir-pouvoir* as 'being able to do something'. Taking this into account opens for a perspective on curatorial agency: While in reflexive museology the 'exhibitionary complex' has been theorized along the lines of power and knowledge, I suggest, with Spivak, to think curating as a theoretical practice and practical theory that is about being able to do and to change something.

More concretely: Since the 1960s, representation has been confronted with increasing scepticism in the field of art (especially in institutional critique), in theory (especially in cultural studies, postcolonial and post-structuralist theories) and in activism (especially in the new post-identitarian social movements). New Museology has conceptualized the museum as a space of violence, economy, discipline and policing, among others. Representational critique became an important engine for conceptual artistic practices, curatorial approaches and activist reclamations. Let's think for example of all the artistic strategies of processualization, dematerialization and institutional critique, all of which are opposed to the representational mode. Now, some decades later, we can find them back into the representational, canonized and depoliticized museums of contemporary art worldwide. This institutionalization of institutional critique might be one of the reasons why the simplistic dichotomy of a 'bad representational inside' and a 'good anti-representational outside' has become untenable.

And it is exactly at this moment that Spivak's rereading becomes relevant: If we think curating beyond representation as 'being able to do something', then it involves processes that produce themselves – so it is no longer about exhibitions as sites for setting up valuable objects and representing objective values, but rather about spaces for curatorial action in which unexpected encounters and discourses become possible, in which taking a stand (as unplannable as this may be) seems more important than, say, precise hanging plans. Gerald Raunig describes this potential to act at the very heart of the nexus of power and knowledge as 'instituant practices'. He writes: 'What is

needed, therefore, are practices that conduct radical social criticism, yet which do not fancy themselves in an imagined distance to institutions; at the same time, practices that are self-critical and yet do not cling to their own involvement, their complicity, their imprisoned existence in the art field, their fixation on institutions and the institution, their own being-institution.[2] From this perspective, curating becomes a political and intellectual practice or, as Oliver Marchart referring to Antonio Gramsci puts it, an organic intellectual task of organizing.[3] As such, it is post-representational and post-dramatic: it is no longer about showing or representing something, but about ensuring that something can happen.[4]

Moreover, following James Clifford and Mary Louise Pratt, exhibitions can be understood as shared social spaces where different agents come together and act. This concept of the contact zone is based on contingency and processuality: It is a space of negotiation in which the meaning of words and things is not fixed but always open for discussion. Representation is replaced by process: Rather than dealing with objective values and valuable objects curating entails agency, unexpected encounters and discursive examinations. However, in collaborative discussions asymmetric relations between participants have to be taken into account. Thus, as Clifford points out, the aim should not be a 'give-and-take that could lead to a final meeting of minds, a coming together that would erase the discrepancies, the ongoing power imbalances of contact relations'.[5] Accordingly, post-representational curating creates spaces for negotiation, openly addressing contradictions within seemingly symmetrical relations. This also may involve conflict as Clifford speaks of the contact zone as a conflict zone. Both references show that critical curating as agency does not only become processual but is potentially conflictual.

A decided 'perhaps'

Marchart defines the curatorial function as 'the organization of conflict', taking into account the fact that antagonism cannot be organized.[6] So it would be definitely easy to think curating as able to create political situations. But how can curating then become a place in which something can happen? Maybe it can address contradictions and organize spaces of negotiation and action. For Jacques Derrida, the impossible is the condition of possibility of the possible. In the context of post-representative curating, this could suggest that there

is a dimension of agency in its very uncontrollability. Because when there is only space for the necessary, change is impossible. Thus Derrida integrates the 'perhaps' in his philosophical discourse:

> I will not say that this thought of the impossible possible, this other thinking of the possible is a thinking of necessity but rather, as I have also tried to demonstrate elsewhere, a thinking of the 'perhaps' that Nietzsche speaks of and that philosophy has always tried to subjugate. There is no future and no relation to the coming of the event without experience of the 'perhaps'.[7]

A question mark within

A question mark held up on a placard in a demonstration in Buenos Aires in 2004 marks contradictions in a double sense. As an act of disobedience expressing solidarity and as an urban-social performance the work transforms the side we take into a reflexive position. The question mark may be added to the demands of the demonstration and makes it incomplete and negotiable (the same effect is created by adding the name of the artists' group, etc. to any list of artists). However, the precondition for this form of reflexivity is the fact that the artists are right in the middle of the demonstration. This form of criticism and of questioning can only really be formulated 'in the thick' of the demonstration.

Contradictions are thus meant in a double sense: as forms of opposition against existing conditions and as reflexive discussions on the possibility of a critical position within discourses and institutions as well as within society at large. Let's call this, referring to Spivak's reading of Foucault, a position of critical agency.

Critical agency

Critical agency defies the dichotomy of 'good' and 'bad' and asks instead for 'the difference within' and what it could mean to still remain able to act. In this process, previously codified spaces of action suddenly open up: discourses and practices take on the apparatus of value-coding and forms of talking back emerge: contradictions against the existing power of interpretation.

The necessity of taking a stance politically and the attendant impossibility of knowing whether we are intellectually on the right side has a way of producing a

mode of impossibility with a qualifying 'perhaps', a temporal suspension that we have to assume, not as something arbitrary but as a constitutive component of the very act of making a decision. What consequences might such a concept as the 'decided perhaps' hold for curating? Derrida himself puts it this way: 'For if this impossible that I'm talking about were to arrive perhaps one day, I leave you to imagine the consequences. Take your time but be quick about it because you do not know what awaits you.'[8]

Notes

1 Gayatri Spivak, *Outside in The Teaching Machine* (London: Routledge, 1993), 34.

2 Gerald Raunig, 'Instituent Practices, Fleeing, Instituting, Transforming', in *Transversal Webjournal* 1 (2006). http://eipcp.net/transversal/0106/raunig/en Accessed 13 July 2012.

3 Oliver Marchart, 'The Curatorial Function, Organizing the Ex/position', in *Curating Critique*, ed. Dorothee Richter and Barnaby Drabble (Frankfurt am Main: Revolver, 2007), 164–70.

4 Currently I work together with the curators Luisa Ziaja and Nataša Petrešin-Bachelez and the political theorist Oliver Marchart on processes and strategies in art and politics after representation under the title 'What comes after the Show?'

5 James Clifford, *Routes: Travel, and Translation in the Late Twentieth Century* (Harvard: Harvard University Press, 1997), 193.

6 Marchart, 'The Curatorial Function, Organizing the Ex/position', 164–70.

7 Jacques Derrida, 'The Future of the Profession or the Unconditional University', in *Deconstructing Derrida*, ed. Peter Pericles Trifonas and Michael A. Peters, trans. Peggy Kamuf (London: Macmillan, 2005), 22.

8 Derrida, 'The Future of the Profession or the Unconditional University', 24.

The Politics of Residual Fun

Valeria Graziano

> It is this precedence of resistances that grounds the figure of the 'researcher-militant', whose quest is to carry out theoretical and practical work oriented to co-produce the knowledges and modes of an alternative sociability, beginning with the power (*potencia*) of those subaltern knowledges.
>
> Colectivo Situaciones[1]

Organizing situations, interventions, events or programmes is a frivolous task, but it bears high stakes. In perilous proximity with micromanagement and biogovernance, the micropolitical import of curating formats the way in which a specific kind of social cooperation – the kind that preoccupies itself with the making (up) of people[2] – gets moulded through specific institutions and circuits. I'd like to focus on this formatting aspect of artistic, educational, political or cultural occasions because, in lay analysis's term, and besides the specific occasion or topic they address, this is what they *do*: they intrinsically set up ambiences of sociability.

I don't mean to propose 'sociability' as the next keyword for anything here. Keywords stifle thought, rather than make it move forward. As with all abstractions, this concept can and will be used against you at the first opportunity. However, it is a term with an interesting history, as it has a tendency to resurface in discourses whenever there is a need or preoccupation with the forms, politics and possibilities of being together aside from necessities, coercions, contracts or mutualities of one sort or another.

The dictionary informs us that the use of sociability dates back to fifth-century France. Apparently, the first author credited to use this term is Charles Bonnet (1770), a Swiss Protestant philosopher who professed the view that 'man

is a sociable being, many of his main faculties have as their direct object Being in Society'.

The reference to the famous Thomas Aquinas sentence 'man is by nature a political, hence social, animal' ('*homo est naturaliter politicus, id est, socialis*') is obvious here. However, according to Hanna Arendt, Thomas Aquinas' version was also a mistranslation. To her, Aristotle's original citation ('Φύσει μέν ἐστιν ἄνθρωπος ζῷον πολιτικόν') actually meant: 'Man is by nature a political animal, despite being also a social one.' But perhaps this should not concern us too much, since as Michel Foucault said, man is no longer 'what he was for Aristotle: a living animal with the additional capacity for a political existence; modern man is an animal whose politics places his existence as a living being in question.'[3]

Since the 'social' is often invoked in cultural lingo to address the realm of the political in a softer manner (socially engaged practices, social intervention, social events, etc.) on the basis of this millenary blurred distinction between the two, to admit to the 'sociable' implication of cultural practices may be a healthy change of register. A first reason for this is that the plane of sociability is not the same as the plane of the political. Eugene Fournière, a French socialist affiliated with the International League for Rational Education, argued that the social growth towards a more just society includes three aspects: a political plane, striving towards democracy; an economic plane, striving towards communism; and a cultural plane, striving towards sociability.[4] Although we can disagree with the reformism of Fournière, the ingredients he signals seem to orient many progressive political and cultural initiatives today. However, while being sociable is not the same as being political, different kinds of sociability entail different kinds of politics.

It does not matter if the 'event' to curate is a festival or a programme, an exhibition or a series, a retrospective or a workshop, an intervention or a master class. It does not matter what the topic, the subject, the trope, the matter of concern or the proposal in the application is. And never mind the duration, as long as there is an open bar. Or better, all of these things matter a lot, along with many other conditions of production, valorization, sustainability, circulation, outcome and evaluation. But all of these things can *matter* – meaning they can literally become materially actualized – because they happen in a degree of autonomy from the habitual patterns of production and social reproduction. People engage with cultural stuff in their spare time (whatever that means, it is usually unpaid), and this posits an extremely serious set of problems about what should happen there.

The art of conversation

Sociability first enters theory through the work of two German theorists: Friedrich D. E. Schleiermacher and Georg Simmel. Despite writing almost a century apart, the two authors conceived sociability (*Geselligkeit*) in a surprisingly similar way. Sociability allowed them both to address a modality of being with others that could be seen as an alternative to the limited relations afforded by domestic and professional life, two spheres that they found socially unsatisfactory, since they allowed interactions only with limited numbers of people, burdened by sets of predetermined roles. Instead, sociability is the 'play form' of society, describing the ethical capacity of being enticed by the condition of being-in-common and to experience the pleasure of the 'interacting interdependence of individuals'.[5] Both authors agreed that sociability is thus the condition for, but also the object of, all social action. In sociable situations, we can acquaint ourselves with a variety of forms of life and their 'peculiarities', free from the necessity to follow precise rules, we can be our own legislators and play a 'social game' of interaction based completely upon our 'personalities', since 'no determinate activity has to be collectively executed, no oeuvre has to be realized in common, no knowledge has to be methodically acquired'.[6] The playful form of sociability offers a world 'in which a democracy of equals is possible without friction' – 'an artificial world, made up of beings who have renounced both the objective and the purely personal features of the intensity and extensiveness of life'.[7]

So far, all nice and good. But what kind of actually lived situations are we supposed to envision when thinking about this concept of sociable conduct? What practices are able to conjure up the idea of sociability?

Even though both Schleiermacher and Simmel spoke at the level of abstract speculation, looking for universal rules that could capture the subtle equilibrium that can preserve sociable encounters, their thought had to be based on much more quotidian and actual lived experiences, and it may be worthwhile here to look at what they actually did when they wanted to practise sociability.

Schleiermacher was an active member of the Jena circle, where he collaborated in the collective project (promoted by Friedrich Schlegel) of the famous romantic journal *Athenaeum*. The Romantics used the formula of the salon, regular meetings populated by chosen intellectuals (particularly popular and important to the Romantic movement were the ones hosted by Rahel Varnhagen and Henriette Herz in Berlin and other German cities), to promote their vision and values, and to practise what Schlegel called interestingly *Symphilosophie* and *Sympoesie*: 'philosophising and composing poetry together'.[8]

As for Simmel, Margarete Susman reported that he and his wife Gertrude, a philosopher herself, hosted weekly meetings at their house in Berlin. These 'cultivated gatherings' saw the participation of the likes of Rainer Maria Rilke, Henri Bergson, Marianne and Max Weber, Stefan George and Lou von Salomè. Marianne Weber wrote that Simmel 'won everyone's heart not only with his exceptional conversational skills but also with his kindness, warmth and genuine humanity'.[9]

Although centuries apart, the sociable ambiences experienced by Schleiermacher and Simmel appear strikingly similar. They were private meetings with a public character, to which only certain selected individuals would be invited, individuals who were regarded as exceptionally talented and/or cultured. The form of 'pure interaction' in both circumstances consisted actually of 'conversation', which Simmel declared to be 'the most extensive instrument of all human common life'. And if there were no legislators, certainly the rules of upper-class etiquette delimited the range of behaviours of participants. Conversation and manners are two elements that connect the aristocratic salon of Schleiermacher's times to the bourgeois intellectual circle of Simmel's era.

The salon was the social ritual par excellence of the European aristocracy prior to the French Revolution, and it continued to exist (although with a different social function) until the 1830s. While historians agree that the salon 'contributed to the creation of a quasi-public sphere by cultivating the expression of political opinions and philosophical discussion that were, inevitably before 1789, generally critical of the monarchy and the church',[10] this sociable ambience also maintained many conservative and elitist traits.

For instance, while the central figure of the salon was often a woman, a *salonniere*, whose task was to preside over the unfolding of harmonious, congenial, philosophical conversations among a mixture of respectable men (old and new rich) of the high society, her role was not that of a feminist in any way: the presence of the salon mistress usually ensured the appropriate kind of behaviour on the part of men, who would, for instance, feel an obligation to smooth the rough edges of political discussions. *Not in front of the ladies!* appears to have been the motto.

Accompanying the rise of the bourgeois middle classes, and in the wake of the liberal French Revolution and the diffusion of the printing press across the continent, the circle and the café (such as the Café du Commerce) came to replace the salon as *the place to be*. The key technology of this newfound sociability was the newspaper; the communal reading and commenting of the news was one of most typical activities at the circle, alongside moderate drinking, playing of card games,

betting, talking and smoking. At that time, 'the layers of sociability' began to shift and to correspond not only 'to social levels, but also to cultural ones'[11]: you had *to be good* to be invited to join the club, never mind the fact that those who could be any good were usually those who lived off rent or had a clerical employment (as one must have time to take part to the circle's activity and read the news).

Despite their many differences – the salon was characterized by 'tradition, familial space, diversity, morality, [the] non-political'; the circle by 'innovation, extra-familial space, masculine exclusivity, suspect morality, risk of politics'[12] – the ambiences of sociability of the European upper classes, liberal at best, remain consistently ambiences for conversations. This is peculiar and worthy of attention, as these people actually did have able bodies but they preferred to do things *with words*: a specific modality of co-presence, a specific relationship with the world that implies the presence of other kinds of actors who could be trusted to carry out whatever was discussed in the parlour: as this very name proclaims, the egalitarian or agonistic sociability of the 'circle' delimits a discreet space where the most classical division of labour gets actualized: the division between planners (inside the circumference) and executioners (outside).

Furthermore, it is a specific body that participates in these conversations. It is an abstract body made of properties and based on propriety. In the words of David Graeber: 'The logic of setting an abstract being apart necessarily involves setting it off against something; in practice, that always seems to mean creating a residual category of people – if not some racial or ethnic category, then workers, the poor, losers in the economic game – who are seen as chaotic, corporeal, animalistic, dangerous.'[13]

Technologies of fun

The aspect of 'civilization' that is most hostile to festivity is not capitalism or industrialism – both of which are fairly recent innovations – but social hierarchy, which is far more ancient.[14]

Baby: Who's that?

Neil Kellerman: Oh, them. They're the dance people. They're here to keep the, uh, guests happy.[15]

While they did not get invited to the dinner table, these residual categories of people have been in fact busy self-organizing their own modalities of sociable

interactions. Alongside the history of salons and circles, with their conversations, etiquette and selection at the door, runs a parallel genealogy of forms of co-presence based on the capacities of bodies to affect each other through senses and derive sense from it. This lineage runs from the archetypal rhythmic dances of prehistoric human groups, through the ecstatic religious rituals of ancient civilizations, taking us to the famously subversive exuberance of European medieval carnivals and the musical celebrations of slaves and colonized populations, all the way to contemporary social movements. All these feasts involve language as only one of the available technologies, alongside collective dancing, music, singing, eating and drinking, using drugs and other substances that alter the state of consciousness, masking, costuming and inventing new personae, playing games, mocking and fooling around. Often they have been called the mob, rather than the more dignified multitude. It is perhaps revealing to notice how this kind of residual sociability, based on the art of losing oneself, has become translated with an incapacity to possess oneself, to self-manage and regulate one's behaviour. The idea of collective excitement has been described time and again as regressive and potentially dangerous, something to be managed and given proper form. But a close look at these practices strongly opposes any claim of a lack of will or awareness.

If spontaneity is to be found in the feast, it is not in the sense of impulsivity or instinct. Carnivals, ritual dancing, parties and gatherings required careful preparation, organizational skills, elaborate crafts, aesthetic sensibilities and intense negotiations. It is not a coincidence that the medieval 'youth abbeys' responsible for 'putting on satirical charivaris to mock immoral villagers as well as to organize celebrations like Carnival'[16] were also the nuclei of the first organized peasant revolts in medieval and early modern times. Similarly, in the faraway colonies, slave revolts were often initiated by the societies – such as the *convois* in Trinidad or the *cabildos* in Cuba – in charge of organizing festive celebrations.[17] In the words of Stallybrass and White, 'it is in fact striking how frequently violent social clashes apparently "coincided" with carnival . . . to call it a "coincidence" of societal revolt and carnival is deeply misleading for . . . it was only in the late 18th and early 19th centuries – and then only in certain areas – that one can reasonably talk of popular politics dissociated from the carnevalesque at all.'[18]

What is at stake here are two different modes of actualizing what after Gilbert Simondon can be called the transindividual. In the dialogical sociability of salons and circles, the self is produced at the level of language and action is postponed

for later. In the festive sociability of popular gatherings the self is constituted at the level of an expanded semiotics that passes through a material body that moves, sweats and misbehaves, and enters in a relation with others and the world through contact and not discourse. And while both kinds of sociability involve a degree of reciprocity and transversality – against the mono-directionality of the spectacle, which in the age of interactivity seems a smaller problem – the first can at best achieve a change in 'attitude', but only the second can generate a shift in 'position'.[19]

In this context, it must be noted that the salon was also, between 1725 and the 1890s, the name of the greatest annual art event in the Western world.[20] In the nineteenth century the idea of a public salon extended to an annual government-sponsored juried exhibition of new painting and sculpture, held in large commercial halls, to which the ticket-bearing public was invited.[21] As for academic or critical practices, the main model of reference remains to this days the symposium, which revealingly, is also named after the exclusive 'reception' of ancient Greece.

Any attempt to think about curatorial practices today should reflect about the political implications of the double genealogy that came to constitute it, as part of a politics of preserving ambiences where we can co-produce our selves in different ways from those already sanitized by the smooth logic of capitalist governance.

The salon format brought with it a kind of utopian sociability that is highly compatible with neoliberalism. It is not surprising that Stephen Pearl Andrews, an American individualist anarchist active in the second half of the nineteenth century, would write:

> The highest type of human society in the existing social order is found in the parlor. In the elegant and refined reunions of the aristocratic classes there is none of the impertinent interference of legislation. The individuality of each is fully admitted. Intercourse, therefore, is perfectly free. Conversation is continuous, brilliant, and varied. Groups are formed according to attraction. They are continuously broken up, and re-formed through the operation of the same subtle and all-pervading influence. Mutual deference pervades all classes, and the most perfect harmony, ever yet attained, in complex human relations, prevails under precisely those circumstances which Legislators and Statesmen dread as the conditions of inevitable anarchy and confusion. If there are laws of etiquette at all, there are mere suggestions of principles admitted into and judged of for himself or herself, by each individual mind.[22]

What is more surprising is that the same quote can be found in the appendix of Hakim Bey's *T.A.Z.* (Temporary Autonomous Zone), a cult book for the cyberpunk countercultures and network communities since the beginning of the 1990s. The fact that this influential author quoted Pearl Andrews' 'Dinner Party' next to 'sixties-style "tribal gathering", the forest conclave of eco-saboteurs, the idyllic Beltane of the neo-pagans, anarchist conferences, gay fairy circles (. . .) Harlem rent parties of the twenties, nightclubs, banquets, old-time libertarian picnics'[23] reveals a commonly accepted notion of sociability that does not look at its devices and contents itself to celebrate it as intrinsically spontaneous and liberating. It is not so. Different modes of sociability bear implications on who we can be collectively. Conversational practices and events come out of this not as essentially flawed either. The point is to recognize that their invariable trait is to produce an experience of speculative or reflexive acceleration that, a bit like in the architecture of irony, needs accomplices as much as those who *do not get it*. So, aside from the dialogical convivial situations, it is important to learn from other genealogies of sociability, predicated this time upon technologies able to sustain what I'd like to call 'expanded encounters', that is, encounters that are able to generate a kind of self-delight that does not need residual categories in order to exist.

The recent turn towards pedagogy that traverses the cultural field is already moving in this direction. However, sometimes I wonder whether alongside the semantics of education – with its laboratories and schools, investigations and experimentations – cultural practitioners could find some fresh political perspectives by attending to the sociable conditions of production and reception of their work not only in practice (as it often already happens in everyday care) but also through a shared discussion of its joys and fatigues. After all, the best school memories are the ones that happened in the toilet during recess.

Instead of insisting on generating a critical dialogue or political awareness, festive sociability is about practising an 'attractive labour', not in the sense of Charles Fourier, but in the sense of sustaining the enticement of extreme pleasures and appetites within the situations of resistance, insurgency and exodus (that already populate the contemporary social sphere). To bastardize the curatorial enterprises in the light of the sociabilities of the residual populations is not about an idea of inclusiveness, empowerment or participation. It involves the communization of the idea of pleasure and fun, not as entertainment (which literally means 'to stay where you are') but as diversion (to experience difference). Those who organize festivities for themselves have usually been the ones who, after the party, went on and burned down the salons where the

interesting conversations have been happening. To practise residual fun may be an alternative to both the elitism and populism of this scene.

Notes

1 Colectivo Situaciones, *On the Researcher-Militant*, September 2003, http://eipcp. net/transversal/0406/colectivosituaciones/en. Accessed 20 August 2012.

2 Term borrowed from Ian Hacking, *Making Up People, London Review of Books* 28, no. 16 (17 August 2006): 23–6.

3 Michel Foucault, *History of Sexuality I: The Will to Knowledge*, trans. Robert Hurley (London: Penguin, 1998), 143.

4 At times Fournière calls it 'sociality' too.

5 Georg Simmel, 'Sociology of Sociability', in *American Journal of Sociology* 55, no. 3 (November 1949): 254–61. Simmel presented the paper *Sociologie der Geselligkeit* (Sociology of Sociability) at the first German Sociology congress (1910) and the same article was republished with slight modifications in 1917 with the title *Die Geselligkeit. Beispiel der reinen oder formalen Soziologie.*

6 Friedrich Schleiermacher, *Essay on a Theory of Social Behavior*, trans. and ed. Peter Folley (London: Edwin Mellen Press Ltd, 2006), 130.

7 Simmel, 'Sociology of Sociability', 124.

8 'Perhaps a new era for the sciences and arts would commence if philosophizing and composing poetry together (*Symphilosophie* und *Sympoesie*) would become so generalized and intimate so that it wouldn't appear strange at all that many natures would complete each other by composing communal works.' Friedrich Schlegel, *Kritische Gesamtausgabe*, vol. 2 (Berlin: Walter de Gruyter, 1987), 132, my translation.

9 Marianne Weber, *Max Weber: A Biography*, trans. Harry Zohn (New York: John Wiley and Sons, 1975), 370.

10 Robert A. Nye, 'Review of Steven Kale, *French Salons: High Society and Political Sociability from the Old Regime to the Revolution of 1848*', in *Journal of Social History* (22 September 2005).

11 Maurice Agulhon, 'Le Cercle dans la France bourgeoise, 1810–1848. Étude d'une mutation de sociabilité', in *Romantisme* 17–18 (1977): 255–6.

12 Agulhon, 'Le Cercle dans la France bourgeoise'.

13 David Graeber, 'Manners, Deference, and Private Property in Early Modern Europe', in *Comparative Studies in Society and History* 39, no. 4 (October 1997): 694–728.

14 Barbara Ehrenreich, *Dancing in the Streets: A History of Collective Joy* (London: Granta Books, 2008), 251.

15 Emile Ardolino, *Dirty Dancing*, 1987.

16 Quoted in Graeber, 'Manners, Deference, and Private Property in Early Modern Europe'.

17 Ehrenreich, *Dancing in the Streets*.

18 Quoted in Ehrenreich, *Dancing in the Streets*, 103.

19 I borrow the terms 'attitude' and 'position' from Trevor Paglen and Aaron Gach, *Tactics Without Tears*, who in turn adopted this distinction following Walter Benjamin, 'Author as Producer', in *Reflections*, trans. Peter Demetz (New York: Schocken Books, 1978), 222. www.tacticalmagic.org/CTM/thoughts/Tactics%20 Without%20Tears%201.htm. Accessed 12 August 2012.

20 Also in relation to artistic expression, the salon also connotes a music genre popular in nineteenth-century Europe, composed expressly to exalt the virtuosity of the executioners.

21 From Wikipedia: http://en.wikipedia.org/wiki/Salon_%28Paris%29. Accessed 12 August 2012.

22 Stephen Pearl Andrews, 'The Dinner Party', in *The Science of Society* (1852).

23 Hakim Bey, *The Temporary Autonomous Zone, Ontological Anarchy, Poetic Terrorism*, http://hermetic.com/bey/taz_cont.html. Accessed 12 August 2012.

Part V

Refigurations

Textual rereading is never enough, even if one defines the text as the world. Reading, no matter how active, is not a powerful enough trope; we do not swerve decisively enough. The trick is to make metaphor and materiality implode in the culturally specific apparatuses of bodily production. What constitutes an apparatus of bodily production cannot be known in advance of engaging in the always messy projects of description, narration, intervention, inhabiting, conversing, exchanging, and building. The point is to get at how worlds are made and unmade, in order to participate in the processes, in order to foster some forms of life and not others. If technology, like language, is a form of life, we cannot afford neutrality about its constitution and sustenance. The point is not just to read the webs of knowledge production; the point is to reconfigure what counts as knowledge in the interests of reconstituting the generative forces of embodiment. I am calling this practice materialized refiguration; both words matter. The point is, in short, to make a difference – however modestly, however partially, however much without either narrative or scientific guarantees.

<div align="right">Donna J. Haraway*</div>

*Donna J. Haraway, 'A Game of Cat's Cradle: Science Studies, Feminist Theory, Cultural Studies', in *Configurations* 2, no. 1 (1994): 60–1.

Modern Art: Its Very Idea and the Time/Space of the Collection

Helmut Draxler

Modern art cannot be understood by looking at the individual paintings, sculptures, and objects that are conventionally said to exemplify it; one must consider them with a view to what unites them. Accordingly, modern art ought to be conceived as a peculiar narrative form that lends meaning and significance to this nexus. At the level of its motif, it abhors the narrative register; taken as a whole, however, it reveals itself to be defined by narrative form, and even a fairly simple one. The central motif of this narrative form is the overcoming of representation, of the picture constituted as likeness or reflection, on the way towards the assertion of the particular and autonomous reality of its picture-objects. Individual heroes paved this way, and even today scholars seek to trace the 'prehistory of abstract art'[1] and assess historic forms of expression with regard to their 'modernness' as measured by this narrative. Each individual work of art then reveals how far it has come on this path, becoming an indicator of progress towards an ideal, while the dubious pretensions of that ideal are rarely reflected upon. Even the avant-gardist critique of modern art at bottom continues in the same narrative vein precisely in its negative fixation on it, by searching for an autonomous reality beyond even the autonomous picture-objects or deriving said pretensions from the overcoming of these objects.

If we wish to take a contemporary stance vis-à-vis modern art, if we seek to assess it and place it in its historic context, then, it will be decisive that we avoid retelling this narrative as the 'myth of an era'.[2] In other words, it will be decisive that we neither historicize it as different from 'contemporary art' (as a concluded historic phenomenon charged with significance) nor simply invoke it as a 'different modernity'. The goal must be instead to reconstruct the narrative

form itself in its institutional and discursive conditions and its interconnections with other factors of modernization and to examine it in its uncanny presence. The point of this narrative form is that the intended agent of the overcoming of representation is the very same historical genealogy that conceives itself as progress. My argument, by contrast, will be that both elements, representation and genealogy, can be thought not as opposites but as closely tied in with, and hence utterly incapable of dissolving, each other. Both the narrative motif of representation and that of historical genealogy are rooted in the fundamental modes of the arrangement of pictures that first emerged in the depictions of collections since the seventeenth century. The collection itself can thus be defined as the primary code[3] in accordance with which the nexus uniting the pictures was able to manifest itself in a historically specific form and that made the elaboration of the questions of representation and genealogy possible in the first place. The spatio-temporal coordinates of these modes of arrangement have not only decisively informed the genesis of the phenomenon known as modern art; to this day, they partly frame the ways in which we can think about it.

In other words, the space of the collection that appears in seventeenth-century gallery paintings represents not just the prince's treasures and the prince himself, but most importantly the pictures, as special objects of representation. The path from the cabinets of curiosities of the Renaissance to the gallery in the modern sense indicates the changing status of the pictures. That a prince would have a 'forest' of pictures represent him makes sense only if these pictures and the mode of their arrangement could be held capable of accomplishing something special with regard to representation itself. The picture as the depiction of a scene capturing something of the 'world', whatever its nature, the picture as a tableau, that is to say, as an individual and collectible picture-object, and the picture as an element in a series of pictures that increasingly refer to one another – all these adumbrate the different levels on which the idea of representation unfolds. It would be insufficient, then, to describe representation as the mere depiction of a reality of whatever kind. Rather, representation designates the process in which the picture is charged with a specific meaning, in which whatever is depicted is assigned special significance within the framework of the symbolic form of the tableau, the form, banal in and of itself, of a – usually rectangular – movable pictorial support medium.

The imaginative space of a nexus of pictures that emerges in the gallery accordingly indicates not only the transition from the accumulation of curiosities to the taxonomical arrangement of pictures based on their sizes, themes, or genres or the schools of painting they exemplify, but also the emergence of a

particular space composed of pictures. The 'theatrum pictorum'[4] – coulisse-like picture-walls, superimpositions of pictures resembling collage and sequences of picture-spaces folded in the manner of a house of cards – becomes the defining metaphor of this space. René Magritte is therefore not the first to conceive this picture-space as the ineluctable horizon of thinking before which pictures always refer only to other pictures. Even in the seventeenth century, this special space of representation refers first and foremost to itself, the representation of representation. Yet, in doing so, it depicts not only self-referentially itself, it also includes specific forms of relations in its field of vision: relations between the concrete picture-space and the space of pictures, between the people who populate the picture-space (the painter and the prince, for example), between them and the spaces and pictures to which each is assigned and finally between the picture-space/space of pictures and an exterior space, which is in most instances only hinted at. The selection of the pictures and the way they are arranged increasingly also come to define the volatile power of these relations on the level of substance. Starting in the eighteenth century, the growing historical dimension in particular swells this space of imagination to a phantasmatic magnitude into which reflections on the meaning of history, on processes of the formation of consciousness and on psychological dispositions find themselves. Giovanni Battista Piranesi, notably, reinterprets the accumulation of historic remnants into pictures of the internalization of imperial space. A thread leads from there to the abysmal collection-spaces in John Soane, and finally to that peculiar collector, Sigmund Freud, who will translate the space of the collection into the topology of psychological functions.[5]

The time of the collection accordingly appears primarily as a function of a particular mode of spatial arrangement. The nineteenth century witnesses the gradual ascent of historical forms of presentation that increasingly transform the space of pictures into the line of a sequential flow. The dynamisms governing this sequence, however, lend themselves to the most diverse interpretations – from progressive development to catastrophic demise. Heinrich Wölfflin finally sets this genealogical principle down as the transpersonal structural principle of art history. It ascribes to every work the internalized logic of a process, understood as obeying quasi-natural laws that take place between various polar principles, the 'fundamental concepts of art history'. What emerges, based on photographic reproductions, is the time/space of an 'Imaginary Museum' spanning all concrete times and spaces. Yet even here, progress and regression are in balance – in the sense of the eternal recurrence of the same forever unchanging sequences, of *corso* and *ricorso*, as Giambattista Vico had described them.

Now modern art does not simply take the side of progress. It seeks instead to internalize the principle of genealogy and thereby to overcome once and for all the cycle of recurrence and, with it, representation. Each work conceives itself as standing at a particular moment in time and executing the logical consequence of the development of the historical 'condition of the material' (Adorno). This aspiration must be read not simply as seeking progress over some tradition, whatever its nature, but as the innermost consequence of that tradition. In other words, forces from within the tradition urge the work to transcend it. Modern art accordingly embodies these forces of tradition itself, suspending its own ambition to transcend the tradition. Nor does modern art escape representation; to the contrary, enlisting the assistance of genealogy, it drives representation to its extreme. That becomes clear once we understand that representation, far from being the illusionistic depiction of a particular reality, is an expectation of significance brought to the symbolic form of the tableau. In this sense, Piet Mondrian and Kazimir Malevich mark not the cancellation of the representational regime but its essence in a heightened form in which the very overcoming of representation as depiction allows for the attainment of another, 'representative' meaning: in the true 'Suprematism', the picture is charged with an ultimate and universal worldliness. With regard to the question of placement in the space of pictures, both positions remain torn between turning to a radical isolation of the picture, which will finally be realized in the form of presentation known as the White Cube, and transforming the 'theatre of pictures' into the endeavours towards a total work of art undertaken by De Stijl and the Constructivists.

Modern art, then, is certainly not only modern. It adopts the early modern idea of representation precisely where it seems to repudiate it. And the idea of an inner genealogical principle does not help it escape history; on the contrary, it inscribes it only the more deeply in that history. Modern art is and remains therefore firmly anchored in European history, even if it has found its temple in New York and has long become an available code that lends itself to a variety of global utilizations. Particularly indicative of this fact are the enlightenment myths of liberation and universality it has appropriated to itself. That appropriation should not lead us to forget, however, that these myths are also variants of a specific hegemonic narrative form that must even today be understood as a reflection of the same tradition it pretends to have overcome. That means that no end to the 'representational regime' is in sight. The collection as a metaphor of the accumulation of wealth or capital, but also of symbolic worldliness and power, and its coordinates in time-space continue to define the specificity of a culture just as a European or more generally Western culture seeks to enforce

a dominant reading of globalization. So we need a critical revisionism that examines the mythical potential of the narrative form of modern art, tracing its criteria and categorizations and the inclusions and exclusions they give rise to as well as the representational and genealogical logics on which it is based. Such a revisionism would probably allow us to adopt a different perspective on the structural dynamisms concealed by one-dimensional logics of autonomous development, a perspective in which the interdependency between different processes of modernization would be the precondition for understanding the internal as well as external multiplicities[6] that, we might come to realize, make up 'modern art', with all the tensions defining its contemporary manifestations, between on the one hand, the theatre of pictures on billboards and social networks and, on the other, the theatre of art staged by the global art business.

Translated by Gerrit Jackson

Notes

1 Otto Stelzer, *Die Vorgeschichte der abstrakten Kunst* (Munchen: Piper, 1964).

2 Paul Veyne, *Die Originalität des Unbekannten. Für eine andere Geschichtsschreibung* (Frankfurt am Main: Fischer-TB.-Vlg., 1988), S. 26.

3 In a similar and highly interesting way Boris Groys talks about the 'logic' of the collection. I just don't share his 'entropic', almost apocalyptic and totalizing interpretation of that logic. See Boris Groys, *Logik der Sammlung. Am Ende des musealen Zeitalters* (Munich: Essays, 1997).

4 Ernst Vegelin van Claerbergen, ed., *David Teniers and the Theatre of Painting* (London: Courtauld Institute of Art Gallery in association with Paul Holberton Publishing, 2006).

5 See: Donald Kuspit, 'A Mighty Metaphor: The Analogy of Archaeology and Psychoanalysis', in *Sigmund Freud and Art: His Personal Collection of Antiquities*, ed. Lynn Gamwell and Richard Wells (New York: Harry N Abrams, 1989), 133–51 and Janine Burke, *The Sphinx on the Table: Sigmund Freud's Art Collection and the Devolopment of Psychoanalysis* (New York: Walker & Company, 2006).

6 See Shmuel Eisenstadt, *Die Vielfalt der Moderne*, trans. Brigitte Schluchter (Metternich: Velbrück 2000).

Two Invoking Media: Radio and Exhibition

Jean-Louis Déotte

The main hypothesis of Walter Benjamin's essay, *The Work of Art in Age of Mechanical Reproduction*, is as follows: whether traditional (lithography) or industrial (photography), mechanical reproductions were always the condition of possibility of the arts. As such, they do not belong to the sphere of art. The first thesis in the 1935 essay tells us why: each period has their own sensibilities. From this we can deduce that each period gives their own specific determination to the arts. The main question for aesthetics is therefore to determine their own configurations or what Rancière calls, in a rather restrictive fashion, their 'aesthetic regimes'. This is restrictive because Walter Benjamin's thesis does not limit itself to particular literary (Flaubert) or philosophical patterns (Plato, Aristotle). Benjamin's *The Author as Producer* develops 'the theory that a decisive criterion of a revolutionary function of literature lies in the extent to which technical advances lead to a transformation of artistic forms and hence of intellectual means of production'.[1]

From this, one can put forward the idea that a medium of communication, such as an exhibition or a radio, for example, becomes effective only when their constituent principles are made visible or audible through the creation of a specific artistic project. This event obviously supposes the creation of a technical device: the exhibition in the eighteenth century or the radio in Germany in 1920, for example.

Let me take the radio as an example. The first years of its creation are crucial: during a short period of time, experimentations took place, but these did not last long. This short-lived aesthetic period was soon replaced by a period dedicated to political communications, and specifically from 1933, to propaganda in the name of mass mobilization. Walter Benjamin grasped the opportunity just when

an opening was possible and produced radio programmes for children. These radio stories became known as *Hörspielmacher*, subsequently translated and published under the title of *Enlightenment for Children* (1988), four *Hörspiele*, several *Hörmodelle*, and without forgetting the *Funkspiele* (radiophonic games).

The same idea (a medium of communication only becomes effective when their constituent principles are made visible through an artistic project) can be said about the birth of television and later of the internet version 2.0. Things have not changed.

Overall, one can then surmise that a new medium of communication that is able to generate artistic productions – of the art-device variety – becomes an aesthetic device that, because of its endless reconfigurations, effectively knows no end. The oldest of such an aesthetic device, the camera obscura, for example, is still operative as the recent work of Christine Felten and Veronique Massinger clearly testifies.[2]

Although he devoted crucial pages to narration, photography, and cinema, Walter Benjamin never wrote, besides a few theoretical notes, about the radio or about exhibitions. However, this might not necessarily be due to a lack of opportunity. If an aesthetic device (perspective, for example) generates a new understanding of what an event stands for, and therefore what a show means, a medium of communication, by contrast, only ever imposes itself by shortening space and time. A new medium imposes itself to speech, the visual, the sonic like a instrument of power. Benjamin perceived this when he discovered that the clock that dominated the broadcasting room only counted the passing minutes. A mistake that made him realize the worst kind of blank in front of a microphone: to run out of things to say. The time of a new medium is the time of communication, its counting unit is its economic value. A medium of communication is always a tool of authority, whereby there are always clearly identifiable receivers and emitters, that is, following the classical scheme for communication, a recipient and a supplier. The gap between the two cannot be bridged because it is a functional one. One can indeed transform the reader into an author, but there will always be a hierarchical order of distribution. This is not the case for an apparatus.

Besides, in order to enter the category of 'mechanical reproduction', both the radio and the exhibition – and indeed the television – must not be interpreted solely as a system purely composed of receivers and emitters. It is necessary that its reproductive dimension is secure: phonographs, audio and video cassettes, catalogues, etc. There is no memory without the possibility of reiteration,

without writing, and therefore without support. This is what also allows one to classify technically a device: as support and writing. For this reason, it is better to say a surface of (re)production than to use Lyotard's expression: a surface of inscription.[3] There is a coherence and a continuity in Benjamin's aesthetic, from the first texts[4] right up to his texts on Brecht. Benjamin indeed conceives artistic production only under the aegis of reproduction. Reproduction must be thought out as a world of archives, of archival forms, not unlike a library, collection, museum, or a musical or choreographic repertory, for example. Time after time, we all inherit, even as children, these surfaces of (re)production. Pedagogy must be thought in relation to its transmission. For this reason, reading always necessarily precedes writing. Artistic forms are always already there. The only thing that changes is the mode of transmission. Narration is one of these modes of transmission, but it is not the only one, there is also drama, allegory or the hanging of works in an exhibition.

The idea of a surface of (re)production needs further investigation. It stands for the matrix of artistic production. As a reader of Fiedler (Klee's master), Benjamin highlights its importance when he says that the work of art concretizes a flow of consciousness or, in painting, a flow of colours. If artists did not produce such forms, such concrete configurations of what shows itself, one would see or hear nothing in the world. It is the work that allows the world to become visible or audible. As the saying goes: art allows for vision [*l'art fait voir*]. Benjamin addresses the issue of form in his early work. Ever since the Renaissance, our cultural heritage conceives form in terms of *disegno*: it is drawing that configures and informs. Hence the manner in which Classicism interprets painting in relation to drawing: to take place, painting only requires a dyer's know-how. Drawing then embodies the Idea or the concept and colour becomes that which has no form.

Benjamin's innovation is to refuse this secondariness by invoking the name. For Benjamin, the name is what really configures form. Benjamin's aesthetic gives prominence to naming. This is clearly shown in his *Small History of Photography*, in which Benjamin criticizes the political pretensions of objective photography because it shows factories as if a photograph could denounce historical social realities on its own! Images need to be named; photographs require tags. Benjamin's interest in Brecht's epic theatre is due to the fact that narrative continuity is recurrently broken and that brandished placards allow to proclaim a point of view that serves to name the scene. The name as the identifiable form is what stands for the surface of (re)production. This does not

mean that what counts is the didactic relation as Rancière would have it, but the subjugation of aesthetics to theology (the name is the profane opposite to the Divine word as action).

<div align="right">Translated by Jean-Paul Martinon</div>

Notes

1 Walter Benjamin, 'Notes from Svendborg, Summer 1934', in *Selected Writings Volume 2, Part 2: 1931–1934*, ed. Michael William Jennings, Howard Eiland and Gary Smith, trans. Marcus Paul Bullock (Harvard: Harvard University Press, 2005), 783.

2 Christine Felten, Veronique Massinger, *Caravana obscura*, 1991–2007.

3 Jean-François Lyotard, *Discourse, Figure*, trans. Antony Hudek (Minneapolis: University of Minnesota Press, 2011).

4 Walter Benjamin, *Selected Writings, Volume 1: 1913–1926*, ed. Michael William Jennings, Howard Eiland and Gary Smith, trans. Marcus Paul Bullock (Harvard: Harvard University Press, 2002).

In Unfamiliar Terrain: Preliminary Notes towards Site-Relationality and the Curatorial

Anshuman Dasgupta

Figure 21.1 Installation view of the *Alien Nation Project* with participants and viewers, Rhenok, Sikkim, 2011, photo: Anshuman Dasgupta.

This essay starts with the assumption that specific sites in their relational dynamics perform and therefore expose the curatorial.

The said assumption and the questions that follow are born out of a period of engagement with critical thought concerned about site-related discursive practices. One such engagement with a specific geographic location provides an occasion to study how the apparently neutral term 'curatorial' can be seen to perform in a relatively unfamiliar terrain.

This is also an attempt to position the curatorial at the crossroads of disciplines that, while not having conventionally matched orientations, have potential intersections, by which they connect to each other. For, in examining site-relationalities (or the dynamics of human interaction and participation via the sensuous means of art), we can only encounter other disciplines such as geography, ethnography, anthropology, histories (in the form of dialogues/ orality) and their related sub-disciplines.

As the focus is on the visual and aural orientation of the particular spatial project under consideration in this essay, the term curatorial will then be understood as the unifying platform of this disciplinary crossroads; a crossroads that is comparatively sensuous in comparison to the more analytic social sciences.

The encounter of disciplines and their proliferating critical sub-disciplines throw up several questions.

a. Do sites (as referred to in anthropologically led sensuous practices) invoke communities?
b. What kind of community do we have in mind? A found community, an organic community or a transitional one?
c. How is one to map the transformation of the members of communities through the prospectively active sense-intervention, often called 'art' (e.g. site-specific and/or site-related art)?
d. How does the foreignness of an ethnographer/artist fare in the community and/or the site-related interactivity?

Report on Balikci Denjongpa's project

These questions will be addressed with regards to a specific geographic location that is considered a site of crisis for various reasons: Sikkim, the landlocked state in the north-eastern part of India, surrounded by three international borders: Bhutan, Nepal and China/Tibet. I shall put forward two different models of

interactivity – the first concerns a report written by an entrenched anthropologist on a film project and her efforts and assessment of this film; the second concerns my own efforts at a multi-sited interactivity, from which I expect different possibilities to be made visible.

I will begin with the anthropological report of Dr Anna Balikci Denjongpa, a Canadian anthropologist, educated in Canada and the United Kingdom and currently settled in Sikkim as the Director of the Sikkim Archive Project at the Namgyal Institute of Tibetology in Gangtok.

In the process of setting up a Sikkim archive in 2003, Balikci Denjongpa made an anthropological audiovisual project, which, as she says, helped build relationships with the local communities, thus making some of the members effectively confident in documenting, commenting upon and representing their own culture. Her report exposes those very dynamics that theorists have posited as key documents of reflexivity and meta-discipline.[1]

This report was written after the six films that she, along with her team, produced for the Namgyal Institute of Tibetology (publicly available). There is also one unfinished film on Lachen, the rough cut of which she gave me privileged access to.

Balikci Denjongpa's report does not just consist of an anthropological notebook. Through it, she brings forth the dynamics of relations between the different disciplines as well as the different groups involved in her research-cum-film project. The economy and conflict of positions are often expressed (albeit, subtly). Her report is rife with suggestions of inner conflicts and contradictions within the insular communities (Bhutias or Lepchas); but never within the majority of Nepalese (75% of the population) who, by her description, have occupied the region since the 1860s with the result of unsettling the traditional Bhutia Lepcha populace and reducing it to a mere 20 per cent. She says in her report, 'As a result, Sikkim's indigenous cultures are quickly eroding, and it was thought that a documented video recording be made in some of its most traditional villages while the exercise is still thought to be worthwhile.' This is typical of what George E. Marcus designates as 'salvage ethnography'.[2]

She also writes how the relative purity of the indigenous cultures is being maintained in Lachen and Dzongu (two villages north of Sikkim populated by indigenous Lepchas and Bhutias). To quote her:

This is partly due to the fact that both communities are located in remote areas that are restricted and where outsiders are forbidden to settle on a permanent basis; even indigenous Sikkimese from elsewhere of the state require special

permits to enter these protected areas on casual visits. This has, to some extent
limited the influence of the Nepali language in both Dzongu and Lachen, a
language which is dominant now in other regions of the state.[3]

In her research in these areas, Balikci Denjongpa was accompanied by Dawa
Lepcha and Phurba Bhutia, who are former residents of these places and belong to
the community. Balikci Denjongpa herself admits to being accepted as a 'daughter-
in-law', which, she is, by virtue of marrying a Bhutia herself. This report then
shows a complexity of interpersonal and potentially intercommunity relations in
the process of gaining an access to the culture as revealed in the circumstantial
descriptions of the making of her anthropological films. She writes:

> Projects such as ours are usually carried out by outsiders – Westerners, or Indians
> from Mumbai or Delhi[4] – who come to Sikkim for a few weeks or months to
> carry out a particular study and then disappear. The fact that we were a local
> team inspired confidence and opened many doors. Not only were we locals, we
> were from the Namgyal Institute of Tibetology, the only government sponsored
> institution in Sikkim devoted to the study of Buddhism and the cultures of its
> Buddhist communities. This ensured that whatever we filmed will remain within
> Sikkim and will remain accessible.

> As far as I am concerned, the main reason I am included in the 'local' category is
> because I am married to Jigme, a Sikkimese Bhutia and as the Lachenpas put it,
> I am the daughter-in-law of the land. My marriage certifies that I will not leave
> Sikkim, and I will be loyal to the Bhutia community, that I will not desert or
> misrepresent them and will forever remain accountable.[5]

Her report can therefore be read in the different contexts that the same site
provides us with. The *first* of these being, her privileged access as an insider
despite being an outsider by origin and growth.

The *second* reading comes with her confessional statements, which informs
us of the facts in terms of her access to the area: the fact that she stayed with the
village headman, her initial entry into the village as a curator of a collection of
photographs that had been shot by one of two travellers in the early twentieth
century and such factors that made the village *Dzomsa* (the political body) and
the *Pipon* (the headman) to accept this project. She talks of the censorship during
post-production quite elaborately:

> Although we have gained confidence and participation of the local political and
> cultural authorities and are now permitted to film just about everything, it does
> not mean we have the license to show everything to the outside world. This

is where shared understanding and trust come in. If the *Pipon* or the *Lachen Rimpoche* (religious head) says that something we filmed is not to be shown to the rest of the village, it will not be shown to the rest of the village. If either says that it will not be shown outside the village, it will not be shown outside the village. While viewing a final edit, if the *Lachen Rimpoche* or the *Pipon* says that a particular scene needs to be cut out, this particular scene will be cut out. Although those situations are rare, they do present themselves now and again, mostly when disputes are involved.[6]

Further on, with regards to anthropological authority, power and ethics, she writes:

> As an anthropologist responsible for contents, this may come into conflict with my obligation towards objectivity and true representation. But actually, it doesn't. It is important to me that the films be made with and for the local community and their sensitivities be taken into consideration. The films are made mostly for their own use and Lachenpas have a right to say how they would or wouldn't be liked to be represented. What is important for me as an anthropologist is that the original footage be as complete as possible and remains archived as such for future reference. Villagers are aware that the complete footage will be there at the Institute. So far this has not created any problem since the complete footage remained under my control . . . I doubt any of the material needs vetting at this point since by then, all these conflicts will have lost their relevance they now enjoy and will have become somewhat meaningless to them. They will, however, remain important examples of Lachenpa social behaviour.

The *third* aspect of Balikci Denjongpa's report reveals how she becomes complicit with the Institute she is serving: by focusing not only on certain ethnicities (namely, Lepcha and Bhutias) who she feels are marginalized and vanishing, but also by working on behalf of the fallen dynasty – the Namgyals/Chogyals (the ex-royal family of Sikkim) after whom the Institute is named. Their dynastic history remains relevant in the context of Sikkim's past political history, the present Institute and its future projects, and perhaps, also to the anthropologist's own feelings.[7]

Report on the Alien Nation Project: The dynamics of community

The principal meeting point between Dr Anna Balikci Denjongpa's report and my multi-sited engagements in Sikkim could be the sheer parity of attitudes to

site relations: those of the ethnographer and those of the participants. 'The most important form of local knowledge in which the multi-sited ethnographer is interested is that which parallels the ethnographer's own interest – in mapping itself.'[8]

In search of our own form of interactivity, in a workshop titled 'Alien-Nation' during my multi-sited project in Sikkim, our team worked out two modes of interaction in two separate locations: Aritar in east Sikkim and Gangtok. One of them involved a flexible map-making project, which gave participants the opportunity to create their own subjective options from the available cartographies. This resulted in an imaginative set of projections as a way of deviating from the conventional cartographic mode. In the second exercise, we got into conversation with the participants. They related what they thought of their surroundings. These conversations made us realize again the geographic determinations of the site and often, beyond geographic issues, the everyday relationships to it, such as the gender balance in daily activities.

The communities in Sikkim are generally mobile. For Balikci Denjongpa, the project entailed capturing a community in a static format: she wanted to grab the traditional Lepcha and Bhutia cultures, their depredation/death and the anxiety of their preservation. By contrast, our approach was much more organic, the rapport was the primary expectation in the preparation for our workshop. We were ready to attend to transitional, unfamiliar and even to the alien forms of the local tradition in the process of transformation.[9]

Site-relationality: Map-making as gesture

The map-making exercise had two aims. On the one hand, the task was to figure out how the participants liked to represent their locality; on the other, in keeping with our joint interests, we wanted to see how the participants located and/ or fantasized a possible future – in the form of a wish list, for example. Thus, compared to a traditional cartography this was a geographic visualization.[10]

It might be relevant here to detail/delineate the profiles of some of the participants in our Alien Nation Workshop, along with their particular visualizations:

A Utopian Work. Songay is a Sikkimese girl of Bhutia lineage with a degree in literature from Calcutta, and a postgraduate degree in media studies from Delhi MCRC. She took part in our Alien Nation Workshop. She drew a diagram, which was like a wheel with spokes radiating from the centre to the periphery.

She defined the spokes as a process of transformation from the current society to a fairer and more democratic society with a better gender balance, equality and freedom of speech and thought.

A Mapped Wish List. Roshni Chettri, a girl in her mid-twenties of mixed Nepalese and Khasi parentage, was born and brought up in Shillong, the capital city of Meghalaya. She did her higher education in Delhi and was subsequently employed as a copywriter in an advertising agency. She was newly married and this was her first stay in Sikkim. In the workshop, she drew a picture that was primarily a wishful projection for her locality, Todong, where she now lived with her in-laws. Her drawing consisted of roads circumnavigating intermittently scattered hillocks, existing shops in the area, and multistorey buildings that were randomly coming up in gross violation of the local laws of construction (implemented after the earthquake of 18 September 2011) and of which she did not approve. All these were drawn alongside drawings of imaginary inhabitants' houses: artists, poets, writers, thinkers, philosophers, etc. The end result was a picture that mixed what existed with what she wished were there in Todong. It was interesting to notice that she packed both together, placing in a utopian manner a poet, an artist and a filmmaker in a community where, today, in reality, only professionals like doctors, lawyers, and engineers lived (who for Roshni were boring professionals, only interested in money).

Residual Drawing. The drawing of a map of Ongmit's twin villages took her back to the Lepcha community, in the north of Sikkim, which she could have overlooked, since she and her immediate family were settled and established in Gangtok. She need not have gone back to her roots. Yet, when given the option to draw the picture of either her known world or of a world that she wished for, she chose to draw those two villages in the north, the traditional preserve of the Lepcha communities. The drawings helped her imagine the difference between the fact of belonging and dwelling in that community and her current race for a BBA degree and, subsequently, employment. Even while drawing the picture, Ongmit was not too sure if the village heads would approve.

Doma's Story. Doma is a Bhutia girl who studied Ceramics from Santiniketan and is a practicing artist in Delhi. She also has had a brief stint in a corporate job. She drew a map that consisted of an imaginary projection of the future reality of her home in Sikkim. It is interesting to note that most of the participants from the upper classes, who also had somewhat progressive multi-city backgrounds, painted their maps in a colourful and imaginary manner. They found the future to be a more interesting thing to address than the reality of the present. Doma,

thus, drew a palace and its surroundings where clouds hover above the familiar and the unfamiliar, in a somewhat cohabited temporality.

Daily Life as a Map. Kewal Parihar is a graduate who works as a tour operator. He studied at the Aritar high school. He knew Bijoy Pradhan as his teacher and a community person, and joined the workshop group heeding his teacher's request. Seniors are respected in the Nepalese society; additionally there is a community bonding among the people in a mountain village with sparse population. He may also have been interested in cultivating us as people from Calcutta and associated with a university, who could be useful in his future plans. Kewal is from close to the border and aims to open a resort there. With the help of a friend from the Aritar village, he composed a map that covered an entire journey from his village to the Rhenok market. Interestingly, temples formed the central accents of his map and not the habitual schools or colleges; even his home was missing.

Summation: Conflict and endless overlaps of disciplinary thoughts

Anthropological projects are usually understood in the form of a report or research writing. This is their ultimate function. By contrast, an anthropological film project creates another register of cognition. For example, when one shows a written report on an anthropological film, it produces a different effect than the one achieved when the film is shown. We can expect yet another effect when a different version of the film is screened, or the raw footage comes out of the archives. In both cases, the commitments to holism in anthropological projects can only be increasingly problematic.

If ethnography is about writing, the curatorial is silent speech. The curatorial deals with and reveals murmurs, inflections that are not verbal and intonations that are only visually expressed. If one takes these notes towards site-relationality and the curatorial into consideration, then we are faced with the possibility that the curatorial might effectively go beyond a certain fixity of presence. Because it is juxtaposed with time, the curatorial stands for a simultaneity of events that never quite add up. This is similar to map-making, in which words and images perform independently to build their own unexpected patterns. This is also similar to when one starts a conversation that does not have an end in view. The curatorial begins; it is a catalyst. It is perhaps both a nectar and a poison, but one cannot do without it.

Notes

1 Anna Balikci Denjongpa, 'The Sikkim Video Archive: A Collaborative Effort Between Anthropologist, Indigenous Filmmakers, and the Local Community', in *Future-Past: Cultural Heritage and Collaborative, Ethnographic Film Work*, ed. Peter I. Crawford and Baste Engelbroecht (Copenhagen: Intervention Press, 2012).

2 George E. Marcus, 'Contemporary Problem of Ethnography in the Modern World System', in *Writing Culture*, ed. James Clifford and George E. Marcus (Berkeley: University of California Press, 1988).

3 Balikci Denjongpa, 'The Sikkim Video Archive', 1.

4 The presence of the two most distant cities seems surprising to me and makes me read 'between the lines' of this statement. The first modern film after the colonial phase of Sikkim and in its transition to becoming a part of the Indian union was made by the eminent Satyajit Ray. His *Sikkim* (1971) was the only film banned by the Censor Board. The other two films of recent times are those of Mr Arghya Basu, from Calcutta and Pune, made in the last decade. Even overlooking this slippage, we can figure out a peculiar traditional anthropological insistence on insidedness or rapport, which tells more about her style of filming than the report itself.

5 Balikci Denjongpa, 'The Sikkim Video Archive', 6.

6 Balikci Denjongpa, 'The Sikkim Video Archive', 7–8.

7 As the most of the articulators suggest, there was a democratic upsurge against the ex-Chogyals or rulers of Sikkim, which was largely led by the Nepamul Sikkimese.Prior to this time, the Sikkimese world was dominated by the Bhutia Nomgyal minority and their deployed Kazis. The post-1973 Sikkim seems to have been claimed by the mostly Nepalese populace though Lepchas and more importantly the Bhutias also have a significant political presence.

8 Marcus, 'Contemporary Problem of Ethnography', 112.

9 The actual ethno-dynamics of Sikkim are now a function of distribution. The Nepamul Indians (or 'persons of Nepali origin') who were apparently exploited earlier in their history rose to power after 1973, established their command and control and even after the Indian takeover reigned over the Lepcha and Bhutia for close to 40 years, by implication. See A. C. Sinha, *Sikkim: Federal and Democratic* (New Delhi: Indus Publications, 2008) and Madhusmita Bhadra, *Sikkim: Democracy and Social Change* (Calcutta: Minerva Associates, 1992).

10 Jeremy Crampton differentiates the function of traditional cartography and what is understood by 'geographic visualization': 'Traditional cartography has emphasized public use, low interactivity and revealing known facts, while visualization emphasizes private use, high interactivity, and exploring unknowns.' Jeremy Crampton, 'Maps as Social Constructions: Power, Communication, and Visualization', in *Critical Geographies: A Collection of Readings,* ed. Harald Bauder and Salvatore Engel-Di Mauro (Kelowna: Praxis Press, 2008), 720.

Curating Ghostly Objects: Counter-Memories in Cinematic Space

Cihat Arinç

Introduction: The curatorial mode of filmmaking

In the last decade, film theory has turned its face towards memory studies as well as spatial theory. Film scholars have started to investigate the complex relations between film, space and cultural memory. Within a wide range of debates in contemporary film studies, cinema is redefined as a technology of memory through a set of concepts such as 'prosthetic memory',[1] 'mediated memory'[2] and 'meta-archive'.[3] Cinematic space[4] is also considered by many scholars to be a topography of remembering with reference to the famous French historian Pierre Nora's frequently cited concept of *lieu de mémoire* [site of memory].[5] Although contemporary film scholars' attempts to redefine film and cinematic space in relation to the notion of cultural memory bring fresh insights into current debates regarding the possibilities of the moving image, these approaches need to be elaborated through a reconsideration of both the affective power of visible, audible and intelligible *objects* being exhibited in cinematic space as ghostly traces of a catastrophic past and the role of the *filmmaker* in the organization of those objects.

In order to rethink the relationship between film, space and memory, this short essay addresses the following question around the 'mnemonic turn' in the contemporary cinema of Turkey: What happens when filmmakers use the cinematic space as an exhibition space in order to insert relegated or peripheral knowledge that is alien to the public domain? To begin with, I should emphasize that the following lines are neither about the practice of *curating* nor about a theory of the *curatorial* in a conventional sense. Instead, I take the term 'the

curatorial' as an expanded notion that goes beyond museological practices and includes filmmaking activity. Hence, I propose the concept 'the curatorial mode of filmmaking' to explain the idiosyncratic set designs of memory-films.

In this essay, I argue that 'memory-film', or mnemopolitical cinema, a genre coined by Russell Kilbourn in his *Cinema, Memory, Modernity*, appears to assign priority to the *set design*, or the narrative organization of cinematic space, through visible, audible and intelligible objects of contested histories: mnemopolitical film directors working in different traditions of world cinema mostly use film as a narrative device to express selected spaces (especially haunted places of past violence) or use cinematic space to express selected narratives (especially traumatic stories of massacres, ethnic conflicts and forced migrations). Hence, visual, aural and autobiographical objects (e.g. family photos, ethno-linguistic voices, narratives of past) taking place in most scenes of memory-films are carefully selected, gathered and presented to amplify the mnemonic mood of these movies. They appear to be ghostly objects that speak for themselves as traces of catastrophic events, allegories of violent encounters or fragments of other histories. Therefore, in a mnemopolitical film practice, the filmmaker ceases to be 'the author of film', but rather appears to be 'the curator of cinematic space' who selects, collects, arranges and exhibits ghostly objects as evidence of past violence or ruins of silenced histories.[6] The curatorial mode of filmmaking, in this sense, expands the horizon of screenscape turning it into an exhibition place where counter-memories are unfolded and externalized by means of the display of ghostly objects such as haunted landscapes, polyphonic soundscapes and counter-narratives. In post-authoritarian societies where history needs to shift from official history (History with capital H) to minor and plurivocal histories, cinema is often restructured as a counter-hegemonic medium in which dominant discourses of national histories are disrupted and disenchanted through the exhibition of counter-memory objects.

The curatorial mode of filmmaking has become the major aesthetico-political style that governs the practice of many contemporary filmmakers in Turkey. Since the mid-1990s, the new cinema of Turkey[7] has turned out to be the site of a persistent haunting where ghostly objects have been presented such as architecture of enmity (e.g. the Wall in Cyprus), ethnic soundscapes (e.g. ethno-linguistic sounds of Kurdish, Greek and Armenian) and silenced narratives (e.g. forced migrations of Anatolian Greeks and Armenians as well as that of Balkan Muslim Turks; and mass killings of Turkish Cypriots, Kurds and Alawites).

All these catastrophic moments have remained either less known or entirely unknown to the public and have rarely been recorded in history books until

the 2000s. The cinematic space has been redefined in the still emerging mnemopolitical film cultures of Turkey as an exhibition place where these invisible things, inaudible sounds and untold narratives of contested histories have been collected and curated, or in the root meaning of the word, 'cared for'. In this filmic exhibition space, filmmakers have opened the horizon of *non-knowledge* (knowledge to come) by exposing the *spectator* to the haunting power of the *specter* of marginalized knowledge: haunting, as Gordon states, is 'a very particular way of knowing what has happened or is happening'.[8] In other words, the cinematic landscapes of the new cinema of Turkey have been organized through haunted places of oppression where the cinematic spectres of marginalized and silenced communities challenge the viewer's so-called knowledge about social past/present: they demand from the viewer a movement away from certain knowledge positions.

Playing the role of *parasites*, these cinematic spectres constitute a kind of black hole of unintelligibility that disrupts the decisive character of knowledge, thus they make the spectator able to realize that he does not know what he thinks he knows. They start a counter-intuitive process of subjective transformation associated with witnessing a set of spectral alterities on the screen where the dark side of national history is conjured up. In order to dismantle what is socially accepted as *knowledge/memory* in the public domain of Turkey, the 'curators' of cinematic space have disseminated the seeds of *non-knowledge/rememoration* through exhibiting mainly three types of ghostly objects: architecture of enmity, polyphonic soundscape and counter-narrative.

Exhibiting warchitecture: Borders as sites of catastrophic memories

One of the distinctive features of the post-Yeşilçam cinema of Turkey is its display of violent geographies of memory, that is haunted landscapes as mnemonic signs of violent encounters. As Asuman Suner points out, home, distance, border and migration have appeared to be repeated themes in the new wave cinema of Turkey.[9] Revolving around individual stories, geographies of oblivion and minor histories with autobiographical elements, films such as *Distant* (*Uzak*, Nuri Bilge Ceylan, 2002) and *Distant* (*Dûr*, Kazım Öz, 2005) obsessively aim at exploring the experience of being in a perpetual transition, or of living in the endless moment of in-betweenness with anti-heroic characters living on the margins of the global urban culture. There are also remarkable films whose

characters are those living on the borders of the nation state. Although we find in the Yeşilçam period of Turkish cinema (early 1950s–late 1980s) early examples of what Hamid Naficy calls 'the cinema of borders'[10] such as *The Law of the Border* (*Hudutların Kanunu*, Ömer Lütfi Akad, 1966), the post-Yeşilçam films take the issue in a more radical manner in the sense that they problematize the hegemonic politics of the border and demand from their spectators to reconsider the functions of borders in the postmodern globalized world. In the traditional sense, borders function in order to establish identities, namely to invent lines of division between a mythical 'us' and an equally mythical 'them'. As Étienne Balibar explains, 'Every discussion of borders relates, precisely, to the establishment of definite identities, national or otherwise.'[11] Balibar considers 'borders' as convenient instruments which are used by the state to reduce the complexity of identifying, namely to 'fix' identities that are, in practice, not very well defined.

One of these border-films is *Mud* (*Çamur*, Derviş Zaim, 2003), in which the Turkish Cypriot director's use of the Green Line (the border between the northern and southern sides of Cyprus that separates the city of Lefkoşa/Nicosia into two) intends to reveal the spectral condition of the social life on the island while unsettling the spectator's sense of place and worldliness: within the framing of this cinematic exhibition of the Wall, border as a visible–invisible line of division means a place of disjunction, unbelonging and intercommunal struggles – thus exposing an architecture of enmity. Zaim's cinematico-curatorial practice deconstructs the Green Line and calls for a reconsideration of its spectral condition and political meaning: this impermeable border is obviously the ghostly trace of violent past encounters between Greek Cypriots and Turkish Cypriots in 1963 and 1974, but should it continue to exist, implying as it does the so-called impossibility of coexistence? As Cockburn lucidly explains, the Cyprus Partition Line strictly defines the political conditions of living together for Cypriots, having different meanings at different levels: although the Wall became a relatively permeable border in 2004, it still exists as a ghostly entity that signals that there is an inaccessible outside for Turkish and Greek Cypriots and that this outside has been invented and maintained through an ethnocentric territorial order:

> . . . the Line lives, though in varying forms, wherever Cypriot communities have taken root. At the geographical level it constitutes two opposed ethno-national patriarchal polities, differentially shaping the lives and chances of thousands of people. And at the global level, it has symbolic meaning as the fence between the West and the Rest.[12]

By exhibiting Cyprus as a 'garrison island' with armed guards and 'forbidden' signs, Zaim's Cyprus trilogy (*Mud, Parallel Trips* and *Shadows and Faces*) aims at creating a kind of cartographic disorientation in the spectators to allows them to be estranged from a normalized and naturalized political geography: in order to unframe the political geography and defend the primacy of human geography, these films indirectly constitute examples of experimental cartography that map a cinematic *terra incognita*, an unknown possible future territory, a co-inhabited space in which one presence is not at the expense of the other. Further, in his cinematic landscape of Cyprus, Zaim subtly creates a contrast between the spaces of security (borders and garrisons that signify disintegrated and alienated souls of the East Mediterranean after 1974) and the spaces of intimacy (homes, narrow streets and local spaces of shared life on the island before 1964) to emphasize the forced evolution of the friend/neighbour into the foe.[13] As Balibar states, borders turn neighbours into strangers first, and then turn those strangers into enemies.[14] For example, Greek Cypriot actress Popi Avraam who played one of the main characters, Anna, in the last film of Zaim's Cyprus trilogy, *Shadows and Faces*, recounts how she started thinking about her identity as a young girl when her Turkish Cypriot neighbours were forced to leave their homes: 'We were just children. When our Turkish neighbours began to abandon their homes, I remember thinking, "Who are these people? Who are the Turks? And who are we?"'[15] Whereas Zaim's counter-geopolitical camera focuses on the invention of the border in the postcolonial Cyprus, Turkish Kurdish filmmaker Hüseyin Karabey's road movie *My Marlon and Brando / Gitmek* (2008) revolves around the theme of border-crossing and appears as a moving statement on the confining artificiality of borders. Taking place during America's invasion of Iraq in 2002, Karabey's film is based on the true story of a cross-border romance between Iraqi Kurdish actor Hama Ali and his Turkish actress girlfriend Ayça Damgacı, revealing an eye-opening cinematic journey across the borders between Turkey, Iraq and Iran: with its striking images from a geography of oblivion, this border-film exposes its spectators to the relegated knowledge about the grim racism and repression faced by Kurds in these three countries.

Far from depicting the world as a borderless global village, Zaim's and Karabey's border-films tease out a world of walls, barriers, fences, checkpoints and death to explore the abjected lives of ethnic others. In this sense, the cinema of borders is concerned with what Judith Butler describes as 'those "unlivable" and "uninhabitable" zones of social life which are nevertheless densely populated by those who do not enjoy the status of the subject'.[16] Moreover, Zaim and Karabey present in their cinematic spaces the memories of borders on both collective and

individual levels (border as a site of counter-memory and border-crossing as an act of critical remembering) and in a radical way to make the spectators realize that borders are no longer simply lines of division that frame a national territory, instead they become unremittingly expanding zones where people indefinitely dwell. Balibar states that the quantitative relation between 'border' and 'territory' has now been inverted. 'This means that borders are becoming the object of protest and contestation as well as of an unremitting reinforcement . . .'[17] Briefly speaking, the border-films of the new cinema in Turkey exhibit borders as sites of catastrophic memories with the purpose of raising an awareness regarding the fact that borders have long stopped functioning as a limit to the political, marking where the political community ends, and started functioning as political entities themselves. In other words, border-films betray how certain forms of radical alterity and enmity are mentally and physically constructed by the geopolitical imaginary and the culture of fear and securitization.

Curating soundscapes: Remembering the polyvocal/ multilingual society

Another distinctive feature of the post-Yeşilçam cinema of Turkey which makes it discernible from the earlier periods of Turkish film history is definitely its plurivocal and polyphonic soundscape, which is neither harmonious nor cacophonous.

First of all, since the 1990s, the voices of vernacular languages and the sounds of local auditory cultures have started to resonate more often than before in the soundscape of Turkey's contemporary cinema. Filmmakers have been creating conversational spaces in their films through curating dialogues written in the vernacular languages such as Kurdish (e.g. *Big Man, Little Love / Büyük Adam Küçük Aşk*, Handan İpekçi, 2001), which has always been considered by the Kemalist elite as an element of dissonance that causes a diversion from – even a big threat to – the vocal unity of Turkish national culture, and Homshetsi/ Western Armenian and Kirmancki/Zazaki, which have come under the danger of disappearing (e.g. *Autumn / Sonbahar*, Özcan Alper, 2008; *Where Is My Mother Tongue? / Zonê Ma Koti yo? / Ana Dilim Nerede?*, Veli Kahraman, 2012) as an inevitable result of the homogenizing tendency of the Kemalist cultural policy.

The most remarkable cinematic work of the last decade that gathers the voices of vernacular languages has been a semi-ethnographic film, or a semi-fictional documentary, *Two Languages, One Suitcase* (aka *On the Way to School / İki Dil*

Bir Bavul, Orhan Eskiköy and Özgür Doğan, 2008), which is based on the story of real characters who come across with each other in a Kurdish village in south-east Turkey: a young Turkish teacher, Emre Aydın, who doesn't speak Kurdish, and his encounters with Kurdish school boys and girls, who don't speak Turkish. By exhibiting the Turkish teacher's suffering from his desparate situation of being unable to communicate with his students, the film with its performative style not only allows its Turkish viewers to remember the existence of other languages spoken in Turkey and to rethink of their privilege of having a language, Turkish, that is widely spoken all over the country, but also opens a space for a critical discussion on the right of being educated in one's mother tongue.

Derviş Zaim's *Shadows and Faces* (*Gölgeler ve Suretler*, 2011), on the other hand, was another film that displays the voice as a pivotal element in filmic space to remind one of the lost 'bilingual' society of Cyprus which had existed until 1974. We witness the once peaceful coexistence of the two linguistic communities in the polyvocal space of Zaim's film where conversations between Turkish Cypriot and Greek Cypriot characters being performed by actors and actresses from both sides (Osman Alkaş and Hazar Ergüçlü from North Cyprus, and Popi Avraam and Konstantinos Gavriel from South Cyprus) have been constituted by both Greek and Turkish with local Cypriot dialects and accents.

Second, I should emphasize that the cinematic soundscapes of the recent films are not merely limited to the voices of languages. The auditory cultures have also been diversified in the dynamic topography of Turkey's contemporary cinema that can be mapped as a fluid and shifting surface that is enveloped by different sounds of local acoustic heritages. For instance, the opening scene of Selim Güneş's *White as Snow / Kar Beyaz* (2010) is accompanied by enthusiastic Caucasian folk songs and dances which find their roots in north-east Turkey and Georgia.

Third, the mnemopolitical films of the post-Yeşilçam cinema have made us listen not only to the voices of characters and the melodies of ethnic cultures but also the counterpart of voice/sound, namely, deep silence or muteness. In Yeşim Ustaoğlu's *Waiting for Clouds* (*Bulutları Beklerken*, 2003), we are presented with a silenced character, Ayşe/Eleni, who keeps silent about her Pontic Greek origin and her true identity for half a century after the population exchange between Greece and Turkey in 1923, because of the assimilation policies regarding 'minorities' starting with the Turkish nation-building process.[18] Another example is the protagonist of Derviş Zaim's *Mud* (*Çamur*, 2003), Ali, who appears as a crippled figure who loses his voice. This mute body was a perfect allegory of the Cypriots for whom *always* others have spoken, that is the United States, the

former USSR, the United Kingdom, Greece and Turkey. In the soundscapes of these films, the unspeakable speaks only through the silence of the characters, and accordingly what Dolar calls 'the voice of ethics' emerges from within the very silence or muteness of the Other, which was described as 'a silence that cannot be silenced'.[19] In other words, silenced characters appear as either the silenced subjects of history (the ones whose views about their own future are not consulted in the process of decision-making) or the agents of silenced histories (those whose subjective experiences of past events are not mentioned in mainstream historiography).

Silence, as Trouillot explains, is not merely an absence in the official history but 'an active and transitive process: one "silences" a fact or an individual as a silencer silences a gun. One engages in the practice of silencing. Mentions and silences are thus active, dialectical counterparts of which history is the synthesis'.[20] In this sense, the 'mute bodies' of the new wave cinema have a political function, which makes them idiosyncratically different from the mute bodies and disembodied voices of Yeşilçam movies that find their roots in 'dubbing'.[21] To sum up, filmmakers of Turkey's new cinema have mostly redefined the cinematic landscapes of their films as curatorial spaces where they exhibited the voice, silence, melodies and irreducible sounds of the Other. Silences as well as diegetic and extradiegetic sounds were collected and presented in these movies as ghostly aural objects, or phonographic ghosts, which appeared to be the uncanny source of historical non-knowledge.

Performing counter-narratives: Reminiscing unofficial histories

Counter-narratives constitute the third type of ghostly objects, namely irreducible traces of absence, that have been curated in the cinematic spaces of the new cinema of Turkey. Individual accounts of lived times, subjective dimensions of collective histories, testimonial practices of the survivors and witnesses of massacres and autobiographical narratives have resonated as counter-narratives in many mnemopolitical movies including narrative films and oral history documentaries, providing perspectives that run opposite or counter to the official history, that is, the Kemalist master narrative. The counter-narratives of the post-Yeşilçam films arise out of the experiences of individuals or groups that do not fit and are critical of the Kemalist master narrative. Hence, as expected, minor histories as counter-narratives have often been neglected by the Kemalist

ideology and by its 'historiography of oblivion', that is, the official discourse of history and its politics of forgetting, 'whose purpose is not simply to "revise" understandings of the past, but specifically to obliterate the memory of certain events from public consciousness'.[22] The new cinema of Turkey has not only provided a deconstructive mode of collective remembering through *curating* fragments of alternative histories, or less-known individual stories of the social past, but it has also been producing a 'memory-to-come', that is, a critical archive about the history of the present time for future generations which stands opposed to Kemalist historiography. Although few stories have been told and recorded of different communities and of their collective memories until now, we find noteworthy examples of counter-narratives in both contemporary documentary and narrative films of the mnemopolitical cinema in Turkey.

Two oral history documentary films, *38: A Documentary on [the] Kurdish Massacre in Dersim* (*38: Dersim Katliamı Belgeseli*, Çayan Demirel, 2006) and *Two Locks of Hair: The Missing Girls of Dersim* (*İki Tutam Saç: Dersim'in Kayıp Kızları*, Nezahat and Kazım Gündoğan, 2011), which reveal the dark side of the early years of the Republican period, are particularly worthy of mentioning here. Calling for a responsible and emphatic spectatorship through a mode of 'forced remembering',[23] both films direct the attention of the viewer primarily towards different individual stories of eyewitnesses regarding the Dersim Massacre, which occured during Mustafa Kemal Atatürk's dictatorship of the 1930s. Although the close ties that Atatürk and his Republican People's Party (CHP) had with the fascist European governments of the 1930s, those of Hitler and Mussolini, are well known today, Dersim Massacre has remained until now a relatively unknown catastrophic event, gracefully passed over in silence or deliberately misrepresented by most historians. As part of the 'Kemalist civilizing mission', a military campaign was launched in March 1937 against parts of the rebellious Kurdish district of Dersim, renamed Tunceli in 1935. This mountainous region between the cities of Sivas, Erzincan and Elazığ had not been brought under the control of the state. The Dersim campaign lasted until September 1938 and resulted in the deaths of many thousands of civilian victims. Recently, in a November 2011 speech, Prime Minister Tayyip Erdoğan apologized on behalf of the Turkish state for the Dersim killings and referred to this catastrophic event as a 'massacre'.

In his oral history documentary, *38*, Çayan Demirel pursues a politics of mourning aiming to provide a counter-hegemonic discourse of memory through a detailed account of *what happened* in Dersim and with the aid of thorough interviews made with survivors. Nezahat and Kazım Gündoğan, on the other

hand, focus on the *consequences* of the disaster in their loosely structured oral history documentary, *Two Locks of Hair*, by excavating the exilic stories of little girls who were adopted by families of high-ranking Turkish army officers after their parents were ruthlessly exterminated during the state's intervention against the Dersim revolt. Both films expose the spectators to a difficult knowledge about the horrendous history of Kemalist ideology, revealing how the single-party regime perceived Kurds to be 'internal enemies', that is, obstacles to the grand goal of national unity, and how several attempts were made to crush Kurds (either through extermination or through assimilation) without hesitation along with *all* other ethnic and religious groups including both Muslims (Sunnis and Alawites) and non-Muslims (Christians and Jews) in an attempt at a crudely secularized, militarized and Westernized culture.[24]

Conclusion

With a specific attention to the ghostly objects of the new wave cinema of Turkey, this chapter attempted to offer some insights into the *organization of cinematic space* as a place of counter-memories and proposed the concept of 'the curatorial mode of filmmaking'. In the scope of this essay, film as a term, refers to a technology of memory which means more than cinematic images as moving indexical traces. If so, then filmic space, as argued above, can appear either as a dynamic location of memory or as a 'spacing' of rememoration, that is, an endless externalization of contested memories and memory-to-come. I examined the spatial characteristics of selected films and argued that the filmmakers of those cinematic works use cinematic space as an exhibition place to curate counter-memory objects of violent pasts or silenced histories. In a cinematic space of exhibition, sensible and intelligible objects such as architecture of enmity, unfamiliar sonic elements of radical alterity, testimonial practices of the survivors and witnesses of massacres and autobiographical narratives appear as 'ghosts', or troubling figures of non-knowledge, that bring forth a series of elements of less chronicled, or unknown, parts of national history to constitute a counter-public memory which offers questions about the function of dominant knowledge production on national history. While both memory and history are fields of discursive struggle, memory 'suggests a more dialogic relationship between the temporal constituencies of "now" and "then"'.[25] Through its cinematic constellations of ghostly objects, the curatorial mode of filmmaking not only contributes to the neverending process of negotiation and

contestation that structures public memory in Turkey, but also provides relevant materials for the post-Kemalist account of an inherently multicultural nation.

Notes

1 Alison Landsberg, 'Prosthetic Memory: The Ethics and Politics of Memory in an Age of Mass Culture', in *Memory and Popular Film*, ed. Paul Grainge (Manchester: Manchester University Press, 2003), 146.

2 Jose van Dijck, *Mediated Memories in the Digital Age* (Stanford, CA: Stanford University Press, 2007), 1.

3 Russel Kilbourn, *Cinema, Memory, Modernity: The Representations of Memory from the Art Film to Transnational Cinema* (London: Routledge, 2010), 45.

4 I use the notion of 'cinematic space' throughout the text as a term that shelters both screenscape and film screen. Screenscape refers to cinematic landscape (or film set), namely the places in which the camera records the filmic event, whereas film screen signifies the surface which envelops the cinematic landscape, or onto which the filmic event is projected.

5 Pierre Nora, 'Between Memory and History: *Les Lieux de Mémoire*', in *Representations* 26 (Spring): 7–25.

6 Here, I should emphasize the distinction between the curator of film and 'the filmmaker as the curator of cinematic space'. The latter has nothing to do with *curating films*, but it would be better to describe what the filmmaker does as *curating ghostly objects in cinematic space*.

7 'The New Cinema of Turkey' has emerged in the last decade as an umbrella term to embrace mainly contemporary Turkish cinema and Kurdish cinema of Turkey, but it also has the potential to include future cinemas of the country as Anatolia's heterogeneous society has been composed of many ethnic Muslim groups and non-Muslim minorities of Turkish, Kurdish, Zaza, Circassian, Georgian, Laz, Bosnian, Albanian, Tatar, Arab, Romani, Greek, Armenian, Aramean/Syriac, Jewish and Levantine descent. A special issue on this cultural term was published in the film magazine *Hayal Perdesi* ('Dosya: Türk Sineması mı, Türkiye Sineması mı?' [Dossier: Turkish Cinema, or the Cinema of Turkey?], no. 20, January–February 2011, 32–75), and it was also used in a book by Savaş Arslan (2010).

8 Avery Gordon, *Ghostly Matters: Haunting and the Sociological Imagination* (Minneapolis, MN: University of Minnesota Press, 2008), 8.

9 Asuman Suner, *New Turkish Cinema: Belonging, Identity and Memory* (London: I. B. Tauris, 2010).

10 Hamid Naficy, *An Accented Cinema: Exilic and Diasporic Filmmaking* (Princeton, NJ: Princeton University Press, 2001), 222–87.

11 Etienne Balibar, 'What is a Border?' in *Politics and the Other Scene,* trans. Christine Jones, James Swenson and Chris Turner (London: Verso, 2002), 76.

12 Cynthia Cockburn, *The Line: Women, Partition and the Gender Order in Cyprus* (London: Zed Books, 2004), 40.

13 Derviş Zaim took one step further in the 'exhibition of border' in his Cyprus trilogy with the gala screening of *Shadows and Faces*, which examines the 1963 massacres against Turkish Cypriots through the story of a girl and her missing father, on the Green Line on 5 March 2011. This special screening gathered people from both sides including a group of around 20 Greek Cypriot journalists and intellectuals from the southern part of the island.

14 Etienne Balibar, 'Strangers as Enemies: Further Reflections on the Aporias of Transnational Citizenship', paper delivered at The Institute on Globalization and the Human Condition, McMaster University, on 16 March 2006, available at: www.globalautonomy.ca/global1/servlet/Xml2pdf?fn=RA_Balibar_Strangers. Accessed 17 May 2012.

15 Popi Avraam, cited in Ali Koca, 'Derviş Zaim's New Film Leaves Cypriot Turks, Greeks in Tears', in *Today's Zaman* (9 March 2011), online copy available at: www.todayszaman.com/newsDetail_getNewsById.action?load=detay&newsId=237667&link=237667. Accessed 17 May 2012.

16 Judith Butler, *Bodies That Matter: On the Discursive Limits of Sex* (London: Routledge, 2011), xiii.

17 Balibar, 'What is a Border?', 92.

18 Asuman Sulner, 'Elusive Fragments of an Uneasy Past: Representations of Non-Muslim Minorities in New Turkish Cinema', in *Turkish Literature and Cultural Memory: Multiculturalism as a Literary Theme after 1980,* ed. Catharina Dufft (Wiesbaden: Harrassowitz Verlag, 2009), 137–46.

19 Mladen Dolar, *A Voice and Nothing More* (Cambridge: MIT Press, 2006), 98.

20 Michel-Rolf Trouillot, *Silencing the Past: Power and the Production of History* (Boston: Beacon Press, 1995), 48.

21 Nezih Erdoğan, 'Mute Bodies, Disembodied Voices: Notes on Sound in Turkish Popular Cinema', in *Screen* 43, no. 3 (2002): 233–49.

22 Tessa Morris-Suzuki, *The Past Within Us: Media, Memory, History* (London: Verso, 2005), 8.

23 Russell J. A. Kilbourn, *Cinema, Memory, Modernity: The Representations of Memory from the Art Film to Transnational Cinema* (London: Routledge, 2010), 64.

24 Ironically, Kemalism's totalitarian cultural policy in the nation-building process has often been called 'Turkification' in spite of the fact that it definitely appeared as a form of secret 'colonization' project which successfully self-administered an 'organized amnesia' (Özyürek 2007, 3) through the absolute negation of native cultural heritage. Given its oppressive social engineering and cultural programme

of Westernization with radical reforms in language, alphabet, and all branches of arts (including the notorious case of music in the form of the famous ban on Turkish *maqam* music; the Kemalist regime banned its education in 1926 and its broadcast between 1934–6) Kemalism can be considered as the ideology of 'auto-colonization', a unique and unprecedented form of colonization in the history of colonialisms, which was based on the principle of self-negation (even self-destruction), that is, *de-Ottomanization*.

25 Paul Grainge, 'Introduction: Memory and Popular Film', in *Memory and Popular Film,* ed. Paul Grainge (Manchester: Manchester University Press, 2003), 1.

Non-Museums

Adnan Madani

Srinagar, 1963

In the capital of Indian Kashmir, that astonishingly verdant and starkly beautiful valley – a disputed territory, several times the cause of war between India and Pakistan and the main focus of the absurd militarism that plagues both nations – there is a curious reliquary, sacred to Muslims throughout the region. The 'Hazratbal' shrine, with its name made up of a corrupted amalgam of an ancient, pre-Islamic word and a more recent Arabic interloper, is a monument which jealously guards a hair that belonged – allegedly – to the holiest prophet of the Muslims, Muhammad. How this hair arrived in this place, hundreds of years ago and hundreds of years after the death of this venerable man from Arabia is a story that has its own place elsewhere, in the traditions and tropes of such narratives; suffice it to say that there is little doubt in the minds and hearts of the devotees of this shrine that this medium-length keratinous filament is indeed one of the only, if not the only object with which the pious, hungry for divine grace, can connect themselves bodily to the history and wonder of the founding moments of their religion and identity. So, when sometime in the late winter of 1963 the guardians of the shrine admitted that the hair had mysteriously vanished, the consequences were felt immediately and perilously in the body of the Muslim population of India as well as in the nervous political structures of this young and divided country. With no clues as to the location of the relic, riots were imminent and the very highest authorities, including Prime Minister Nehru, became personally – and very visibly – involved in the recovery efforts. Muslims, distraught and bereft, rumbled dangerously about conspiracies to deprive them of their most sacred possession; theories abounded as to the reasons behind

such a provocation, and as to the best way of countering such an attack. In this area, revenge and bloodshed are never too far away.

After a frenzied investigation lasting some months, it was announced that the hair had been recovered through the heroic efforts of the investigators who were specially appointed to the task: the item had, it transpired, merely been borrowed by a particularly influential Kashmiri family, at the request of an old woman who in her dying moments desired a last few opportunities of communion (*deedar*, *darshan* or 'sacred seeing') with the beloved Prophet's hair. An employee of the shrine was arrested for the act of stealing the hair and declared guilty, though few were entirely satisfied with the public show of culpability and punishment. The crucial moment of this story, on which restoration of communal harmony depended, was the public return of the hair to the shrine and its acceptance by the hereditary keepers. As is only proper to the religious realm (and the shrewd pragmatism that preserves it) scientific analysis of the recovered object was hastily and conclusively shunned by both the representatives of the government and the traditional guardians of the shrine. In a critical moment, the person deemed to be most familiar with the hair before its disappearance, a venerable man of faith, was handed the hair which he examined in great detail, checking it presumably for length, colour, texture and perhaps even something indefinable which carried the sanctity of the personage from which it had long since been detached. After patiently bowing to the task, and with some show of satisfaction, he unbent and solemnly declared the hair to be authentic beyond all doubt. The crowds, gathered breathlessly throughout the examination, breathed out collectively. Possibly, a civil war or unrest was averted in this instant. Reality – through an unsubtle insistence on procedures of the mythic, the animistic and the archaic – was restored to the unsteady balance between the secular and the religious that characterizes much of the thought and culture of the Indian subcontinent.

Kassel, 2012

Like many artists and writers from Pakistan, I first came to Europe to study – with an idea of abundance and authenticity in mind, one that was gradually dissolved through the multiplicity of real experiences and events that eventually erase or blur the outlines of the semi-mythical narratives that form a vision of 'the West' for us. This much is taken for granted everywhere. Our education in art and art history produces an engagement with an intensive version of this

narrative, one that distils the colonial transfer of culture and knowledge to a pure essence: modernity, history, destiny, call it what you will. These concepts are unquestioned events for us, but ones that happened elsewhere, and must therefore be claimed, reclaimed, visited, imported. To this end we travel and make pilgrimages. I make many such pilgrimages a year to museums, conferences and events, often without ever knowing precisely what my role is.

Already on the plane, the destination – the latest Documenta – creates for me a sense of reverberating awareness of space, of installation and curatorial connections. Soon after takeoff there is the usual announcement, and with mechanical regularity a number of passengers press their laptops into service. With varying speeds and noises, the machines wake up and await the commands that will create emails, revise reports, type essays; in other words, ensure the productivity that allows the world to become a village, as they used to say, or at least a series of interconnected and simultaneous villages. I wonder if any of the passengers lit up by the blue lights of their screens are also en route to the exhibition, and I amuse myself by trying to think of ways to distinguish them from the office workers, the bankers, the civil servants. A touch of bohemianism in the clothing perhaps? An ironic or historically knowing approach to personal adornment, in the form of a retro moustache or hairstyle? Shoes or items of clothing that fall into the now globally recognized tribalism of street style that has us, non-conformists, all dressed like one another – the right degree of turn-up for the trousers maybe? I get some ideas, make some deductions and convince myself that at least one fellow passenger is also a traveller in art. Perhaps I will see him on the ICE train from Berlin to Kassel later, poring over the same computer, clearing a path for his arrival and work or solving the technical problems surrounding some artist's multi-channel video installation (they are so easy to transport yet so painful to set up!). On reflection, he is possibly too hip and trendy to be an artist himself. Certainly a functionary, if anything, within the complex network of galleries and organizations that get invitations to important previews, and can witness the works of art while they are still fresh and auratically blessed with the nervous presence of the artists putting finishing touches.

I arrive at the exhibition – no trace of my fellow passenger by the way, probably just a student or musician or cool technology entrepreneur – and indeed, my friend and fellow artist whom I have come to visit and support is fiddling with the details of her video work. She asks me what I think of the arrangement, she has left traces of the installation – scaffolding, paint tins, etc. – around the projection screen, as evidence of a desire to leave the work open and unbound by the neat conventions of video art. I seem uncertain, and she senses this and

responds: Didn't I once write in a journal essay about the growing slickness of South Asian art and the alarming tendency for artists to produce work that seems destined from inception for biennials and art fairs – that is work that 'travels well'? Hadn't I urged on her and other colleagues a more thoughtful or playful engagement with the streams of cultural capital that we must all join, regretfully or joyfully? My own answer at this time, put on the spot, is simply to leave the decisions to her. I am here to see the product of her imagination and will judge it as such; perhaps I am old-fashioned that way because I also know that art today is a seamless collaboration between all the players involved, creative, critical and administrative. Lyotard says of Daniel Buren[1] that he was right to see more of the hand of the curator in the museum exhibition than of the artist – it's just that he was wrong to be angry about this situation. We are all producers and ceaselessly itinerant pilgrims, especially the critics and writers and theorists – we travel particularly well (and cheaply).

My friend asks for reassurance elsewhere, finds it and is eventually pleased – justly – with the reception of her work in this most prestigious of events. She can be quite certain that this means that she has 'made it' in the bigger world of European art, and South Asian writers and curators will take an even stronger interest in her work, will fly to Berlin and London and New York to see it.

National Art Gallery, Islamabad, 2007

The heyday of the latest in a long line of military regimes in Pakistan; constant political strife has not yet clouded the popularity of the former President, General Musharraf, among the 'educated middle classes', who nod collective and vigorous assent to his culturally progressive policies, particularly his call for activities that promote what he calls the 'soft image' of Pakistan. This image, in all its textural force or non-force, is meant to bring to an end the myth of Pakistan as a backward, un-modernized theocracy. The example of Turkey is much discussed in drawing rooms and in media briefings. It is clear that the existential questions that threaten Pakistan must be answered in the minds of people elsewhere. Investors, travellers in cultural and conventional capital must become unafraid of the strangeness, the hardness and resistance of this new country, become convinced of its pliability and sameness. To this end, the country's first 'National Art Gallery' is inaugurated amidst great fanfare and jostling for position and prominence in what will presumably become the centre for the thriving and increasingly commercially viable contemporary art world in Pakistan.

Leaving aside the architectural attempts to signify a concern with heritage and local history on the façade of the building, the museum that is eventually built is a perfect example of the kind of blank expression that characterizes the neutral faces of supermarkets, airport lounges, hospitals, museums, coffee shops everywhere. A 'non-place', to use Marc Augé's word,[2] a space in which nothing can truly *happen*. It could hardly be otherwise, given the project's brief: contemporaneity in art demands precisely this neutrality, this lack of resistance to the sense of the globe and the extension of its transnational filaments through such portals. The location too, is perfect: the tiny capital city of Islamabad was purpose-built as an administrative centre far away from the disruptive living reality of the previous capital. Nestled in the hills below Kashmir, a heavy-handed mixture of neo-Islamic kitsch and concrete modernism, a city of pastiche that now contains this hopeful gallery that will focus the energies of the entire nation's bright artists, many of them quickly making their names on the international scene (where else?).

Given the inevitable destiny of culture-by-diktat, I don't need to add, perhaps, that this museum is today virtually silent, neither a home to great treasures nor an instigator of national/cultural 'vitality' (whatever this might mean). The task that Lyotard imagines for the museum and its surrounding culture – to present art in its 'alertness' and to fight against what is 'inert' in the rituals of viewing, producing and archiving objects – seems impossible when galleries and museums function merely as mirrors for the outside world, or attractors for foreign investment in the manner of industrial expositions and fairs.

In the sense urged by Lyotard (an urgent sense), the alertness of art must be created or preserved by the museum, but only through the selection of art that is not made expressly for this or any other imaginary museum. In doing so, the museum will be able to remove itself from the easy circuit of approval, connoisseurship, patronage, funding that characterizes the global art world. Furthermore, for Lyotard, to be 'contemporary' in art is to be contemporary with *all* of the history of art and its many possibilities – explored or unrealized – and to be unafraid of conditions of anachronism that rupture the homogeneity of museum-time. This contemporaneity is nothing less than a religious commitment, even more so in a secular age, where the religious approach is transferred to the realm of culture and values.

Perhaps this incompatibility explains the absence or inadequacy of museums in Pakistan – where religious life and history still permeate the thought of a nation. The cold secularism of the white cube (even with gentle Mughal

embellishments) and the equally cold intellectualism of the contemporary art within are seen as repellent or simply irrelevant. This art belongs to a different life, a different place and history that cannot account – perhaps – for the ferocious tide of fervour that threatens death and unspeakable violence over a single missing hair.

Toba Tek Singh, 1948 or 1949

Saadat Hassan Manto's famous story[3] about the partition of the Indian subcontinent along religious lines is also a reflection borne out of a profound engagement with the terror and humour of political nominalism (in perhaps the same way as Duchamp's entire oeuvre can be seen as a nominalist's encounter with art history). In Manto's story, a year or two after the time of Partition (but the chronology of the story is deliberately hazy, the reliability of the narrator suspect) the inmates of a lunatic asylum begin to wonder which side of the border they will end up on, as the authorities decide to exchange and repatriate Muslim, Hindu and Sikh lunatics. The inmates speculate on matters such as how it is possible for a city to be in India one day and in Pakistan the next, but find no satisfactory answer. One man in particular, a Sikh who is often referred to by the name of his village, Toba Tek Singh, and who is known for never lying or sitting down and for speaking in a garbled, untranslatable mixture of English and Punjabi, becomes terrified at the prospect of ending up in Pakistan and insists, at the time of the exchange, that his village Toba Tek Singh is precisely where he himself is standing, facing a border which he refuses to cross. In the final moments of the story, Toba Tek Singh is found pitched face forward on the barbed wire, in the no man's land that separates India from Pakistan.

In the identification of the lunatic and the name of the place he comes from, and in the eventual resting place he finds on the boundary line of hostility and division, there should be a dark lesson. Reassuringly, there is none. Two countries created by the drive of historical myths that no one believes in any longer, framed by sharp wire and sentry posts, erase themselves and their lived history to justify their continued existence, to deny the absurdity of their being and the possibility of their extinction through irrelevance rather than nuclear war. It is this no man's land and its uncontainable anxiety that is now recreating the landscape of the nations in their very own singular image.

Notes

1 Jean-Francois Lyotard, 'Concealments', in *Postmodern Fables*, trans. Georges Van Den Abbeele (Minneapolis: University of Minnesota Press, 2003).

2 Marc Augé, *Non-Places: An Introduction to Supermodernity,* trans. John Howe (London: Verso, 2008).

3 Sa'adat Hasan Manto, 'Toba Tek Singh', in *Mottled Dawn: Fifty Partition Sketches and Stories*, trans. Khalid Hassan (London: Penguin, 2003).

Part VI

Stages

The polis, properly speaking, is not the city-state in its physical location; it is the organization of the people as it arises out of acting and speaking together, and its true space lies between people living together for this purpose, no matter where they happen to be. 'Wherever you go, you will be a polis': these famous words became not merely the watchword of Greek colonization, they expressed the conviction that action and speech create a space between the participants which can find its proper location almost any time and anywhere. It is the space of appearance in the widest sense of the word, namely, the space where I appear to others as others appear to me, where men exist not merely like other living or inanimate things, but make their appearance explicitly. This space does not always exist, and although all men are capable of deed and word, most of them – like the slave, the foreigner, and the barbarian in antiquity, like the labourer or craftsman prior to the modern age, the jobholder or businessman in our world – do not live in it. No man, moreover, can live in it all the time. To be deprived of it means to be deprived of reality, which, humanly and politically speaking is the same as appearance. To men the reality of the world is guaranteed by the presence of others, by its appearing to all; 'for what appears to all, this we call Being', and whatever lacks this appearance comes and passes away like a dream, intimately and exclusively our own by without reality.

Hannah Arendt*

* Hannah Arendt, *The Human Condition* (Chicago: University of Chicago Press, 1998), 198–9.

Curating, Dramatization and the Diagram: Notes towards a Sensible Stage

Bridget Crone

I will try to define dramatization more rigorously: they are dynamisms, dynamic spatio-temporal determinations, pre-qualitative and preextensive, taking 'place' in intensive systems in which differences in depth are distributed, having partial subjects [sujets-ébauches] as their 'patients', having the actualization of Ideas as their function . . .

Gilles Deleuze[1]

There have been many recent debates about what exactly constitutes 'the curatorial' amid the expansion of so-called curatorial activity to include performances, various educational and participatory projects and of course talks and screening programmes. Definitions that have been proposed for this expansion include: the para-curatorial, new institutionalism and the educational turn, all of which in various ways describe the activities of curators other than producing exhibitions in the gallery. Rather than entering into discussions of the definition of practice, this text argues that the curatorial instigates a very specific form of activity relevant to our contemporary context. This context could be crudely described as a state of acceleration and movement, producing a crisis that is simultaneously financial, social and cultural and, at the same time, conceptual in manner. This crisis has been typified as the move from the centralization inherent in the Foucauldian model of 'disciplinary society' in which individuals fit into the institutionalization of life according to their given role, to the Deleuzian model of 'control society': a decentred, individualistic and highly creative mode in which individuals constantly modulate their behaviour through forms of competitive self-governance. In brief, the contention is that

the constant modulation and movement of this system creates an opacity in which everything, all of the time, is in flux and formation. Curatorial activity insinuates itself within this context in the manner of a diagrammatic operation: a methodology that attempts to organize or make sense of this chaotic and ever-changing world. The diagram, therefore, gives form to a world that is otherwise abstract, obtuse and chaotic: as a diagrammatic operation, the curatorial is what, here, we will term *the sensible stage*.[2]

Thinking about the curatorial as a sensible stage is to focus on the emergence of subjects and ideas through the exhibitionary structure. This definition of the curatorial dispels or disregards the debates surrounding the para-curatorial for example, and, instead, favours an expanded notion of practice that focuses on its operation and what this operation makes visible. Furthermore the concept of the sensible stage provides a motif for two contrary tendencies within current curatorial practice: on the one hand, what could be termed a shared-authorship that emerges through a given situation. This is an immersion into the commonality of the sensible in which the body of the curator is literally submerged in the 'common sensorium' of all bodies in the situation.[3] On the other hand, the concept of the stage provides the opportunity to force a split or rupture within this immersive commonality of the sensible, reinserting representation and spectatorship into this situation. In a paper presented at the *Société française de philosophie* on 28 January 1967, Deleuze presented the concept of 'dramatization' or what he called 'the method of dramatization'. Deeply embedded in the movement and expressionism of his early work, dramatization provides Deleuze with a method that articulates the 'spatio-temporal dynamisms' that serve to bubble up, splurge forth or *actualize* the Idea. Put very crudely, what this means is that rather than being the result of a Platonic demand (what? how?), the idea is actualized through the particular dynamics inherent in a particular time and place: a 'special theatre', Deleuze calls it.[4] Through the 'agitations of space, pockets of time, pure syntheses of speeds, directions and rhythms', this dramatization enables the emergence of subjects and, of course, ideas.[5] However, because these subjects and ideas are produced through the situation itself – through a kind of subterranean dynamic that exists 'beneath organization', 'a system filled with qualities and developed in extension' – there is a constant threat of not emerging or disintegrating back into obscurity.[6] The concept of the sensible stage counters this threat of obscurification by locating the stage as a highly visible site of encounter. The sensible stage exists somewhere between the emergent dramatization of intensities (or differences) and the rupturing or

splintering[7] of these through a theatrical mode that suggests the reassertion of a dialectical force.

This approach accepts the 'para' activities of the curatorial as a given and, instead, focuses its interest on what is made visible and how, that is, the moment of encounter or *staging*. Here curatorial practice is intrinsically performative because it is bound up with the moment of encounter: it is realized through a coming together of its component parts that can only ever be encountered in the instant. In addition, and most importantly, this definition of the curatorial as a diagrammatic activity acknowledges an understanding of our contemporary context that is characterized by movement. This is an acceleration of the logics of flow, dissemination and collapse that is apparent in Deleuze and Guattari's work for example, and is addressed by theorists working today who characterize the current crises of neoliberalism through these dynamics (our crisis, its effectiveness). Thinking about the curatorial as a diagrammatic operation is to consider it as an operation that engenders a visibility, and, as the work of artists such as the young London-based artist Cara Tolmie demonstrates, this is the act of creating the stage for its own realization. For example, in her performance, *Myriad Mouth Line* (2011), Tolmie articulates the fragility and contingent nature of this stage.[8] The performance begins with Tolmie traversing the four edges of a square. She walks a square. Then she dances it: activating her body in a series of mannered, intensely bodily movements. Then, her voice rings out in shrieking, rhythmic manifestations at each of the four corners of the square that her body traces and activates in space. First the body, then the voice emitted through the body: the body pushes through space carving out a space for something to happen within but the happening is in itself the articulation of the stage: movement and form in one. It's an architecture created through movement. Plastic. Mobile. Mutable. *Myriad Mouth Line* creates a temporary space for its own emergence. And therefore, the way in which Tolmie's performance emerges from its own architecture reveals the diagrammatic nature of the curatorial.

Tolmie describes *Myriad Mouth Line* in distinctly filmic terms, breaking the performance down into a series of five frames that she unpacks and critiques in the final, fifth frame. The effect of this approach is to emphasize the temporal fragility of the space that she creates for and through the work. Furthermore, the equation with a filmic process of projection acts to further articulate a sense of contingency within the work so that our attention is directed to the performance as a moment that appears out of a generalized formlessness. In other words, the appearance of the performance occurs within the very likelihood that it might not appear or might not be visible and instead remain undifferentiated

among a mass of bodies, images and movement. Evoking the apparatus of film in this way means that Tolmie is able to activate something important about the projection of film itself: it simultaneously appears and is transformed through its appearance. This is to suggest, therefore, that in *Myriad Mouth Line*, the body of the performer is simultaneously projected on the stage as well as creating (outlining, delineating, activating) the stage for its own appearance. And so, in evoking the filmic device of the frame, Tolmie highlights the continual movement of the image as an affective flow of bodies from which she emerges, becoming differentiated as she undertakes the performance. Tolmie's action of self-realization through the staging of the apparatus of the performance (the delineation of the stage) and herself as a subject that appears within this stage is a *method of dramatization* akin to that proposed by Deleuze.

Understanding the projection of images (analogue or digital) as a moment of appearing and actualization provides a means for understanding the concept of the diagram, particularly in relation to a world in which images move around us continually in an undifferentiated flow: they are everywhere and nowhere – a fleeting flash of colour, a suggestion of colour that is at once visual and synaesthetic: as much a feeling as a seeing. This abstract movement or flow of images is no gentle or meandering durational activity but rather a speedy and savage chaotic surge of affects where bodies and images are collapsed together into one massive tidal wave of information that's rich with potentiality and potent with chaotic drives. Deleuze has described this as a form of abstraction in which there is a tension between collapsing into this tidal wave (and just going with the flow) and fighting it in order to emerge from its depths. The diagram therefore describes the lines along which the inside and outside (immersion and emergence) fold together, separate, re-fold and so on. And, the curatorial stage emerges along these lines: the result of a series of pressures that force it out of the 'thickness of the body' or bodies together.[9] Thinking the curatorial in this way is to think of curating as the result of a constellation of pressures and forces that in gathering force (or necessity) act together in producing this point of emergence. Thus producing what we have termed here the act of *staging*.

The concept of staging provides a means for understanding curatorial activity whether an exhibition, time-based event, talk or screening as a moment of appearance that occurs through (and despite) the contesting movements of disintegration and potentiality. Furthermore through its etymological links to theatre, architecture as well as rupture and time, staging is a counter force to the 'deep' abstraction of movement and extension. In this way, staging offers us a double-action because it simultaneously recognizes our immersion in the

unfolding action and at the same time it separates us from it, offering us the view from 'outside' of the stage: a position of spectatorship. In his book, *Theatricality as Medium*, Samuel Weber articulates this privileging of sight in the etymology of theatre as a 'desire for exteriority and control'.[10] However at the same time, Weber highlights the immersive impetus of self-presence within theatre in which 'thinking and being are the same'. The doubling produces, according to Weber, a constantly divided or split subject in relation to theatre, that is a subject that is split between 'life and death, spectator and actor, strange and familiar'.[11] If we attempt to define the concept of staging in the same manner, we achieve a to-ing and fro-ing between a time and place that is, on the one hand, causal – that is, it surges forth, the result of a build-up of pressure and forces – and, on the other hand, is an imposed or divisive structure. It is the tension between the two that gives a frailty to the notion of staging as something that occurs in between an organic causality and an imposed structure.

Like the twin motifs of dramatization and diagram (the drive towards 'pure spatio-temporal dynamism' on the one hand and organization and legibility on the other), the sensible and the stage offer a means for accentuating the counter-pull between these forces. Alain Badiou has described theatre as the coming together of the body and text in the presence of a public (which is itself created by the occasion of the theatre itself). We could say in this way that theatre is both aleatoric and contingent – the result of a meeting between bodies and text – and at the same time deeply causal because it is produced through and by these bodies meeting. What this means for the curatorial, then, is that it is a procedure that is both produced through the situation (i.e. its singularity emerges from the sum of its parts, the meeting of body and text) and at the same time it is an outside factor – an organizing principle that brings things together to produce something new. The curatorial stage or diagram is therefore produced through the meeting of various players (or in Deleuze-Spinozean terms, bodies) and at the same time, it insinuates a legibility upon this encounter. The concept of the sensible stage therefore responds to this situation suggesting that the curatorial operation exists within and is produced through an encounter with a loose assemblage of components or participants. In this way, the role of curator is also produced through the curatorial activity – it is a part that is played and produced or produced and played simultaneously. Yet at the same time, the stage itself is not an immanent structure. It is not simply produced through the meeting of bodies or the meeting of body and text as Badiou defines theatre, but it exists through language as a 'given': that is, as its own form that has a past and future all of its own. What this means is that the stage of our encounter – the exhibition,

the gallery or museum, the talk, the theatre, the screening and so on, all of these things – provide a structural framework that pre-exists the encounter with the body but they do so as a kind of virtual or possible that is itself dramatized through the encounter with the body. In this way, the sensible stage proposes a path between the emergent intensity of Deleuze's dramatization and Badiou's articulation of theatre as the meeting of bodies and text.

Considering the curatorial through this concept of the sensible stage enables us to understand curatorial activity as part of this 'evolving field of operations' as Paul O'Neill suggests in a recent essay on the para-curatorial.[12] However, if, alongside this, we consider our contemporary context to be a continually evolving field characterized by a constant acceleration of movement, then the para-curatorial only serves to further strengthen this already dominating form of activity by following the logic of accumulation, expansion and dispersion. But if, on the other hand, we recognize and capitalize on the contradiction inherent in the diagram, that is the space between the two terms 'sensible' and 'stage' (the contrary pull of disintegration and illumination), then, through the motif of staging as a means to propose both separation and immersion at once, the role of the curatorial (whether para or not) is both the action and performance of disruption. That is to say, that the curatorial recognizes itself as an inherent part of the activity that it stages and also somehow separates. However it is the reflexivity of this position – a kind of helpless duality of action and retreat – that makes its action powerful because it activates both a desire for autonomy and its impossibility.

Notes

1 Gilles Deleuze, 'The Method of Dramatization', in *Desert Islands and Other Texts 1953–74,* trans. Mike Taormina (New York: Semiotext(e), 2004), 108.

2 See Bridget Crone, ed., *The Sensible Stage: Staging and the Moving Image* (Bristol: Picture This, 2012).

3 See Jacques Rancière, *The Politics of Aesthetics*, trans. Gabriel Rockhill (London: Continuum, 2006).

4 Deleuze, *Desert Islands*, 94.

5 Deleuze, *Desert Islands,* 96.

6 Deleuze, *Desert Islands,* 97, 98.

7 Badiou differentiates his concept of 'splitting' or 'forcing' from the Hegelian dialectic however, and in a manner that is too complicated to go into here. Suffice to say that Badiou's split is an event in which the possibility of something new is created through the splitting of accepted relations.

8 Cara Tolmie's performance originally took place at the London Frieze Art Fair in 2011. It was recreated as part of the LUX / ICA Biennial of Moving Images, *Sensible Stage*, curated by Bridget Crone in 2012.

9 Gilles Deleuze, *The Logic of Sense*, trans. Constantin V. Boundas (London: Continuum, 2005), 178.

10 Samuel Weber, *Theatricality as Medium* (New York: Fordham University Press, 2004), 3.

11 Weber, *Theatricality as Medium*, 42.

12 See Paul O'Neill, 'The Curatorial Constellation and the Paracuratorial Paradox', in *The Exhibitionist* 6 (2011).

Curating Context

Aneta Szyłak

After developing a series of projects relating to particular locations, buildings and historical narratives, I found myself in possession of a somewhat unexpected expertise which I have ended up calling 'curating context'. When, on occasion, I have been asked to teach what I mean by 'curating context' as a 'discipline', I always feel uneasy about it, as if this disciplinary approach would rob the practice of some as yet ungraspable element. I suspect that 'curating context' is not really a discipline or a methodology, but rather an approach that reveals not only a way of understanding an artwork as a possibility, but also as a way of understanding the task of the curator not simply as displaying artworks, but as transgressing the limitations of the very context of art.

There is more and more openly formulated demand for art to do more, be more or become something else. I am considering curating context not as a site-specific adornment or a display of local discoveries, but as a way of activating a context and subsequently changing what we think this context is all about. What I want to address here is not the activity of making exhibitions – setting up artworks for display, for example – but rather setting a friction between them and with their surroundings.

'She is a methodologist of "contextual curating", a colleague of mine once said about me in front of a group of students. However astonishing this naming was, it forced me to revisit the process that led me to be given that name.

Being addressed as 'a methodologist' in a field that has not yet taken shape causes a feeling of responsibility for something that is already being recognized as a practice but is not certain whether or how it can become knowledge and what kind of implications this holds. In his *The Practice of Everyday Life*, Michel

de Certeau defines The Expert as the one who exchanges competence for authority:

> Ultimately, the more authority the Expert has, the less competence he has, up to the point where his fund of competence is exhausted, like the energy necessary to put a mobile into movement. During the process of conversion, he is not without some competence (he either has to have some or make people think he has), but he abandons the competence he possesses as his authority is extended further and further, drawn out of its orbit by social demands and/or political responsibilities. That is the (general?) paradox of authority: a knowledge is ascribed to it and this knowledge is precisely what it lacks where it is exercised.[1]

That is to say, the more we put into practical use what we know, the more we see ourselves as situated in a form of practice that is recognized as assigned to us. This turns us into an object of study and a fixed point of reference and makes us lose the legitimacy of our inventiveness and of our ability to be politically transformative. Most dramatically, de Certeau writes of The Expert that 'He misunderstands the order which he represents. He no longer knows what he is saying.'[2] De Certeau is pointing at the use of objects, symbols or traditions in everyday practice and the way this use gives legitimacy to knowledge (including the banalities, materialities and simplicities of our immediate surroundings). This expertise then leads to repetitive forms of doing, a repetition that loses the audacity of the inventiveness of the moment of action, thus becoming legitimate and accepted forms of practice.[3]

These were also my concerns as this supposed 'methodologist of contextual curating' that I had become: that I could continue performing in a way that had quickly become normalized as a practice without examining the ethical or political implications or interrogating the forces that prompted the idea of curating context to slowly become a form of knowledge.

Maybe it is not worth looking at curating context as if it were an already established practice or a form of knowledge-production. Instead, I might aim to examine it in the moment of its formulation. To think it through as a mode of inhabiting the immediate environment for which we are responsible, as a mode of being with context. This includes not only material elements and immaterial knowledge, but also everyone implicated in that context, and the pursuant forms of relations and shared narratives. Jean-Luc Nancy writes that:

> Praxis is the endless transformation of the subject of a sense in itself: a sense that it is nothing other than its communication – and by the same token, its

concealment. The concealment of thinking is its praxis: thinking then undoes its object in order to become the thinking that is: we, with one another and with the world.[4]

Considering this statement, maybe we should then see no division between renovating a building, teaching, making an artwork, cleaning the floor, establishing an art institution or making a political statement. All material and immaterial labour, including monotonous works and impulsive actions, become one and contribute to the taking of a stance within a given condition. Above all, it is simply doing what is necessary to be done.

The question is how such works and actions become operational for the recognition and activation of context. This, I posit, is foundational for formulating the term 'curating context'. Such an understanding of different levels and forms of curatorial responsibility seems to be attuned with Paolo Virno's opinion that

> The customary frontiers separating Intellect, Work, and Action (or, if you prefer, theory, poiesis, and praxis) have given way, and everywhere we see the signs of incursions and crossovers.[5]

This contextual activity includes numerous practical demands which, at the level of curating, not only influence curatorial positions and decisions but also reveal and make active its invisible, unpredictable and uncontrollable elements. This leads me towards the supposition that perhaps we are not curating 'in-context' but rather we 'curate context' as such. In so doing, we are not only addressing artworks, these same artworks also become the means of arriving at meaning. Granted, we do not fully control what one can learn from curating context. First, the context can also be activated by something else, thus forcing us to admit that we are not in complete control. Second, the attention of the users of context – never singular – can also point at a 'meaning' that simply had slipped through our fingers, as if it had never been there.[6]

Thinking through this contextual activity, I am not intending to set a catalogue of rules and recipes for 'contextual curating', one that would immediately become a methodological fossil. There is no attempt here to discipline curating context but to turn our attention to the ungraspable and ambiguous, to eventful moments and to all these slippages that escape our lucid categorizations and leave us always in want for more. I am trying instead to incorporate a diverse set of elements in order to implicate curatorial practices – a practice which is here understood to encompass not only exhibition-making, but also the working of different forms of social relations, incepting, conceptualizing and launching art

institutions, fighting financial limits, struggling with the materiality of a site, taking political stances, voicing discontent and all their accompanying burdens and pressures.

Curating context might be an attempt to theorize a form of curatorial practice in the visual arts, understood not only as the task of curating displays that use artworks to narrate or expose context, but as a way of engaging them and ourselves in an inquiry into the specifics of context and its meaning. This means to be under the influence and even oppression of context. I am interested in what we can learn from these forms of engagement that are not positioned in praise of or in homage to context.

I understand context as a synchronic composite of unfitting, fragmented material and immaterial elements. It includes not only what appears as a dominant or overarching visual narrative, but also what does not fit, what is unwanted, troublesome, awkward and impossible to theorize. Sometimes, context also incorporates and simultaneously obscures autobiographical details in a colourful sub-set of stories made up of personal motivations, difficulties and relations that are invisible but nonetheless operational in one's practice. In a way, it adds a hidden context that is not habitable by those who engage with contextual curating, but remains nonetheless a clandestine influence on curating context.[7]

Grappling with materials of which I am an inseparable part sets up a pivotal question, or a series of questions: How am I to speak about a context that I am inextricably a part of? Am I not also an active agent of contextual relations before being an individual on a stage? By throwing myself into the local how exactly do I become a part of it? Through what means can I begin to arrive at its meaning? How can I insert things, actions and ideas into a context that I recognize in order to make it active? How can I operate in order not to instantiate meaning, but make it happen?

Curating context is a proposal that sets questions in regard to space and time. It is not just a particular location, economic, social or political condition or a local narrative, it also includes layers of historic formations that are connected to it. Henri Lefebvre addresses this social space as a 'writing tablet' of history:

> The uncertain traces left by events are not only the marks on (or in) space: society in its actuality also deposits its script, the result and product of social activities. Time has more than one writing-system. The space endangered by time is always actual and synchronic, and it always presents itself as of a piece; its component parts are bound together by internal links and connections themselves produced by time.[8]

This attempt takes place at a moment when we are coming to understand that something has happened to the ways in which curatorial activity contributes to knowledge production today. As 'curating' is swiftly growing to be understood as the problematics of staging exhibitions, a subject of study, a profession, an appealing career choice, as well as a contemporary model of public intellectual, it is also becoming ever more urgent to ask what the curatorial is and what it does. The curatorial, as formulated by Jean-Paul Martinon, is not exhibition-making, a curatorial practice or curating as such. The curatorial is the event of knowledge that is made possible by the curator both intentionally and unintentionally at a particular moment in space and time.[9] It has relational/interactive features and focuses not on the 'end product' (the exhibition, conference or publication) but rather on the performative implications of such an enterprise. I see curating context as a practical contribution to the more general concept of the curatorial – as its cognitive, affectual momentum.

Traces of thinking towards the curatorial can be found in a text from the mid-1990s, expressed using a different vocabulary but with a similarly intended meaning. Ine Gevers in 'Curating: the Art of Creating Contexts' closely approaches our notion of the curatorial, although she continues to use the term 'curating'. Gevers understands that:

> Curating is a practice that permits the creation of different interpretative contexts, embracing different political, social and psychological positions, theories and ideologies, at the same time as making critical connections between them. To put it more simply, it is about opening up 'spaces', within which different discourses can be brought into relationship with one another, 'spaces of transformation' in which both critical and self-critical engagement are put into work as the chief transforming agents. Such 'spaces' would bring personal strategies into the public domain in a way that encourages an arena of inter-subjectivity. These imaginary contexts, then, would have to engage with the discourse of the viewer/respondent on the level of the aesthetic, the ethical and the cognitive and would have to place emphasis not so much on the 'autonomous' objects or works of art but on the signifying process offered by the context as a whole and the transformation worked by all of its component agencies acting together.[10]

Gevers does not, however, elaborate on the eventful or affectual potential of the curatorial and omits the fact that what it makes possible is not just a single address towards the public, but a more complex form of implication that also includes those who cause the process or who seem to remain peripheral to it in a relational and reciprocal manner.[11] In addition, one could say that what she

means by creating contexts is the stimulation of intertextual relations. I would assert that context is an already existing condition, which we come to recognize and inhabit. We can thus curate it in a sense that we insert our selves, things or stories in order to activate it. But what Gevers contributes to the discussion is a call for making active the relations between things, thoughts, subjects and spaces going beyond the staging of research on art or presenting artworks. The way she addresses the opening 'spaces' that subsequently can become an 'arena of inter-subjectivity' sets the ground for what I would call curating context as a moment of sharing understanding. Gevers recognizes the potentiality of the unexpected in what we now call the curatorial.

In considering curating context with regard to the curatorial, it is essential to find out how we can productively engage with the context – be it a narrative, locality or material residue – an activity often seen as a kind of idealistic agenda in unimportant places. We must ask ourselves: How can the context be not only identified, unearthed or singled out but also made active without being reduced to just an exposure of local histories or an exotics of particularity? How can the local become a membrane that resonates new possibilities? How can we enter a situation and inhabit the erratic nature of its context? How can we deal with the troubling dimension of the fact that 'feelings are always local'?[12] How we can we affect and be affected by the scattered calcifications of narratives and counter-narratives, fictions, falsifications, failed economies, lost relations and physical damages?

The layers of factual information, illustration and interpretation included in the context all fuse with the emotional affect and the texture of its encounter. All these offer an insight into what is found (spatial, material, relational, political, cultural, ethical, economic or historical meanings – whether personal or empirical) and what Gevers calls the 'imaginary ones'.[13] Context includes not only 'what is there' but also our ability to recognize it, so it is dependent upon the relational potential of this encounter. We learn from a context on the basis of what took place, on the basis of the actions taken and what generated a set of affects. In this way, making an exhibition establishes both the context (an interpretative one) and its intertextual relations. For me, the main idea driving my understanding of context is a broader notion that it is determined by what surrounds us and represents a complex, multifaceted condition beyond the context of the art exhibited.

Context is something that we tend to perceive as a frame but in fact, context is not fixed; its edges are blurred, its texture rich and folded. It is there as a pre-existing order, a surrounding condition (physical, economic, historical,

visual, textual and/or political) and yet it has palimpsestic aspects. Context is a reservoir of knowledge that only comes to the fore with a curatorial practice. Concomitantly, practice is a reaction to the visible and invisible specificity of the surroundings and occurs as a mode of inhabitation, making the context (whether we belong to it or not) vibrant and active. There are many levels and layers to these possible activities, both intentional and not.

Contextual practice is not meant to unearth the depths of context, to make it understandable or visible. It is an act of disturbance. Indeed, the limited potential provided by the act of identifying oneself with a context causes us to infuse, insert, densify and complicate it. We are not taking things from the context, but rather inserting things into it. What does context make possible? Grounding, understanding, political engagement, answerability to ethical demand, knowledge production? This is part of what we are trying to discover. The curatorial does not fix problems and it is not an agent of good will. It does not resolve social problems, but may cause the shared context to come up with modes of articulation that we are able to recognize.

Coda: Your Apples Fall Into My Garden: Two Takes on Context

On Gloucester Road

. . . so we are sitting with Cihat, Je Yun and Iñes at Prêt-à-Manger on Gloucester Road. Je Yun and Iñes are chatting; I don't really know what they are talking about. Sipping slowly my steaming Earl Grey, I struggle to explain to Cihat the concept of estrangement, which I am developing for an exhibition at The Showroom in London. But my efforts fail, as I'm still formulating my thoughts.

. . . so we are swinging gently between talking about our research and writing, Estrangement and its upcoming exhibition in town. And music too, Cihat's way into music. At some point he says it is, you know, a *taqseem*, a *taqseem* . . . a musical improvisation. An Arabic word. What do you mean? There is a Taxim Square in your city, right? I gather it means an improvised space then? No, I think that the square's name is drawn from another meaning, which is 'division'. Like in maths, you know . . . And then, I come to realize that this is what I've been trying to explain to him for an hour about estrangement, which to me can be understood as an improvised space at a division point. It is about bringing the inevitability of the split into the potentiality of a reconnection.

At the same time, I am aware that I can't give him a definition or try to find a synonym. Estrangement can only be coded as a cultural form. It shows itself. It manifests itself. It builds curiosity. It allows for possibilities.

Form is a struggle still calling for a meaning.

An Unsent and Unsigned Letter

. . . so now I must unlearn you my dearest one. Engulfed by love, longing and desire, we have to delete from one another, cell by cell.

Bifo says we have to start desiring each other and become a body again. But since we are to be apart there will be no body aside from the one we are losing. The estranged ones.

In which sense is this being apart more of a potentiality than being together? Estrangement is related, so much, to longing in incompleteness. It gives us a continuity that shared life isn't giving us. We do not yet know when we will touch each other one last time, but the inevitability of it was in the first time we touched one another.

Estrangement is the refusal of giving way to the evaporation of what has brought us together, my dear one.

In my country, the laws say, that if a fruit falls from a tree and lands in your neighbour's garden, it belongs to her. We let apples from our trees fall into each other's garden. My apples in your garden. Your apples in mine. And they keep on falling but it isn't certain for how long.

So what shall we do, dearest one? One can picture them. One can pick them up and eat them. Or let 'em rot. To watch the new tree that is growing from the seeds of your apples. Your apples are falling into my garden.

Written on flights between Gdańsk, Berlin, Sulemaniya and Amsterdam.

Notes

1 Michel de Certeau, *The Practice of Everyday Life*, trans. Steven F. Rendall (Berkeley: University of California Press, 2011), 7–8.

2 De Certeau, *The Practice of Everyday Life*, 8.

3 Not long ago the legendary member of the militant wing of the union Solidarnosc and who spent several years in prison for taking part in numerous riots against Communist rule and who fought for workers' rights in recent times returned from Warsaw. He took part in an anti-fascist demonstration that efficiently and actively idled the growing neo-Nazi manifestation. He said, 'we were not fighting for democracy to have Nazis marching on our streets'. And then he added with

the disarming smile, 'you know, I am doing this all the time; I know how . . . I knew how to stop them . . . I know everything about demonstrations now' [Memorized private conversation]. The protest, the riot and demonstration had become knowledge and what was produced originally by necessity of political momentum in the 1980s is now a form utilized in another political context with different content and modes of protest.

4 Jean-Luc Nancy, *A Finite Thinking*, trans. James Gilbert-Walsh (Stanford: Stanford University Press, 2003), 47.

5 Paolo Virno, 'Virtuosity and Revolution: The Political Theory of Exodus', in *MakeWorld, Paper 2*, trans. Ed Emory, published on the occasion of the European Social Forum in Florence in November 2002. Available at www.makeworlds.org/node/34. Accessed on 17 August 2012.

6 In her text 'Looking Away. Participations in Visual Culture' (*After Criticism: New Responses to Art and Performance*, ed. Gavin Butt, 2005) Irit Rogoff proposes looking away from the contexts of art on display and instead employing a multi-focused perception of things that may not be intended as a part of the presented project.

7 I am inspired by authors such as Kathleen Stewart, the author of *Ordinary Affects* (2007), a book in which the everyday piles up in the form of a series of short stories. The reader encounters situations, peoples and places and learns, as the book goes on, of being somewhere and being affected by it. Another source of inspiration is a small book called *Atlas of Novel Tectonics* by Reiser + Umemoto 2006 dedicated to 'the specific reality of the project'. The book combines fragmented and singled-out issues such as matter and its organization, forms of operations, abuses of knowledge and its representation and so forth. It is combined with diagrams, illustrations and comments as content inserted to stimulate our understanding, not to submit the complete and narrated body of knowledge. The ways that these authors address notions of context in architecture may interest us as well, as they see architecture more as rapture or insert than as the obedient submission to it.

8 Henri Lefebvre, *The Production of Space*, trans. Donald Nicholson-Smith (Oxford: Blackwell, 1991), 110.

9 See in this volume, Jean-Paul Martinon, 'Theses in the Philosophy of Curating'.

10 Ine Gevers, 'Curating: The Art of Creating Contexts', in *Conversation Pieces* (Maastricht: Jan van Eyck Akademie, 1995), 41–2.

11 The issue addressed numerous times by Irit Rogoff in papers such as 'Looking Away: Participations in Visual Culture' or 'The Implicated' presented during C/K seminars.

12 See Joke Buver and Arjen Mulder, *Feelings are Always Local* (Rotterdam: V2 Publishing, 2004).

13 Gevers, 'Curating: The Art of Creating Contexts', 41.

26

Backstage and Processuality: Unfolding the Installation Sites of Curatorial Projects

Ines Moreira

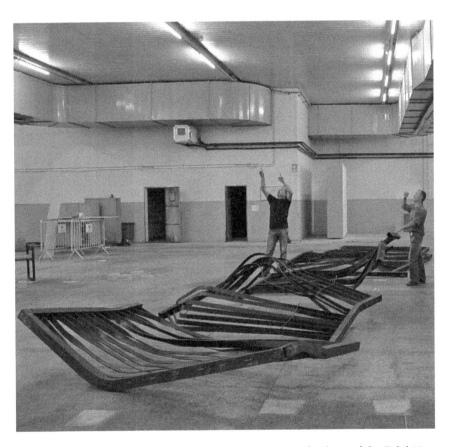

Figure 26.1 Stills from Telmo Domingues's documentary, 'Making of the Exhibition Buildings & Remnants', curators: Ines Moreira and Aneta Szylak for Guimarães 2012, European Capital of Culture.

*That is, practice necessarily entails materiality. And just as materality is integral
to practice, so is it integral to the knowing enacted in practice. Put more simply,
knowing is material.*

Wanda J. Orlinkowski[1]

Exhibition-making is a technical, pragmatic and non-discursive extension
of curatorial projects. Most of the time, it is understood as a 'poor relative' of
research, and as its uncomfortable material and practical annexe. Exhibition-
making fundamentally resembles other production processes: planning,
logistics, setting-up, installation and construction. Its processual condition
recalls a backstage, both as a production space and as a non-representational
practice.

A backstage supports the construction and realization of projects. It shares
the same condition of building sites in architecture and engineering. They are
spaces of profound processuality: building sites of ephemeral architectures. The
notion of backstage (as in theatres or in music stages) refers to the technical and
logistic support of a show. A backstage refers, as well, to a state of incompletion,
an unfinished place where 'the making' takes place. A backstage generates
exhibitions, extends artist's studios and creates exhibitionary structures, from
spatial installations to scenographies.

To consider an event from the angle of its making is to think of states of
becoming, procedures and incomplete objects. A first step is to unfold and
analyse the notions of 'processual' and 'material'. Studies in techno-science
explore technical objects beyond their immediate reduction to technical
representation or to their primary technical functions. Could these studies
provide us with the tools to consider the processual condition of exhibition-
making? Amidst the ongoing debates in these studies, there is a long lineage
of authors who have put forward concepts that engage with processuality and
materiality. Some concepts provide a network and/or framework of ideas with
regards to the objectual, the processual and the material, thus proposing a
precise vocabulary: things [Heiddeger[2]], technical objects [Simondon[3]], partial
objects and assemblages [Deleuze[4]], quasi-objects [Serres[5]], literal metaphors
and figurations [Haraway[6]], actor-networks and actants [Latour[7]], or complex
performative allegories [Law[8]].

Can we rethink the intersections of curatorial research and practice,
processuality and materiality, objects and agents? What if we understood

exhibition-making not as the inevitable practical side of research, but as an extension of a conceptual and discursive project?

Processual notions[9]

A sensitive conceptual approach to the processual dimensions of space can be found in the work of two authors, in close theoretical proximity: Bruno Latour and Albena Yaneva. Latour's text 'Can We Get Our Materialism Back, Please?'[10] is an introduction that provides the core argument for Yaneva's text 'When a Bus Met a Museum: Following Artists, Curators and Workers in Art Installation,'[11] in which she expands the argument by addressing questions of exhibition-making.

Both Latour and Yaneva are concerned with materiality, processuality and with a certain critique of the objectual (and therefore conventional knowledge linearity). Their thinking asks us to consider a critical approach to the hidden processes taking place in exhibitions, which, to summarize, can be named the 'processual production of objects', or 'the process of staging objects'. If the production of objects is not a *thin* but a *thick* reality, as Latour proposes, then objects perform diverse networks that actively assemble other actors and networks. Latour invites us to think of a horizontal interconnected network of agents and actions, as in science laboratories or in technical constructions, which Yaneva explores in *Actor-Network Theory* as a detailed ethnographic approach to the making of an art installation.

The setting-up of an exhibition offers the conditions to observe the ambiguous/ unclear situation of the construction of art installations providing an oblique entrance to museums, as institutions, as collection or as representation. Yaneva explores the gap:

> Institutional theories and material culture studies have rarely addressed the fact that the museum before the opening ceremony of the show is a strange messy world composed of heterogeneous actors with a variable ontology. (...) 'Museum' is here understood as a quasi-technical network involved in art fabrication work: it is both an installation site and an installation setting.[12]

Addressing the exhibition from its reverse perspective (not from the audience or from its conceptual premise) and from the perspective of its construction, its contingencies and other interrelations, Yaneva's field report opens a space between the strictly conceptual and processual nature of production, and the

more rigid notion of a structure behind the formal curatorial plan and the institutional frame of the museum.

Tracing the entrance of a bus from the street and through the meticulous technical phases in which a heterogeneous team 'turns' this bus into an art installation in a museum gallery, Yaneva states:

> Following the actors through the object's tribulations, one can expose the materialization of all these successive installation operations, and show the appearance of a whole collective acting in the space. (. . .) Instead of being situated in a single artistic mind, in the imagination of a genius, the artistic process is instead seen as distributed within this visible collective.[13]

The stabilization of the object in a 'stage' is a long processual path in which the object is nothing but stable and whose definition is shared by a set of agents and actions.

Focusing on the set-up of an art installation brings two very productive notions that help us to expand our thinking: the first is the set-up as *a process of becoming art*; the second is production as performing *the unstable state of the art object*. Both emerge from a thorough description of the materiality, technicality of the processes of making, including its incidents and its daily human dimension.

The process of becoming art is a notion that refers to the relations which are human, material and technical in exhibition-making, articulating art installation as a collective and heteroclite activity:

> A small collective is formed in the situation or moment (. . .). The collective is composed of bus, wooden platform, workers, technicians, their tools and mutual jokes, their small controversies and negotiations. It is composed of technical managers and curators, their conversations, notebooks, doubts and security precautions. (. . .) When the artist orders the displacement of the bus from the left to the right and all the way back again, he displaces this collective in a momentary and reversible way. The bus is in the process of becoming art.[14]

The process of becoming art has an imprecise time span and is variable in its relational geometry.

The second notion is confusing and invites for a definition of the objects as coming from its actions, agencies and procedures. The *unstable state* is therefore not possible to define or clarify, it can only be described in its many performances:

> To analyze the bus's displacements on the platform, the cleaning procedures and the small temporary events in the Dufy hall, I tried to show the numerous

series of infinitely small repetitions of elements and movements, deployed in the uncertainty of art production. This approach allowed defining objects not only by their components (material or symbolic) but by the peculiar ways they are opened and closed, proliferated and black-boxed, multiplied and rarefied. (. . .) [A]rt in the making can be followed by depicting the course of its installation.[15]

The instability at stake is close to the notions of *mess, confusion, and relative disorder* that John Law[16] suggests as modes of knowing, describing and creating new realities.

Call for materialism

Bruno Latour demands a *thick* notion of objects, making clear that a technical construction is more than the strict sum of its parts. He calls for a *material materialism* as opposed to the Cartesian notion of an *idealist materialism*. Undoing the material reduction of objects to its technical representations is one of the central questions in Latour's short, but brilliantly titled essay, 'Can We Get Our Materialism Back, Please?':

> For any piece of machinery, to be drawn to specs by an engineer, on one hand, or to remain functional without rusting and rotting away, on the other, requires us to accept two very different types of existence. To exist as a part inter partes inside the isotopic space invented by the long history of geometry, still-life painting, and technical drawing is not at all the same as existing as an entity that has to resist decay and corruption. Obvious? Yes, of course – but then why do we so often act as if matter itself were made of parts that behave just like those of technical drawings, which live on indefinitely in a timeless, unchanging realm of geometry?[17]

Latour's *materialism* is more than just parts, pieces and bits technically assembled together as objects. It is important to understand that the technical calculation of concrete beams or metal truss that structure a building, plywood walls and wooden staircases in an exhibition cannot represent the wholeness of the concept and its meaning, as in a technical object. In the process of assembling (or setting-up), the lives of repairing, maintaining and disassembling, or the experiential dimension of its inhabiting and producing are some of the many dimension of the *material*.

The fundamental passage in Latour's *call for materialism* touches upon two notions that are familiar to curatorial endeavours, the act of *enframing*, as an

act of depicting an image by freezing its limits, and the more abstract notion of *opacity,* which has been referred by Nina Montmann when proposing a critical revision of institution making in contemporary art, by avocating the right to be opaque as a mode to generate space for experimentation within institutions.[18] They act antagonistically, one freezing objects, the second potentiating processes, bridging more closely the question of *material materialism.* What Latour calls *enframing,* is a question initiating bridges to the terrain of curatorial studies:

> What is so promising about extricating material materialism from its idealist counterpart – of which the concept of 'enframing' is a typical example – is that it accounts for the surprise and opacity that are so typical of techniques-as-things and that techniques-as-objects, drawn in the res extensa mode, completely hide. The exploded-view principle of description makes it possible to overcome one of the main aspects of bringing an artifact into existence: opacity. In other words, it draws the object as if it were open to inspection and mastery while it hides the elementary mode of existence of technical artifacts – to take up Gilbert Simondon's title.[19]

The call for *material materialism* introduces a certain negation (or resistance) of a technical thing to be fully exposed, keeping *experimentation/contingency* within its very opacity. Somehow, materialism is opaque, hides a 'secret' (as in Derrida), and is performed and conjunctive, proceeding as a thing (as in Heiddeger), and not as pure bits and pieces of abstract matter. Certain *opacity is* where *thick objects* perform its materialism, via which escape reduction to objective representation. *Thick objects* are instantiating within opacity the performativity of *materialism.* This potentiates our concerns with exhibition-making and the spatial dimension of curatorial projects.

Unfolding installation sites

The period between vernissage and ending is the most stable, and most objectual period of an exhibition. The unstable definition of scenographies, installations and technical elements, and the confusing set-up processes, tend to be erased from the show, though its documentation may parallel other platforms. But we may only approach the 'processual' nature of space and spatial production if we underline the complexity and multidimensional activities of curating (design, production, materiality and the processes of assembling) and if we grasp what we may designate as curatorial practice in/on processual space.

Most 'designed' spatial installations or scenographies involve professional technical teams (museums, galleries, theatres) that follow plans with protocols that usually have tight contingency margins, which impede processual thinking. By contrast, in more sculptural objects, art installations and experimental participative projects with communities, it is a common practice to find spatial designers taking part in their construction and production. The same happens in artist-run spaces and in self-organized projects, where it is a common praxis to find the curator, architect or artist all taking part in the setting-up process.

From collecting bits and pieces of materials in streets, backyards and sidewalks to sharing and exchanging with other *bricoleurs*, Folke Kobberling and Martin Kaltwasser[20] have been exploring and openly using traditional everyday practices that seem to be disappearing from today's cities: repairing, adapting or self-building. Their art installations may assemble materials found in public space and recycled into new public structures (pergola, gazebo, bus stop, plaza), or use materials from fairs, reusing them in new exhibition pavilions and stands, or generating new art objects that explore the expressivity and the materiality of the found materials, as a critique of environmental exploitation and expenditure. Using their own hands and fellow volunteers and occasionally other skilled craftsmans, they adopt, transform and produce large-scale installations using DIY technique and aesthetics to create art installations of large-scale spaces.

Part of their research explores the policies of making, finding in self-built environments, such as in the legal thresholds of *gecekondu* construction procedures for illegal construction in Turkey, models which they adopt and experiment with as method. The collection, organization and storage of found materials led to Baustoffzentrum, a warehouse storing their materials and resources for building. These are organized in types of wood, colours, shapes and other categories ready to be transformed into art installations, exhibition spaces or urban interventions.

The project *IFA* (2007) at the Art Forum Berlin, for example, transformed the stand of the gallery that represented their work, Galerie Anselm Dreher. The artist/architects designed and built the gallery stand by performing found materials taken from a previous commercial fair of electronic appliances. The art fair's materiality became an extension of the cycle of 'set-up/dismantle' 'set-up/dismantle' typical of fairs, thus embodying in its very space a critical revision of the economic cycles in which these are participating. Kobberling & Kaltwasser transform the position of the experts (whether architect, or artist, or curator) through the setting-up. To engage in a project through its production processes and materials demands to actively take part, to participate. This position differs

from most *idealized* projects – in architecture, scenography or in curating – as this mode of work generates projects which, in some cases, do not precede the set-up of the exhibition – nor as a represented idea, nor as a literal transcription to materials.

Kobberling & Katwasser, have developed their conceptual approach as a mode of 'curatorial thinking'. They are organizers of events, workshops, conferences, educational platforms, thus expanding the limits of what a scenography or a spatial installation can be. Their projects, and the making of their projects, become extended cultural and curatorial projects engaged in processual and material activities.

Processuality can be explored as a mode of making and of thinking of curatorial projects. From different practices generating *material objects and spaces* arise different levels of engagement with the backstage. Aside with the material objects, another layer of a project is to structure the *processes* to create it.

Focusing on the backstage invites an inversion of traditional terms: the practice (exhibition-making and exhibition design) is a mode of participation for curators, proposing an oblique meandering through the object-process-space relations. It invites for reflexivity of the exhibition as a material concept and of the curator as practitioner.

Processual thinking allows one to engage with the dimensions of making as part of the concept of curating, and to depict material space and its technicalities as layers of a curatorial project. Engaging the work as an active participant differs from the supervision and passive observing of conventional research. As a coordinator and a critical observer, a curator's engagement gets closer to that of a doer and may go beyond the position of a witness (reading, writing and thinking), as he/she may intervene in the material processes, opening space for participation and to explore experimentation/contingency as a modality of research and practice.

Curators would act as scaffolds to the process of making, a conceptualizer, a coordinator, but a doer as well, participating actively in deep awareness of the production processes. Curating can become a mode of work-in-between-object-process-idea-materials-text-transportation-concepts-logistics exploring conceptually the practicalities of its own processes. The processuality of exhibition-making, the materiality of exhibition space and the performativity of production processes could all be further explored as modalities of curatorial knowledge.

Notes

1 Wanda J. Orlikowski, 'Material Knowing: The Scaffolding of Human Knowledgeability', *The SeeIT Project at MIT* (October 2005): 3. Available at http://seeit.mit.edu/Publications/OrlikowskI_OKLC_write-up_2006.pdf. Accessed 10 January 2012.

2 Martin Heidegger, 'The Thing', in *Poetry, Language, Thought*, trans. Albert Hofstadter (New York: Perennial Classics, 2001).

3 Gilbert Simondon, *Du mode d'existence des objets techniques* (Paris: Aubier, 1958).

4 Gilles Deleuze and Felix Guattari, *Anti-Oedipus: Capitalism and Schizophrenia*, trans. Mark Seem (London: Athlone Press, 1983).

5 Michel Serres, *Le parasite* (Paris: Grasset, 1981).

6 Donna J. Haraway, *Modest_Witness@Second_Millennium. FemaleMan©_Meets_OncoMouse: Feminism and Technoscience* (London: Routledge, 1997).

7 Bruno Latour, 'On the Difficulty of Being an ANT: An Interlude in the Form of a Dialog', in *Reassembling the Social* (Oxford: Oxford University Press, 2005), 142–56.

8 John Law, *After Method: Mess in Social Science Research* (London: Routledge, 2004).

9 The image illustrating this essay is part of the set-up of an exhibition whose scenography I have designed with *petit CABANON*. The exhibition was called *Art for Life, Art for Living* and took place in Barcelona in May 2011. Curators: Laurent Fiévet and Silvia Guerra. Space: *petit CABANON (Ines Moreira + Paulo Mendes)*. Artists: Isabelle Le Minh, Jean Denant, Quentin Armand, Alejandra Laviada, Mauro Cerqueira, Raul Hevia, Jonathas de Andrade, André Guedes (gasworks), Wind Ferreira (Palais de Tokyo), Sergi Botella, Mariana Zamarbide (Hangar).

10 Bruno Latour, 'Can We Get Our Materialism Back, Please?' *Isis* 98, no. 1 (March 2007): 138–42.

11 Albena Yaneva, 'When a Bus Met a Museum: Following Artists, Curators and Workers in Art Installation', *Museum and Society* 1, no. 3 (November 2003): 116–26.

12 Albena Yaneva, 'When a Bus Met a Museum', 117.

13 Albena Yaneva, 'When a Bus Met a Museum', 118.

14 Albena Yaneva, 'When a Bus Met a Museum', 122.

15 Albena Yaneva, 'When a Bus Met a Museum', 125–6.

16 John Law, *After Method: Mess in Social Science Research* (London: Routledge, 2004).

17 Bruno Latour, 'Can We Get Our Materialism Back, Please?', 139.

18 Nina Montmann, 'Opacity: Current Considerations on Art Institutions and the Economy of Desire', in *Art and its Institutions: Current Conflicts, Critique and Collaborations*, ed. Nina Montmann (London : Black Dog Publishing, 2006), 100.

19 Latour, 'Can We Get Our Materialism Back, Please?', 141.

20 Folke Koebberling and Martin Kaltwasser are a couple of artist and architect
 developing exhibitions, installations and ephemeral urban interventions,
 questioning societies' uses of construction materials as a resource, and the politics
 and the economics of the new. On Folke Koebberling and Martin Kaltwasser body
 of work, see: /www.koebberlingkaltwasser.de

This Is Not About Us

Je Yun Moon

This is not about us, the curators. The curator as a new figure of authority, a proliferating profession, or a self-sufficient institution is not the issue here. This is not about who we are or what we do. It is simply tedious to discuss the rise of the new positionality of curators in the art world as a new form of authority or as a new powerful type of agent. Positions of hegemony have always been present in any type of institution, economy or system. What is so special about one position of hegemony replacing another? This endless identificatory drive to define who or what a curator is owes a great debt to the modern subject machine that has hyperbolically produced self-sufficient, independent individuals as a basic unit for a holistic picture of the world.

Instead, this is about what happens between us, the curators, in the most expanded sense of the word. If one leaves behind the master narrative of *Live in Your [own] Head* proposed by a hetero-normative privileged white male subject, one then finds the possibility of opening up a new understanding of the ontological ground for the curator-subject and its relation to the other.[1] Yes, I am talking here about the driving term that immediately calls for a different space of reflection from that of the curator, one which, so far, has unsatisfactorily been articulated as 'the curatorial'.

What has to be emphasized here is the fact that the word 'curatorial' is not an adjective that describes the mode of operation of professional curators. In other words, the curator is not the first to exist and then the curatorial happens to be its mode of operation. The term 'curatorial' no longer dictates a specific role or position. It is a driving word through which we can begin to negotiate with the imperatives of the modern subject machine.

What I am interested in is the performative aspect of the word 'curatorial' and what its utterance does to the existing identificatory machine that endlessly consumes us. By shifting the discursive space from curator to curatorial, what opens up here is a new mode of operation that is detached from what I would call the assembly-line model: self-sufficient professional individuals gathering together and contributing to each other's output, with these outputs accumulating, one on top of another, thus making up the final work: an exhibition.

Once we detach ourselves from the assembly-line model by uttering the word 'curatorial', what becomes available is what I would like to articulate as a 'choreographic mode of operation'. In the same way that the curatorial is not about the mode of operation of professional curators, the choreographic mode of operation is not necessarily about the mode of operation of professional choreographers. Of course, this does not mean that a choreographic mode of operation cannot be found in contemporary choreographic practices. It does. But what I would like to put forward here is that overall, a choreographic mode of operation opens up a new relation with the identificatory drive of the modern subject machine. How is this possible?

From its very beginning, choreography has been the act of writing one's movements onto somebody else's body.[2] In this way of articulating choreography, two distinctive meanings are put together: to write one's movements and the body of the other. Yet there is no natural transference between writing one's movements and the body of the other. But the very engineering of putting them together is what allows choreography to develop a specific relation with a modern subject machine in Western history.

The very first moment when a discussion on the need to invent this new technology, later called choreography in the history of the West, can be found in the dialogue between a Jesuit priest/dance master, Thoinot Arbeau, and the lawyer Capriol, in *Orchésographie* (1589), which André Lepecki introduces in his book, *Exhausting Dance*.[3] The conversation was triggered by the young lawyer when he pleaded to his master to set his movements down in writing after he realized that the art of dance was vulnerable to the passage of time. Here, writing should not be understood as being subordinate to logocentrism. In other words, writing is not just a representative device, that is inferior to the actual movements of the master. Instead, the technology of writing is deployed in order to inscribe the movements against the passage of time. In other words, writing was what captured the subjectivity of the master in order to repeat its performance and thus preserve it beyond his death.

Thanks to this new technology, the movements of the dead master find a way of always being present. This presence not only manifests itself when the student socializes among themselves, but also as the companions of his own youth reunite together to celebrate his memory.[4] By allowing the transcendental presence of the subject to remain in this way in play, choreography – which later manifested itself as a heterogeneous set of power relations in the development of Western modernity – thus plays an active part in the construction of the modern subject machine. Yet, this transcendental subject always writes one's movements for the body of the other (including one's own youth), from the very first moment of its inception (this is not necessarily emancipatory). This is why the choreographic 'I' is perceived only as providing a 'space of appearance' for the other, borrowing Hannah Arendt's words.[5] This does not change in a situation where one is choreographing for oneself. This is the very spot that enables contemporary choreographic experiments to develop a new relation with the modern subject machine, different from the assembly-line model.

Against this backdrop, it is fascinating to witness how contemporary choreographic experiments have performed the choreographic mode of operation that opens up a new space for reflection by continuously negotiating with the conditions of possibility inherent in the notion of choreography. Here, I am thinking of the proposals made by choreographers such as Brois Charmatz, Jérôme Bel, Jan Ritsema, Christine de Smedt, Eszter Salamon, Xavier Le Roy and Jonathan Burrows, to name but a few. Although it is not possible to bracket them under one umbrella, it is however not difficult to find convergences and interrelationships between their practices. One of the most evident examples of convergence is a recognition of the possibilities inherent in the notion of choreography, as a powerful drive to open up different understandings of the subject, a way of structuring the subject by writing for somebody else's body. In doing so, this group of choreographers begins to use choreography for projects that are entirely different from their historical precedents in theatrical dance.

What seems crucial to me in their operation is the fact these choreographers never stop playing with the limits inherent in the notion of choreography. They are not only flipping around and turning upside down the sets of conditions that allow the subject to write for somebody else's body, they also endlessly bring back the voice of the master without repeating it. In doing so, they turn the existing limits of conventional choreographic practices into the very material that will allow them to set up what I call 'epistemological games'. What I mean here by an epistemological game is the playful work of keeping 'questionability' alive in order to continuously negotiate with the conditions of possibility that have been helplessly circumscribed

within the modern subject machine.[6] This is why the epistemological games set up by this group of choreographers should really be recognized not only as distinctive from those of the revolutionary impulse, but also as transgressive as the spirits of the historical avant-garde under its Hegelian dichotomy.

Overall, their epistemological games have contributed to a rethinking of how one forms a relationship with the never-ending modern subject machine, and this without denying its everlasting operation. Their epistemological games never attempt to 'molecularize' the subject into a 'physic-aesthetic model'.[7] Instead, they create a game between the 'molar' subjects in order to continuously negotiate with the conditions of possibility. Yet, this choreographic mode of operation clearly differs from the operation of networking, as it is not about promoting exchanges or multiple encounters based on self-sufficient subjects.

With regard to the curatorial, the epistemological games that are set up by contemporary choreographic experiments in relation to the discipline of choreography allows the creation of a distance between the practice of curating and the curatorial mode of operation. Again, thinking about the curatorial through choreography has nothing to do with the notion of an expanded field of practice that resembles a melting pot of practices and ideologies. The choreographic mode of operation challenges or disturbs the very ground on which the notion of the curator-subject is safely based and with which it harmoniously maintains its relationship with other disciplines.

Rethinking the curatorial through a choreographic mode of operation thus allows us to open up a different *episteme* for curatorial practice. Curatorial practice is never about us and never about the final product that we ought to produce. It is always, already, a way of writing for somebody else's body in the most expanded sense of the word. In these multiple processes of writing for somebody else's body, what happens between us gets staged and in the process produces a different relation to the modern subject machine.

Notes

1 *Live in Your Head* is the abbreviated title of the historical exhibition *Live in Your Head: When Attitudes Becomes Form*, Kunsthalle Bern, 1969, curated by Herald Szeemann.

2 Etymologically, the word choreography means: body (*chorea*) – writing (*graphy*).

3 André Lepecki, *Exhausting Dance: Performance and the Politics of Movement* (London: Routledge, 2006).

4 Lepecki, *Exhausting Dance*, 26–7.
5 Hannah Arendt, *The Human Condition* (Chicago: University of Chicago Press, 1998), 198.
6 Irit Rogoff articulated 'questionability' in a Curatorial/Knowledge seminar on 16 June 2012.
7 Yves Citton refers to the 'physic-aesthetic model' when he discusses the molecular subject suggested by Neo-Spinozian philosophers in opposition to Rancière's 'molar' subject in 'Political Agency and the Ambivalence of the Sensible', in *Jacques Rancière: History, Politics, Aesthetics*, ed. Gabriel Rockhill and Philip Watts (Durham: Duke University Press, 2006), 129.

Coda: The Curatorial

Charles Esche

It's not as if there's really that much substantial about an individual curatorial practice. It's a parasitical activity in the end, where the ability to manage, negotiate and compromise is generally the most prized of assets. A clever curator has constantly to trim and modify to try to ensure that something approximating a curatorial vision remains visible through the tangle of financial and other interests that shape the ground rules of a given project. Even more so than most contemporary artists, curators are in the hands of urban consultants who determine what might constitute city promotion or cultural development; or increasingly we fall under the influence of capitalist oligarchs for whom art is an element in a constantly shifting game of one-upmanship. Curating may well have its famous personalities and its attempt at a canonical history but there's still something essentially secondary about it . . . or maybe it's better to say that it has aspirations to philosophical or aesthetic coherence but is so often compromised by the expectations of patrons and bureaucracies that the agency of the curatorial is rarely fully deployed.

Of course, this situation is largely true of the artistic act as well. The modernist rhetoric of autonomy and self-expression that apparently gave artists a licence to be funded while not being accountable was always an ideological contract. Arms' length public funding was part of the armoury of the West during the Cold War, a way of promoting the benefits of free market democracy against the more direct instrumentalization of art for political ends in the East. While the Cold War settlement took almost 20 years to decay, after 1989 there was no more ideological reason to fund arts as a manifestation of Western freedom and gradually other motivations – urban improvement, tourism, social inclusion, education – emerged from governments to make it clear that public money came with official expectations. More recently, particularly in states such as the Netherlands, these arguments are being abandoned as culture is seen as of value only to private interest and patronage. These shifts in financial dependence

coincided with the emergence of the freelance, authorial curator as a figure that could negotiate between artistic practices and the bureaucrats or oligarchs who needed to be able to show outputs and outcomes in order to hand over their cash. A process of curator-funder negotiation replaced the arms' length policy of distributing money to art production, one in which artists were only one among a number of interest groups and not necessarily the most privileged. To avoid direct confrontation with the assumed unpredictability of the 'artistic persona', the curator as middleman was beneficial for all sides.

I do not think we should bemoan this condition or understand it to be somehow inferior to the fiction of modernist autonomy. Instead it seems more than rational to expect that money, power and organization will express their own agenda when they come to support the artistic act. However, the analysis I have provided does require careful consideration of the compromised nature of the curatorial as an activity embedded within a system and an analysis of the relative quality of its agency as it is exercised on each individual occasion. We must grasp the impact of the curatorial on the way art is produced, consumed and understood as well as how it might influence the relationship to the different publics that any given project desires to reach.

To perform at all, the curatorial as an activity and a discourse must establish certain clear protocols through which it can communicate. The public exhibition is obviously one, but seminars, congresses, marathons, caucuses, masterclasses and other more or less intensive public moments have gained currency as ways of displaying the curatorial in less fixed settings. Many of these forms are lifted from other disciplines – if we can call the curatorial a discipline – while one or two are generated from within the practice. Publications, often in the style of picture books or picture essays, are common, as are published conference proceedings and other forms that adopt academic models. It is not only in form that the curatorial establishes a limited range of devices in order to conduct itself. The exhibition display goes through cycles of fashion. Look at the consensual tastefulness of so many museum displays, their holdings ordered in terms of content and style with attempts to compare or harmonize artistic concerns across generations (though there is the start of a return to contested chronologies at the moment). Individual artists obviously also have their moment in the curatorial spotlight, when they are included in almost all major international shows and then their names become a little stale, to be replaced by fresh blood.

There is a somewhat insidious connection with the commercial market and its constantly churning need for product here, of course, as curators both pluck artists from the commercial galleries and introduce them to the art fair

circuits via curatorial projects. In the process, curators often come across as purveyors of radical chic, rhetorically supportive of utopian social conditions yet only too willing to organize advanced decorative assemblies at the feasts of the super-rich. Succumbing to such seduction is all too human of course, nor is it limited to the curatorial subculture, but I can't help feeling that the demonstrable gaps between word and deed in curatorial practice would be unsustainable in many other professions. If we are honest, we curators generally grease the wheels of whatever vehicle will allow us to make our 'project' and then hope against hope that we can still produce a critical surplus while keeping the funders happy.

If this sounds a little cynical, perhaps it is. It emerges partly out of personal experience and partly out of the disappointing exercise of reading the original curatorial texts and press releases in Afterall Books' Exhibition Histories series (in preparation). The series looks at landmark exhibitions that have shifted the concept of the curatorial in significant terms over the past 50 years. While there are notable exceptions, the general run of catalogue and other texts that define the curatorial ambitions of an exhibition are little more than puff pieces designed to pump up sales and event promotion. At these moments, the curatorial is indistinguishable from raw marketing propaganda and there is little in the way of self-reflection or visible recognition of the compromised condition in which the practice is operating. Sadly therefore, these texts are of little use in analysing the balance of negotiation, stubbornness, submissiveness and clear thinking that curating inevitably entails. We have therefore to look beyond curators themselves in order to be able to make a judgement about the evidence for and quality of any kind of critical surplus that the curatorial might add to the presentation of works of art. It is this surplus, a figure that emerges beside/above/ below everything else, that the system wants from a curator's activities; that has to be, at least for me and my own work, the chief measurement and validation of the curatorial as a productive, critical activity. It is obvious that producing that surplus is not in the hands of a single agent but is expressed in the collective total of meaning production carried out during, and mostly after, the event itself. It seems that only by revisiting exhibitions after a period and through the eyes of different participants (artists, critics, visitors, funders as well the curators) can some account of the ambition and effectiveness of the curatorial mode of thought and action be made. What this means is that the moment of public exhibition, while essential, is only an element in how curatorial agency might be exercised. Indeed it is arguable that the opening and public viewing is not even the most significant moment. It is striking from the research behind our

Exhibition Histories series how few contemporary visitors were present at those exhibitions that are, by common consent, of canonical significance for curatorial development. This argument is equally true of the various other formats that recent curatorship have constructed. In all their differences, the public moment is always a necessary focus, yet it has also to be seen as one staging post towards the full use value and affect of any given project, as well as the impact of the curatorial in general.

For me, as a curator guilty of all the sins of complicity and self-regard I have discussed above, it is this possibility of this retrospective analysis that still just about saves the day. The study of what the curatorial is by non-curators and the articulations of demands for consistency, rigour, style and substance from beyond the discipline itself are absolutely essential. Although the Curatorial/Knowledge course at Goldsmiths has, among a few others, contributed greatly to an increased critical focus on the act of curating, there is still much work to do, as well as a need for more self-awareness of the aims of curating. Further theoretical underpinning as well as practical field research is needed into how the public and post-public moments of curating are used to construct significance for certain exhibitions and other projects. Equally, current curatorial practice must develop a more knowing, dialectical relationship to its own history in order to avoid being simply instrumentalized as sophisticated entertainment for the winners of the neoliberal system. The task we have in front of us is, I believe to focus on how to deliver critical surplus over the longer term. For this, we need to construct devices that resist full-scale incorporation by funders and create events and exchanges that emerge slowly into the public domain through contestation and debate over time. Curating as an act needs to become less visible as the curatorial as a system of collective knowledge production takes the stage.

Bibliography

1. Museum history and theory

Adorno, Theodor. 'The Valéry Proust Museum.' In *Prisms*. Translated by Samuel and Sherry Weber, 175–7. Cambridge: Cambridge University Press, 1981.

Anderson, Gail, ed. *Reinventing the Museum: Historical and Contemporary Perspectives on the Paradigm Shift*. Lantham: Alta Mira Press, 2004.

Baudrillard, Jean. 'The System of Collecting.' In *Simulations*. Translated by Sheila Faria Glaser. New York: Semiotext, 1983.

Benjamin, Walter. 'Edward Fuchs: Collector and Historian.' In *Selected Writings Volume 3,* edited by Howard Eiland and Michael W. Jennings. Translated by Harry Zohn, 260–302. Harvard: Harvard University Press, 2006.

—. 'Unpacking my Library.' In *One Way Street*. Translated by J. A. Underwood, 161–71. London: Penguin Books, 2009.

Bennett, Tony. *The Birth of the Museum*. London: Routledge, 1995.

Blanchot, Maurice. 'Time, Art and the Museum.' In *Friendship*, 12–41. Translated by Elizabeth Rottenberg. Stanford: Stanford University Press, 1997.

Butler, Cornelia, Seth Siegelaub and Agnes Denes. *From Conceptualism to Feminism: Lucy Lippard's Numbers Shows 1969–74*. London: Afterall Books in association with the Academy of Fine Arts Vienna, the Center for Curatorial Studies, Bard College and Van Abbemuseum, 2012.

Cooke, Lynn and Peter Wollen, eds. *Visual Display: Culture beyond Appearances*. Seattle: DIA Foundation and Bay Press, 1995.

Crimp, Douglas. *On the Museums Ruins*. Cambridge: MIT Press, 1993.

Damisch, Hubert. 'Moves: Playing Chess and Cards with the Museum.' In *Moves,* 73–95. Rotterdam: Museum Boijmans Van Beuningen, 1997.

Déotte, Jean-Louis. 'Rome, the Archetypal Museum and the Louvre, the Negation of Division.' In *Art in Museum,* 215–22, edited by Susan Pearce. London: Athlone Press, 1995.

Duncan, Carol. *Civilising Rituals*. London: Routledge, 1995.

Duro, Paul, ed. *The Rhetoric of the Frame: Essays on the Boundaries of the Artwork*. Cambridge: Cambridge University Press, 1996.

Foster, Hal. *Recodings*. Seattle: Bay Press, 1992.

Garsskamp, Walter. *Die Unästhetische demokratie – Kunst in der Marktgesellschaft*. Munich: Ch. Beck, 1992.

—. *Die Unbelwältigte Moderne – Kunst und Öffentlichkeit.* Munich: Ch. Beck, 1989.

—. *Unerwünschte Monumente – Moderne Kunst im Stadtraum.* Munich: Silke Schreiber, 1989.

—. *Museum Gründer und Museumsstürmer-zur sozialgeschichte des Kunstmuseums.* Munich: Ch. Beck, 1981.

Genoways, Hugh, ed. *Museum Philosophy for the Twentieth-first Century.* Lanham: Alta Mira Press, 2006.

Hauer, Gerlinde, Roswitha Muttenthaler, Anna Schober and Regina Wonisch, eds. *Das inszenierte Geschlecht Feministische Strategien im Museum.* Vienna: Bohlau Verlag, 1997.

Hein, Hilde. *The Museum in Transition, A Philosophical Perspective.* Washington: Smithsonian Institution Press, 2000.

Horne, Donald. *The Great Museum.* London: Pluto, 1979.

Hudson, Kenneth. *Museums of Influence.* Cambridge: Cambridge University Press, 1987.

Jacobs, M. J. *Conversations at the Castle – Changing Audiences and Contemporary Art.* Cambridge: MIT Press and Atlanta Arts Festival, 1998.

Karp, Ivan and Stephen Levine. *Exhibiting Cultures.* Washington: Smithsonian Institution Press, 1991.

Lorente, J. Pedro. *Cathedrals of Urban Modernity.* London: Ashgate, 1998.

Maleuvre, Didier. *Museum Memories: History, Technology, Art.* Stanford: Stanford University Press, 1999.

Malraux, André. 'Museum without Walls.' In *The Voices of Silence*, 13–130. Translated by Stuart Gilbert. Princeton: Princeton University Press, 1978.

Noever, Peter, ed. *The Discursive Museum.* Ostfildern-Ruit: Hatje Cantz, 2001.

O'Doherty, Brian. *Inside the White Cube.* Berkeley: California University Press, 1999.

Pointon, Marcia. *Art Apart: Art Institutions and Ideology across England and North America.* Manchester: Manchester University Press, 1994.

Preziosi, Donald, ed. *Grasping the World: The Idea of the Museum.* London: Ashgate, 2004.

Rogoff, Irit and Daniel Sherman, eds. *Museum Culture.* Minneapolis: Minnesota University Press, 1994.

Staniszewski, M. A. *The Power of Display – A History of Exhibition Installations at The Museum of Modern Art.* Cambridge: MIT Press, 1998.

Tipton, Gemma. *Art in Space.* Dublin: Circa Art Magazine, 2005.

Valéry, Paul. 'The Problem with Museums.' In *Degas, Manet, Morisot*, 34–41. Translated by David Paul. London: Routledge and Kegan Paul, 1972.

Van Mensch, Peter. *Professionalising the Muses, The Museum Profession in Motion.* Amsterdam: AHA Books, 1989.

Van Zoest d'Arts, Rob. ed. *Generators of Culture: The Museum as a Stage.* Amsterdam: AHA Books – Art History Architecture, 1989.

Vergo, Peter. *The New Museology.* London: Reaktion Books, 1989.

2. Curating and the curatorial

Alloway, Lawrence. *The Venice Biennale 1895–1968: From Salon to Goldfish Bowl.* Greenwich: New York Graphic Society, 1968.

Althuser, Bruce. *The Avant-Garde in Exhibition.* Berkeley: California University Press, 1994.

—. 'The Canon of Curating.' *MJ Manifesta Journal* 11 (15 June 2011).

B. Read Series 2, 4, 5 and 7: *The Producers.* Gateshead: BALTIC, 2001.

Bal, Mieke. *Double Exposure: The Subject of Cultural Analysis.* London: Routledge, 1996.

—. *Looking In: The Art of Viewing.* Amsterdam: G&B Arts, 2001.

Beer, Evelyn and Riet de Leeuw, eds. *L'Exposition Imaginaire: The Art of Exhibiting in the Eighties.* Gravenhage: Rijksdienst Beeldende Kunst, 1989.

Benzer, Christa, Christine Bohler and Christiane Erkharter, eds. *Continuing Dialogues.* Vienna: JRP/Ringier, 2008.

Bourriaud, Nicolas. *Relational Aesthetics.* Paris: Les presses du réel, 2002.

Carin, Juoni. *Words of Wisdom, A Curator's Vade Mecum on Contemporary Art.* New York: Independent Curators International, 2001.

Cook, Sarah and Beryl Graham. *Rethinking Curating: Art After New Media.* Cambridge: MIT Press, 2010.

Dubin, Steven. *Displays of Power – Art and Amnesia in America.* New York: New York University Press, 1999.

Enzewor, Okwui. 'Mega-Exhibitions and the Antinomies of a Transnational Global Form.' *Manifesta Journal* 2 (Winter–Spring 2004): 6–31.

Esche, Charles. *Modest Proposals.* Istanbul: Baglam Press, 2005.

Fibisher, Bernard, ed. *L'art exposé: quelques reflexions sur l'exposition dans les années 90.* Küsnacht: Cantz, 1995.

Filipovic, Elena and Marieke van Hal, and Solveig Øvstebo, eds. *The Biennial Reader.* Bergen: Bergen Kunsthall and Ostfildern: Hatje Cantz, 2010.

Fowle, Kate. *Who Cares? Contemporary Curating.* New York: Apex Art, 2007.

Greenberg, Reesa, Bruce Ferguson and Sandy Nairne, eds. *Thinking about Exhibitions.* London: Routledge, 1997.

Groïs, Boris. *Art Power.* Cambridge: MIT Press, 2008.

Hannula, Mika. *Stopping the Process: Contemporary Views on Art and Exhibitions.* Helsinki: NIFCA Publications, 1998.

Lind, Maria, ed. *Curating with Light Luggage.* Munich: Kunstverein, 2004.

—. 'The Curatorial.' *Artforum* 68, no. 2 (October 2009): 65–103.

Lind, Maria and Jens Hoffman. 'To Show or Not to Show.' *Mouse Magazine* 31 (November 2011).

Lumley, Richard. *The Museum-Time-Machine; Putting Cultures on Display.* New York: New York University Press, 1988.

Marincola, Paula, ed. *What Makes a Great Exhibition?* Philadelphia: Philadelphia Exhibitions Initiative, Philadelphia Center for Arts and Heritage, 2006.

Meyer, James, ed. 'Global Tendencies: Globalism and the Large-Scale Exhibition.' *Artforum* XLI, no. 3 (November 2003).

Milevska, Suzana and Biljana Tanurovska-Kjulavkovski, eds. *Curatorial Translation.* Skopje: Euro-Balkan Press, 1998.

Miller, Alicia, ed. *Feedback 0–1: Ideas that Inform, Construct and Concern the Production of Exhibitions and Events.* London: Whitechapel, 2004.

Missiano, Viktor, ed. 'Collective Curating: Special Issue.' In *Manifesta Journal* 8 (2009–10).

Obrist, Hans-Ulrich, ed. *A Brief History of Curating.* Zurich: JRP/Ringier and Paris: Les Presses du réel, 2008.

Okeke-Agulu, Chika. 'The Twenty-First Century and the Mega Show: Roundtable Special Issue.' *Nka Journal of Contemporary African Art* 22–3 (Spring/Summer 2008): 153–88.

O'Neill, Paul, ed. *The Culture of Curating and the Curating of Culture(s).* Cambridge: MIT Press, 2012.

—. *Curating Subjects.* London: Open Editions, 2007.

Paldi, Livia. 'Notes on the Paracuratorial.' *The Exhibitionist* 4 (June 2011): 71–2.

Rand, Steven and Heather Kouris, eds. *Cautionary Tales: Critical Curating.* New York: Apexart, 2007.

Rattemeyer, Christian, ed. *Exhibiting the New Art: 'Op Losse Schroeven' and 'When Attitudes Become Form' 1969.* Afterall Books in association with the Academy of Fine Arts Vienna and Van Abbemuseum, Eindhoven, 2010.

Richter, Dorothee and Barnaby Drabble, eds. *Curating Critique.* Frankfurt am Main: Revolver, 2007.

Rilke, Rainer Maria. *Letters on Cézanne*, edited by Clara Rilke. Translated by Joel Agee. New York: Fromm International, 1985.

Schade, Sigrid, ed. *Curating Degree Zero: An International Curating Symposium.* Nurnberg: Verlag Moderne Kunst, 1999.

Sherman, Daniel. *Worthy Monuments, Art Museums and the Politics of Culture in 19th Century France.* Harvard: Harvard University Press, 1989.

Smith, Terry. *Thinking Contemporary Curating.* New York: ICI, 2012.

Tagg, John. 'A Socialist Perspective on Photographic Practice.' In *Three Perspectives on Photography: Recent British Photography.* London: Hayward Gallery & Arts Council of Great Britain, 1979.

Tanner, Christoph and Ute Tischler, eds. *Men in Black: Handbook of Curatorial Practice.* Frankfurt a. M: Revolver – Archiv für aktuelle Kunst, 2004.

Thea, Carolee. *Foci: Interviews with 10 Curators.* New York: Art Publishers, 2001.

Thomas, Catherine, ed. *The Edge of Everything: Reflections on Curatorial Practice.* Banff: Walter Philips Gallery Editions, 2002.

Townsend, Melanie, ed. *Diverging Curatorial Practices: Beyond the Box.* Banff: Walter Philips Gallery Editions, 2003.

Vanderlinden, Barbara and Elena Filipovic, eds. *The Manifesta Decade: Debates on Contemporary Art Exhibitions and Biennials in Post-Wall Europe*. Cambridge: MIT Press, 2005.

Wade, Gavin, ed. *Curating in the 21st. Century*. Walsall: The New Art Gallery and University of Wolverhampton, 2000.

Weiss, Rachel, Luis Camnitzer, Coco Fusco and Geeta Kapur. *Making Art Global (Part 1): The Third Havana Biennial 1989*. Afterall Books in association with the Academy of Fine Arts Vienna and Van Abbemuseum, Eindhoven, 2011.

White, Peter, ed. *Curatorial Strategies for the Future*. Banff: Walter Philips Gallery Editions, 1996.

Zabel, Igor. 'The Return of the White Cube.' *Manifesta Journal* 1 (Spring–Summer 2003): 12–21.

3. Sociology, anthropology

Barringer, Tim and Tom Flynn. *Colonialism and the Object*. London: Routledge, 1998.

Bourdieu, Pierre and Alain Darbel. *Distinction: A Social Critique of the Judgement of Taste*. Translated by Richard Nice. Harvard: Harvard University Press, 1984.

—. *The Love of Art: European Art Museums and their Public*. Translated by Caroline Beattie and Nick Merriman. London: Polity Press, 1991.

—. *Outline of a Theory of Practice*. Translated by Richard Nice. Harvard: Harvard University Press, 1986.

—. *The Love of Art – European Art Museums and their Public*. Stanford: Stanford University Press, 1990.

Clifford, James. *The Predicament of Culture*. Harvard: Harvard University Press, 1991.

—. *The Predicament of Culture: 20th Century Ethnography*. Harvard: Harvard University Press, 1988.

—. *Routes: Travel, and Translation in the Late Twentieth Century*. Harvard: Harvard University Press, 1997.

DiMaggio, Paul. *Audience Studies in the Performing Arts and Museums – A Critical Review*. Washington: Research Division Report no. 9 (1978).

McCannell, Dean. *The Tourist: A New Theory of the Leisure Class*. Berlin: Schocken Books, 1976.

Price, Sally. *Primtive Art in Civilized Places*. Chicago: University of Chicago Press, 1989.

Thomas, Nicholas. *Entangled Objects*. Harvard: Harvard University Press, 1989.

Virno, Paolo. *The Grammar of the Multitude: For an Analysis of Contemporary Forms of Life*. Translated by Isabella Bertoletti, James Cascaito and Andrea Casson. Los Angeles: Semiotext(e), 2004.

Zollberg, Vera. *Constructing a Sociology of the Arts*. Cambridge: Cambridge University Press, 1990.

4. Artists and exhibitions

Alberro, Alexander and Blake Stimson, eds. *Institutional Critique: An Anthology of Artists' Writings*. Cambridge: MIT Press, 2011.

Bloom, Barbara. *The Reign of Narcissim*. London: Serpentine Gallery, 1991.

Bourdieu, Pierre and Hans Haacke. *Free Exchange*. London: Polity Press, 1995.

Bronson, A. A. and Peggy Gale, eds. *Museums by Artists*. Toronto: Art Metropole, 1999.

Broodthaers, Marcel. *Exhibition Catalogue*. New York: Walker Art Centre, 1990.

Buren, Daniel. *Function of the Museum*. Artforum 12, no. 1 (September 1973).

Crone, Bridget. *The Sensible Stage: Staging and the Moving Image*. Bristol: Picture This, 2012.

Frenkel, Vera. *The Cornelia Lumsden Archive*. Montreal: Montreal World Fair, 1982.

Gaba, Meshac. *Museum of Contemporary African Art*. Amsterdam: Artimo, 2001.

Haacke, Hans. *Unfinished Business*. New York: The New Museum, 1988.

Kravagna, Christian, ed. *The Museum as Arena: Institutional-Critical Statements by Artists*. Cologne: Verlag der Buchhandlung Walther König, 2001.

McShine, Kynaston. *The Museum as Muse, Artists Reflect*. New York: MOMA, 1999.

Muensterberg, Werner. *Collecting, An Unruly Passion*. Princeton: Princeton University Press, 1994.

Wislon, Fred. *Mining the Museum*. New York: Baltimore Historical Society and the New Press, 1991.

5. Theory and philosophy

Adorno, Theodor. *The Culture Industry*. London: Routledge, 1993.

—. *Negative Dialectics*. Translated by E. B. Ashton. London: Routledge, 1990.

Agamben, Giorgio. *The Coming Community*. Minneapolis: Minnesota University Press, 1993.

—. *What is an Apparatus? and Other Essays*. Stanford: Stanford University Press, 2009.

Austin, J. L. *How to Do Things with Words*. Cambridge: Harvard University Press, 1975.

Azoulay, Ariella. *The Civil Contract of Photography: 1*. New York: Zone Books, 2008.

Bal, Mieke and Norman Bryson. 'Semiotics and Art History.' *The Art Bulletin* LVVIII, no. 2 (June 1991): 174–208.

Barthes, Roland. *Image Music Text*. London: Fontana Press, 1977.

Bataille, Georges. *The Accursed Share, Vol. 1*. Translated by Robert Hurley. Cambridge: MIT Press, 1991.

—. 'Museum', in *Encyclopaedia Acephalica*, 64–5. Translated by Ian White. New York: Atlas, 1995.

—. *The Unfinished System of Nonknowledge*. Translated by Michelle and Stuart Kendall. Minneapolis: University of Minnesota Press, 2001.

Baudrillard, Jean. 'The Beaubourg Effect – Implosion and Detterence.' In *October* 20 (1982): 3–23.

Borges, Jorge Luis. *Labyrinths*. Translated by Eliot Weinberger. New York: New Directions, 1962.

Bryson, Norman. *Word and Image, French Painting of the Ancient Regime*. Cambridge: Cambridge University Press, 1981.

Butler, Judith. *Bodies That Matter: On the Discursive Limits of Sex*. London: Routledge, 2011.

—. *Excitable Speech: Politics of the Performative*. Stanford: Stanford University Press, 1997.

—. *The Psychic Life of Power: Theories in Subjection*. London: Routledge, 1996.

De Certeau, Michel. *The Practice of Everyday Life*. Translated by Steven F. Rendall. Berkeley: University of California Press, 2011.

Deleuze, Gilles and Felix Guattari. *The Logic of Sense*. Translated by Constantin V. Boundas. London: Continuum, 2005.

—. *A Thousand Plateaus: Capitalism and Schizophrenia*. London: Athlone, 1988.

Derrida, Jacques. *Archive Fever; A Freudian Impression*. Translated by Eric Prenowitz. Chicago: University of Chicago Press, 1996.

—. *Eyes of the University, Right to Philosophy* 2. Translated by Jan Plug. Stanford: Stanford University Press, 2004.

—. *Of Grammatology*. Translated by Gayatri Spivak. Baltimore: Johns Hopkins University Press, 1974.

—. *Of Hospitality*. Translated by Rachel Bowlby. Stanford: Stanford University Press, 2000.

—. *The Truth in Painting*. Translated by Geffroy Bennington and Ian McLeod. Chicago: University of Chicago Press, 1987.

Donato, Eugenio. 'The Museum's Furnace: Notes Toward a Contextual Reading of Bouvard et Pecuchet.' In *Textual Strategies: Perspectives in Post-Structuralist Criticism*, edited by Josue V. Harari, 213–38. Ithaca: Cornell University Press, 1979.

Foucault, Michel. *The Archaeology of Knowledge*. Translated by A. M. Sheridan Smith. London: Routledge, 2000.

—. *The Order of Things*. Translated by Charles Ruas. London: Tavistock Publications, 1972.

—. 'This Is Not a Pipe.' Translated by James Harkness. In *Continental Aesthetics*, edited by Richard Kearney and David Rasmussen, 374–87. London: Blackwell, 2001.

Grosz, Elizabeth, ed. *Becomings: Explorations in Time, Memory, and Futures*. Ithaca: Cornell University Press, 1999.

Habermas, Jurgen. *Knowledge and Human Interests*. Translated by Jeremy Shapiro. London: Heinemann Educational, 1978.

Heidegger, Martin. *Discourse on Thinking*. Translated by John M. Anderson and E. Hans Freund. New York: Harper & Row, 1966.

—. 'The Thing.' In *Poetry, Language, Thought*. Translated by Albert Hofstadter. New York: Perennial Classics, 2001.

Karacauer, Siegfried. *The Mass Ornament*. Harvard: Harvard University Press, 1995.

Lefebvre, Henry. *The Production of Space*. Translated by Donald Nicholson-Smith. Oxford: Blackwell, 1991.

Lyotard, Jean-François. *Discourse Figure*. Translated by Anthony Hudek. Minneapolis: University Of Minnesota Press, 2011.

Nancy, Jean Luc. *The Inoperative Community*. Minneapolis: University of Minnesota Press, 1998.

Rancière, Jacques. *The Politics of Aesthetics*. Translated by Gabriel Rockhill. London: Continuum, 2006.

Schaeffer, Jean-Marie. 'Experiencing Art Works.' In *Think Art,* 47–54. Rotterdam: Witte de With Centre for Contemporary Art, 1999.

Soja, Edward. *Thirdspaces: Journeys to Los Angeles and Other Real and Imagined Places*. London: Blackwell, 1996.

Williams, William Carlos. *The Embodiment of Knowledge*. New York: New Directions Books, 1974.

6. Participation and education

Arendt, Hannah. *The Human Condition*. Chicago: University of Chicago Press, 1958.

Cox, Geoff and Joasia Krysa, eds. *Engineering Culture: On the Author as the Cultural Producer*. DATA Browser 02. New York: Autonomedia, 2005.

Ehrenreich, Barbara. *Dancing in the Streets: A History of Collective Joy*. London: Granta Books, 2008.

Frieling, Rudolf. *The Art of Participation: 1950 to Now*. London: Thames & Hudson, 2008.

Kester, Grant. *Conversation Pieces: Community and Communication in Modern Art*. Berkeley: University of California Press, 2004.

Laclau, Ernersto and Chantal Mouffe. *Hegemony & Socialist Strategy: Towards a Radical Democratic Politics*. London: Verso, 1985.

Latour, Bruno and Peter Weibel. *Making Things Public: Atmospheres of Democracy*. Cambridge: MIT Press, 2005.

O'Neill, Paul and Mick Wilson, eds. *Curating and the Educational Turn*. London: Open Editions and Amsterdam: de Appel Occasional Table, 2010.

Rogoff, Irit and Angelika Nollert, eds. *A.C.A.D.E.M.Y.* Frankfurt a M.: Revolver, 2006.

Spivak, Gayatri. *Outside in The Teaching Machine*. London: Routledge, 1993.

Index